W9-BZM-833

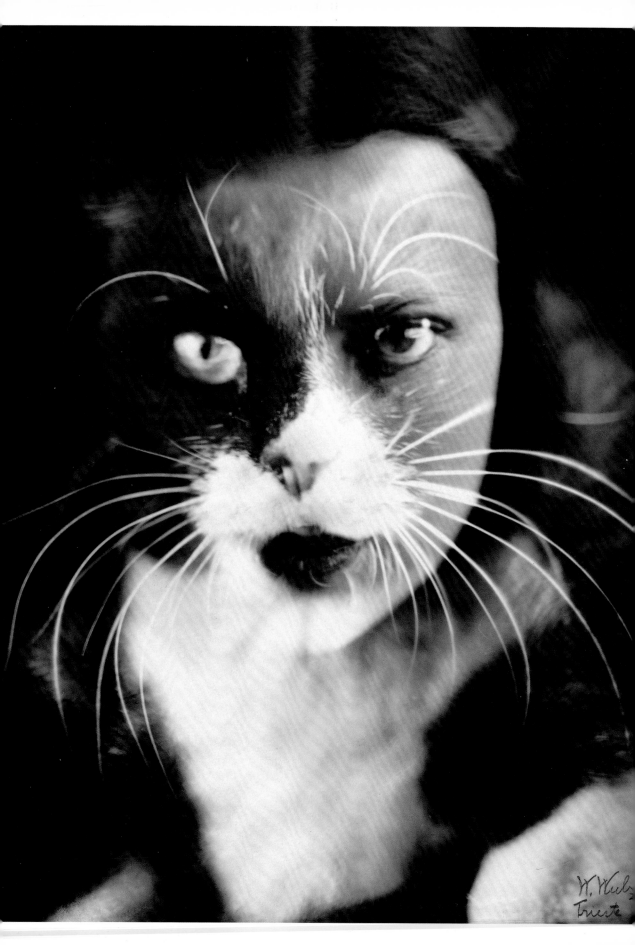

Andrew Bolton

with contributions by Shannon Bell-Price and Elyssa Da Cruz

WILD: FASHION UNTAMED

The Metropolitan Museum of Art, New York

Yale University Press, New Haven and London

This volume has been published in conjunction with the exhibition
"WILD: Fashion Untamed," held at The Metropolitan Museum of Art,
New York, December 7, 2004–March 13, 2005.

The exhibition is made possible by roberto cavalli

Additional support has been provided by
John and Laura Pomerantz.

Published by The Metropolitan Museum of Art, New York

John P. O'Neill, Editor in Chief

Gwen Roginsky, Associate General Manager of Publications

Barbara Cavaliere, Editor

Paula Torres, Production Manager

Design by Takaaki Matsumoto, Matsumoto Incorporated, New York

Printed and bound by Nissha Printing Co., Ltd., Kyoto, Japan

Cover: Adolfo, American (born Cuba, 1933). Hood, polychrome snakeskin, 1965.
Photograph: Bert Stern/*Vogue* copyright © 1965 Condé Nast Publications Inc.

Frontispiece: Wanda Wulz, Italian (1903–1984). *Cat and I*, gelatin silver print,
1932. The Metropolitan Museum of Art, Ford Motor Company Collection,
Gift of Ford Motor Company and John C. Waddell, 1987 (1987.1100.123)

Page 10: Alexander McQueen, British (born 1969). Ensemble, autumn/winter
1997–1998. Courtesy of firstview.com

Cataloging-in-Publication data is available from the Library of Congress.

ISBN 1-58839-135-3 (The Metropolitan Museum of Art)

ISBN 0-300-10638-6 (Yale University Press)

CONTENTS

SPONSOR'S STATEMENT

It is with great pleasure that I support The Metropolitan Museum of Art on the occasion of The Costume Institute's exhibition "WILD: Fashion Untamed," a remarkably well-balanced and comprehensive exploration of a theme that inspires so much of my work. I have been fortunate enough to play a part in some of the recent exhibitions, and I am honored to be able to continue this collaboration for The Costume Institute's latest project.

Animal motifs and the power they convey have always inspired my work and are an extension of all that fascinates me about fashion: the idea of adornment as provocation, the notion that clothes lend confidence and strength to the wearer, and the way a piece of fabric, or a pelt or a plume, can convey sensuality.

My goal always has been to "untame fashion," and I cannot think of a more exciting way to celebrate the power of this process than by being a part of this exhibition.

Roberto Cavalli

DIRECTOR'S FOREWORD

WILD: Fashion Untamed is inspired by an idea originally conceived by the eminent costume historian and late curator in charge of The Costume Institute, Richard Martin. Together with Harold Koda, Martin initiated a continuing series of thematic exhibitions of astonishing diversity and originality, exhibitions that have drawn upon and highlighted the range and richness of the department's encyclopedic collection. With over 80,000 objects from seven centuries and five continents, The Costume Institute's holdings are unrivaled in artistic merit and stand as a testament to the talent and foresight of its curators to seek out and recognize apparel of cultural and historical import.

The Costume Institute Zoo, as Martin's exhibition was to be titled, intended to highlight the especially exuberant splendor of garments in the collection that integrate or replicate furs, leathers, and feathers into their designs. Fashion's application of faunal materials with totemic associations has a long history, even a prehistory, as the curators argue in both the exhibition and this related publication. What is new is their lively and spirited interpretation, inflected as it is by the potent issues of gender, consumption, commodification, and necessarily the ethical treatment of animals. Once again, The Costume Institute expands our understanding of the conceptual and contextual meanings of dress.

WILD: Fashion Untamed, with its focus on the persistent application of animal imagery and materials to apparel, serves as a pendant to The Costume Institute's recent exhibition *Goddess: The Classical Mode*, in which a similar continuum of style throughout history and across cultures was examined. In both instances there is an analysis of the actual construction and formal characteristics of dress. As in previous exhibitions at The Costume Institute, the most avant-gardist fashion is used as an opportunity to explore past precedents, establishing the relevance and manifestation of history in contemporary life.

The Metropolitan Museum is deeply indebted to Roberto Cavalli for his generous support of this exhibition. We likewise remain grateful to John and Laura Pomerantz for their assistance toward the realization of this project.

<div align="right">

Philippe de Montebello
Director
The Metropolitan Museum of Art

</div>

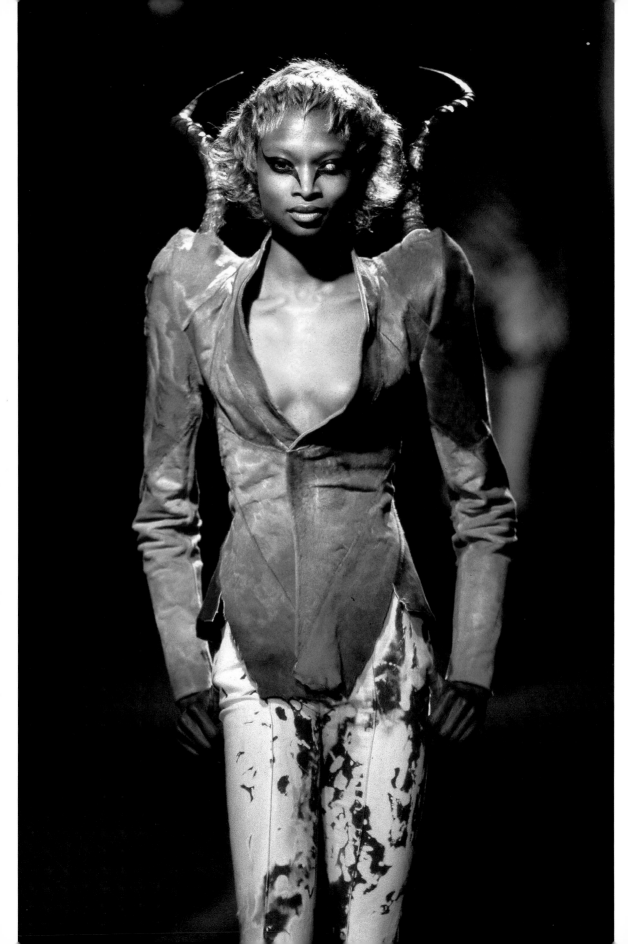

INTRODUCTION

> The horror that stirs deep in man is an obscure awareness that in him something lives so akin to the animal that it might be recognized . . . He may not deny his bestial relationship with animals, the invocation of which revolts him: he must make himself its master.
>
> Walter Benjamin, *One-Way Street* (1928)

Since the birth of haute couture in the mid-nineteenth century, designers have looked to the animal kingdom as a source of raw materials, as a catalyst for inspiration, and as a conduit for their artistic expression. Fur, leather, and feathers are among the principal materials of the couture, requisite to the ateliers of tailoring and dressmaking as well as to the adjunct *petites mains* workshops for accessories and embellishments. Prints based on the bold, graphic patterns of the tiger, zebra, cheetah, leopard, and even the giraffe have been used by designers as much for their strong visual impact as for their implicit eroticism and explicit exoticism. At the same time designers have drawn on animal symbolism, with its folkloric, mythological, and magico-religious associations, to imbue their work with an arresting and sometimes alarming sensuality. Straddling the ideologies of nature and artifice, designers have sought to shape ideals of femininity that evoke and invoke the physical and symbolic characteristics of animals, ideals that have resonance in both the past and the present.

The history of fashion's appropriation of animal skins, prints, and symbolism is also a history of society's changing attitudes and ambivalences toward human-animal relations. Like fashion, which often serves as a cultural barometer, society oscillates between accepting and rejecting the dominant anthropocentric assumptions that have come to shape a hierarchical relation between humans and animals. In tune with Judeo-Christian teachings, René Descartes, considered the father of modern philosophy, believed animals to be inferior to humans because of their inability to speak and to reason. The various animal rights activists and animal welfare organizations that have emerged since the 1970s have attempted to redress this socio-symbolic asymmetry. While their primary focus has been on fur-bearing animals, they have been relatively successful in reconceptualizing the prevailing metaphysics. Their media campaigns, however, which have served as critiques of both the producers and consumers of fur products, have drawn attention not only to society's attitudes toward animal-human relations but also its attitudes toward human-human relations.

Male to male, male to female, and female to female relations are all played out in the highly charged and contested territory of faunal apparel. As early as the Middle Ages, laws were enacted to regulate the use of fur as a status and gender signifier. Julia V. Emberley observed in *The Cultural Politics of Fur* (1997): "This legislation attempted to order multiple regimes of value, not only fur's material signification as a sign of wealth but also its value for instituting class, gender, and religious hierarchies by turning fur into a visual representation of social difference." These hierarchies still hold true today and touch on subjects as controversial as racism, sexism, colonialism, and environmentalism. It is perhaps not coincidental, then, that animal skins, prints, and symbolism appear in fashion at times of sociopolitical turmoil. They dominated the fashion landscape in the 1930s, the 1960s, and the 1980s, as they do today, all periods displaying an acute awareness of race, class, and gender relations as well as heightened sensitivity toward imperialist expansion.

Andrew Bolton
Associate Curator, The Costume Institute
The Metropolitan Museum of Art

CALL OF THE WILD

Animal skins were one of man's earliest sartorial statements, serving the dual functions of protection and adornment. Leather has been used for armor and amour ever since. It was not until several millennia later, however, that the atavistic sources were acknowledged. In the 1960s fashion designers began to reference the prehistoric by using untrimmed pelts and fashioning leather garments with crude shaping, piecing, and whip-stitching. Through the continued use of these materials and techniques late twentieth-century couture has evoked a variety of feminine personas. Of these it is the archetype of the huntress, with her power and free-spirited independence, that is most frequently celebrated. When envisioning this prehistoric stereotype, contemporary designers invariably dress her in pelts, hides, and leathers. The shapes and textures of unfinished skins, with irregular edges and flaws, signify a clear atavistic intent by alluding to primitive dress. Designers impress a savage sexuality onto the wearer by using such ancient tropes to convey modern concepts of womanliness.

Related to this primitive huntress, *La Belle Sauvage* was an outgrowth of Jean-Jacques Rousseau's Enlightenment idea of the "noble savage," as well as other eighteenth-century romantic fantasies about "wild" women who were reared by animals. While these "savages" were deemed to be less than human, their capacity to be "civilized" by their captors spoke to the intrinsic goodness of humanity. Based on similar conventional Pocahontas stereotypes such as the naïve native and Indian "squaw," *La Belle Sauvage* adorns herself in buckskin. During the late 1960s designers and counterculturalists revised the iconography of the feral savage by focusing on her qualities of feminine strength and uninhibited sexuality. Through the pioneering use of apparently raw leather and primitive-looking construction, they effectively redefined these "squaw" tropes and addressed second-wave feminists' goals of freedom and self-sufficiency.

While the political and sartorial underpinnings of the persona of the postmodern huntress were crafted during the 1960s, recent manifestations of the primordial mode appear to be more conflicted. In the new millennium, couturiers have begun to juxtapose coarser animal skins and leather with surprisingly delicate textiles in classic feminine constructions, reasserting the tension between the wild and the tamed. The ultimate personification of these dichotomies is the ancient Amazon, the voluptuous virago and divine huntress. The mythological Amazons worshiped Artemis (Roman Diana's Greek counterpart), the virgin goddess of the hunt and protector of all things wild. They are depicted swathed in spotted pelts, which characterize them as untamable barbarians and illustrate the universal struggle between civilization and savagery.

In this era of techno textiles the use of complete animal hides by couturiers is an assertion of authenticity. Costume history addresses this impulse within the context of postmodern theory. Julia V. Emberley defines our era as "paleolithic late modern," suggesting that we are looking backward and forward simultaneously. If, as Barbara Baines contends, fashion revivals are "searches for paradise lost," then we have journeyed back in our search for sartorial rebirth to the Garden of Eden. Revealing a postmodern paradox the endless archaeology of fashion has extended to prehistory, with fashion looking to the very origins of our species in its continuing impulse forward.

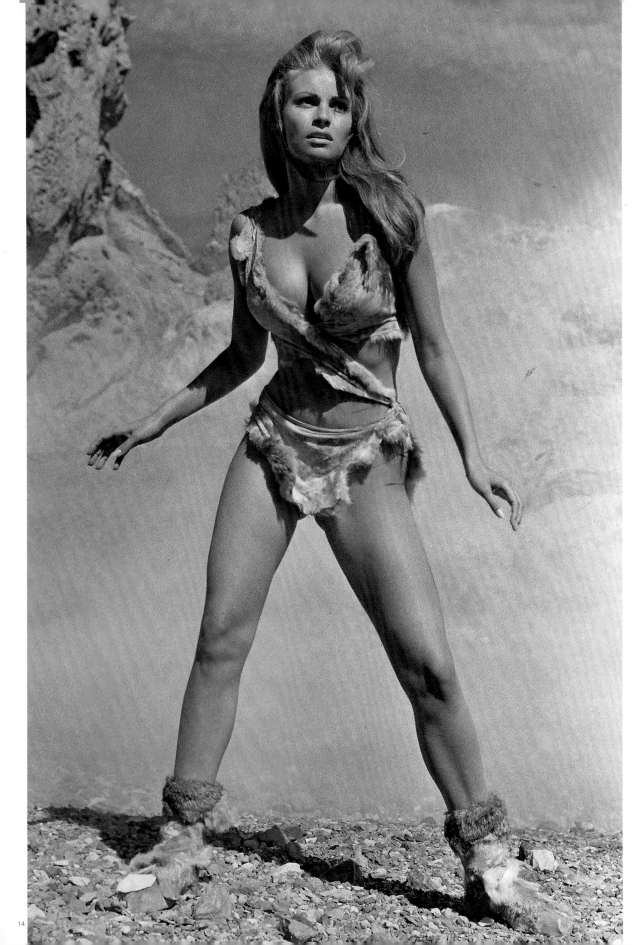

The image of the prehistoric huntress has been portrayed throughout the millennia and has been readily embraced by the purveyors of pop culture, who have reshaped her body and refashioned her clothes to reflect contemporaneous ideals of beauty and sexuality. As seen on page 14, Raquel Welch in the Hammer film *One Million Years B.C.* (1966), comprises one of the more compelling representations of this pop primitive huntress. In one of her earliest roles, Welch plays Loanna, daughter of the chief of the peace-loving, hunter-gatherer Shell Tribe. The voluptuous huntress and her admiring neanderthaloid Tumak, of the war-mongering Rock Tribe, are depicted in a Darwinian struggle for survival against ever-looming threats of extinction. Like the Flintstones, television's animated "modern stone-age family," Loana and Tumak adorn themselves in the skins of animals. While cultural anthropology and ancient archaeology support a skin-wearing hypothesis, Welch's skimpy hide bikini seems an improbable response to a prehistoric woman's impulse to shield her nakedness. Nevertheless, the crudeness of Loana's fur and leather costume with its rough and unfinished edges certainly conveys the savagery of her circumstances.

While a fantastically fashioned prehistoric huntress has been evoked through the glamorous veneer of the Hollywood lens, her more authentic prototype was rendered on the wall of a Mesolithic cave in the Franco-Cantabrian heartland, home to Ice Age big-game hunters (page 16). Early archaeologists interpreted cave art, which often depicts hunting scenes or animal imagery, as evidence of the expressive urge of our oldest ancestors. Subsequent research and discoveries, however, have led archaeologists to propose that such images more likely have religious and ceremonial significance. This cave painting, which is thought to depict shapely dancing women wearing fur or hide skirts, suggests that early man's survival was contingent on the spoils of the hunt. In that context, the animal-skin skirts are explicit manifestations of prehistoric man's ability to control and channel the power of animals to human benefit, an impulse that remains potent to this day.

The primordial mode in which the first humans clothed themselves for literal protection reemerged as metaphor at the end of the twentieth century, as seen in the evocative and provocative paleo-chic imagery in the editorial for Jean Paul Gaultier shown on page 17. Confirming his statement "My fashion is a lot about projecting a strong, unique character to the outside world," Gaultier interpreted the prehistoric huntress as a modern icon of femininity, reiterating the primitive origin of leather clothes as a vital byproduct of the hunt. The stylist's pairing of a sheer knit sweater, which covers but does not hide the body, with a skirt featuring fur-side in and hide-side out is a typical Gaultier transgression. By placing the mother and child in a cave, the stylist conveyed a more explicit prehistoric reference, further underscoring Gaultier's sourcing of antediluvian apparel.

Page 14: Raquel Welch in *One Million Years B.C.*, film still, 1966. Courtesy of Photofest

Page 16: Mesolithic cave painting (detail) from Cova del Moros, Kogul, Spain, ca. 10,000 B.C. Copyright © Archivo Iconografico, S.A./CORBIS

Page 17: Jean Paul Gaultier, French (born 1952). Ensemble, autumn/winter 1999–2000. Photograph: James Dimmock

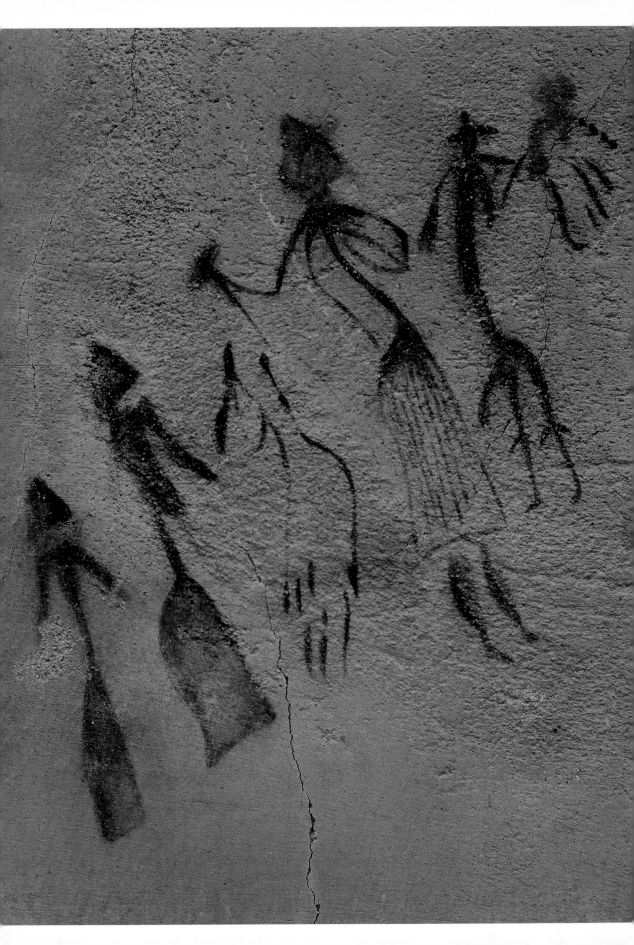

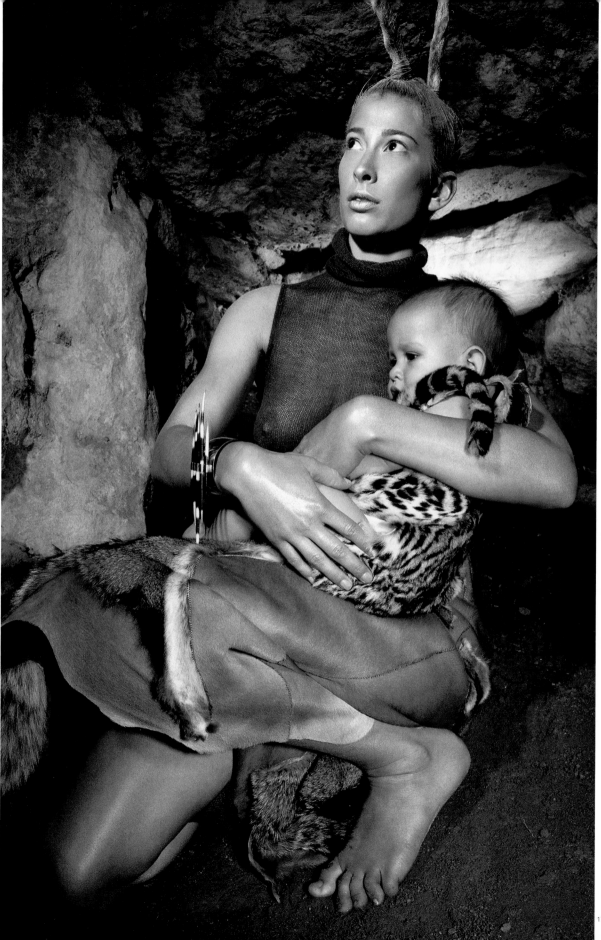

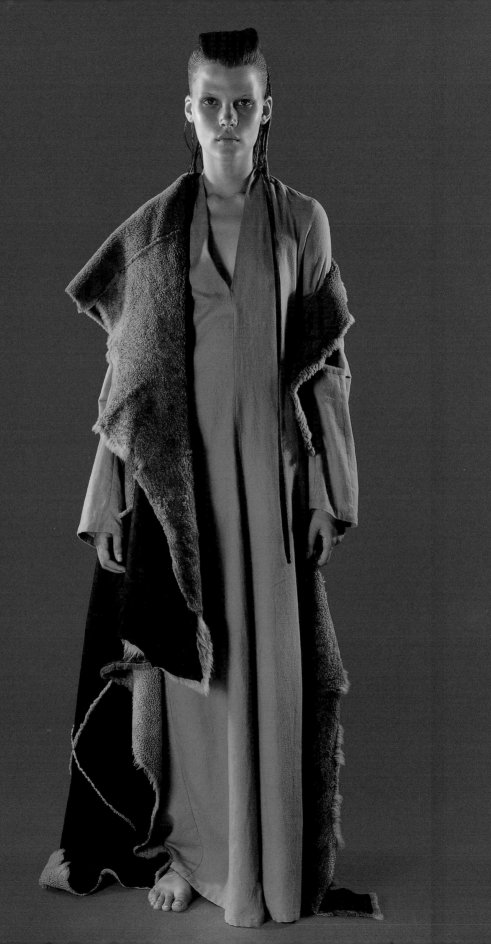

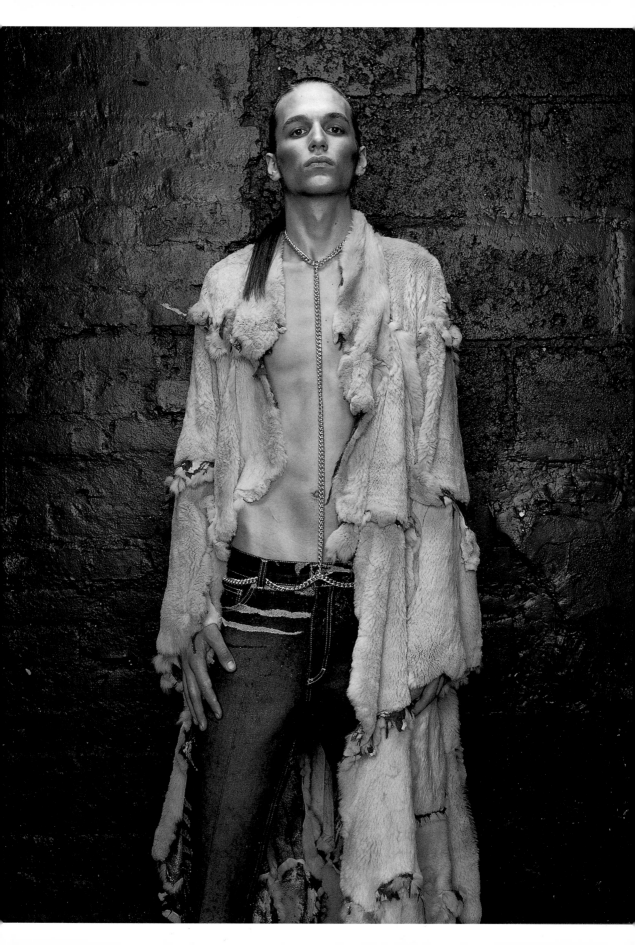

The idea that clothing provides physical and psychological protection from a hostile world, an intimate "mobile home," is evident in the editorials for Ann Demeulemeester and Roberto Cavalli shown on pages 18–19. These menacing Mohicans, clad in deconstructed shearling and organically pieced pelts, are exemplars of fashion's end-of-the-century urges toward sartorial barbarism. They evoke the tribal huntress and androgynous post-apocalyptic warrior, personifying the style known as "modern primitive," an oxymoronic term that entered the popular lexicon during the 1980s, when extreme body modification such as tattooing and piercing became fashionable. By the late 1990s corporeal ornamentation became less invasive and permanent, supplanted as it was by the medium of dress. This shift seen in avant-garde fashion effectively transferred the site of primal expression from one's own skin to one's second skin. While Demeulemeester is renowned for her deconstructionist clothing, this style is atypical of Cavalli's most recent work. However, Cavalli's foundation in innovative leather piecing and patchwork is evident in his use of tiered pelts. In both cases, the naturally raw and rugged feel of the unstructured designs reveals how the modern primitive sensibility has been manifested in fashionable dress. Increasingly, designers have attempted to surpass prior atavistic references, digging deeper into the archaeology of costume to powerful effect.

In fashion's discourse, *La Belle Sauvage*, the "native" hunter-gatherer woman, has become a pendant to the prehistoric huntress. *La Belle Sauvage* was an idiom and conceit of The Enlightenment, evidence of the hegemonic, evolutionary, and imperialist dialectic between "civilized" Europeans and the "uncivilized others" of the new and exotic colonies. In Edward Curtis's portrait shown on page 21, an Arikara rush gatherer personifies what have come to be the stereotypical conventions of the "squaw." As consort to the hunter and brave, she is sheathed in buckskin, the tangible attributes of his prowess as a provider. Curtis's early-twentieth-century photographs of North America's indigenous people were intended to be documentary. But as with so many of his portraits, this image reinforces the myth of the "noble savage." The eighteenth-century French philosopher Jean-Jacques Rousseau perpetuated this myth of "native" peoples' alleged symbiosis with nature and hypothetical biological closeness to animals. However, these idealized associations did not preclude New World colonists from viewing the traditional raw-edged and fringed buckskin garments of the Plains Indians as a sign of wild savagery. During the late 1960s the use of buckskin in clothing and other Native American sartorial signifiers became fashionable as hippies withdrew from society to "get back to nature" and align themselves with an historical "other." For her 1969 album *3614 Jackson Highway*, Cher exuded an exotic appeal when she posed wearing a doeskin tunic with beads and fringe (pages 22–23). The romanticized pastoralism of *La Belle Sauvage* in the guise of a highly stylized and fetishized Pocahontas is infused with new provocative sexuality.

Page 18: Ann Demeulemeester, Belgian (born 1959). Ensemble, autumn/winter 1999–2000. Photograph: Mario Sorrenti

Page 19: Roberto Cavalli, Italian (born 1940). Ensemble, spring/summer 2000. Model: Alexander, Stockholmsgruppen. Photograph: Jens Andersson. Creative Direction/Styling: Robert Nordberg, Loox

Page 21: Edward S. Curtis, American (1868–1952). *The Rush Gatherer—Arikara*, photogravure on vellum, 1909. Reproduction courtesy of Christopher Cardozo, Inc.

Pages 22–23: Cher in a buckskin tunic, 1969. Photograph: Stephen Paley

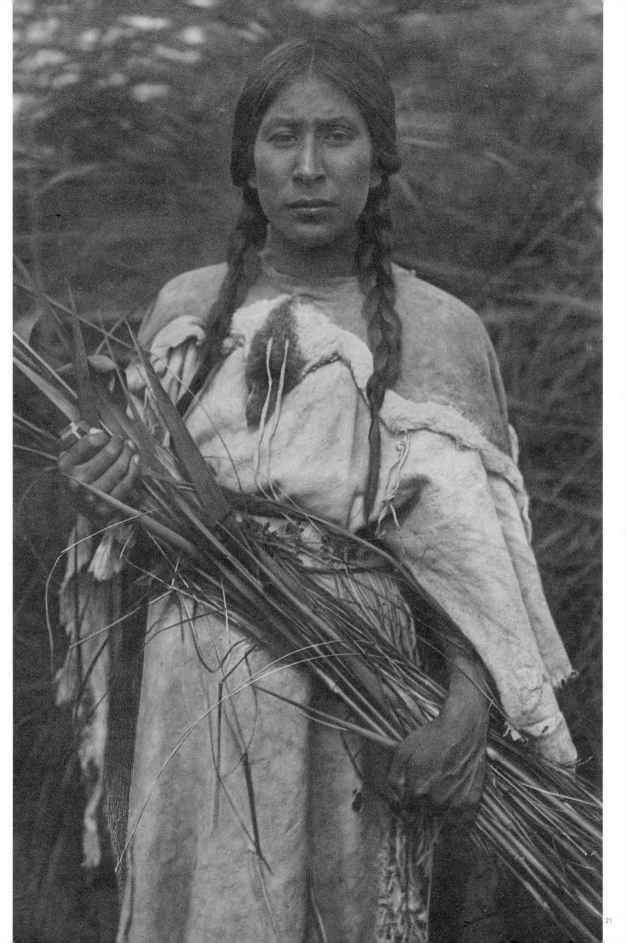

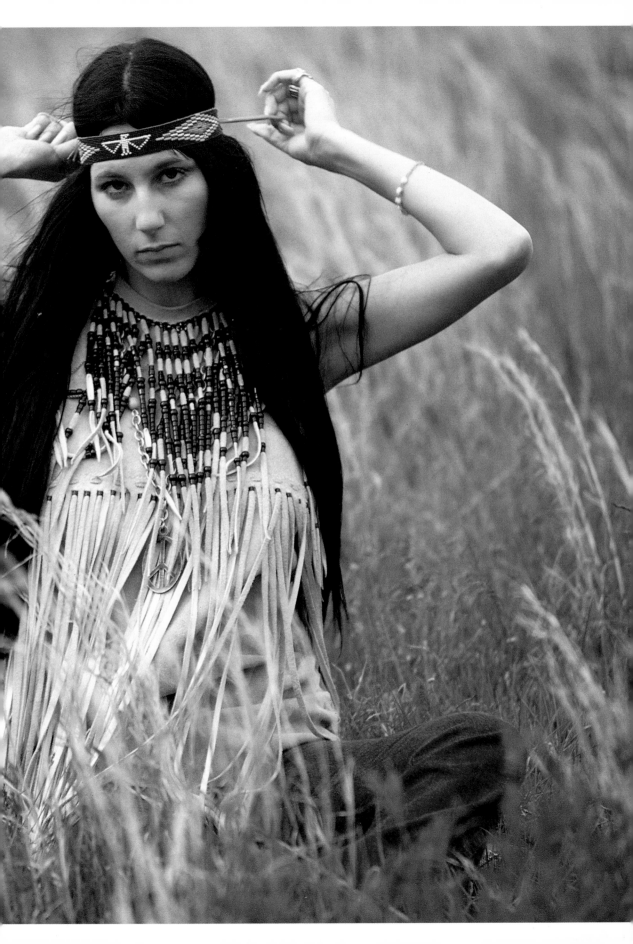

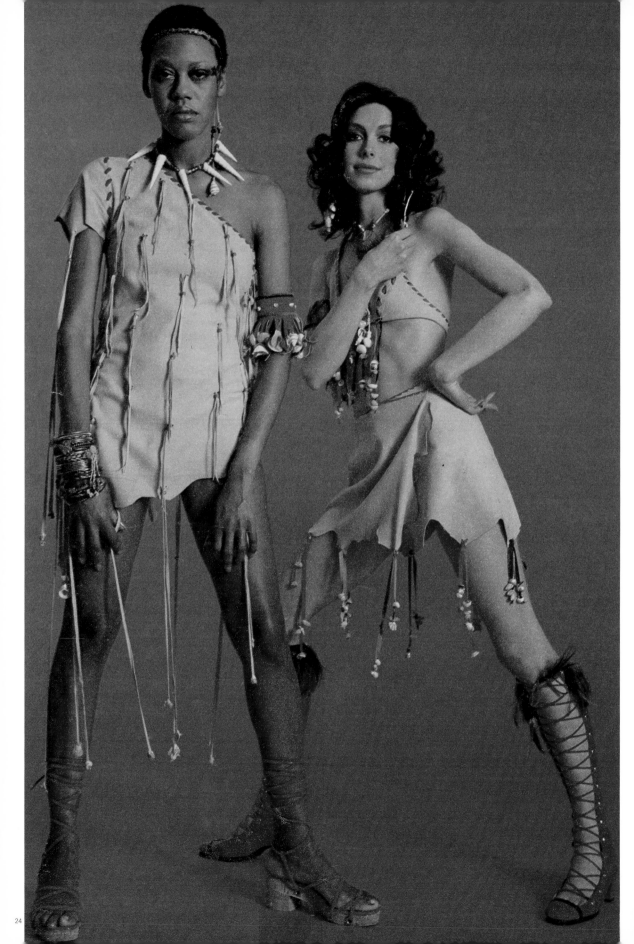

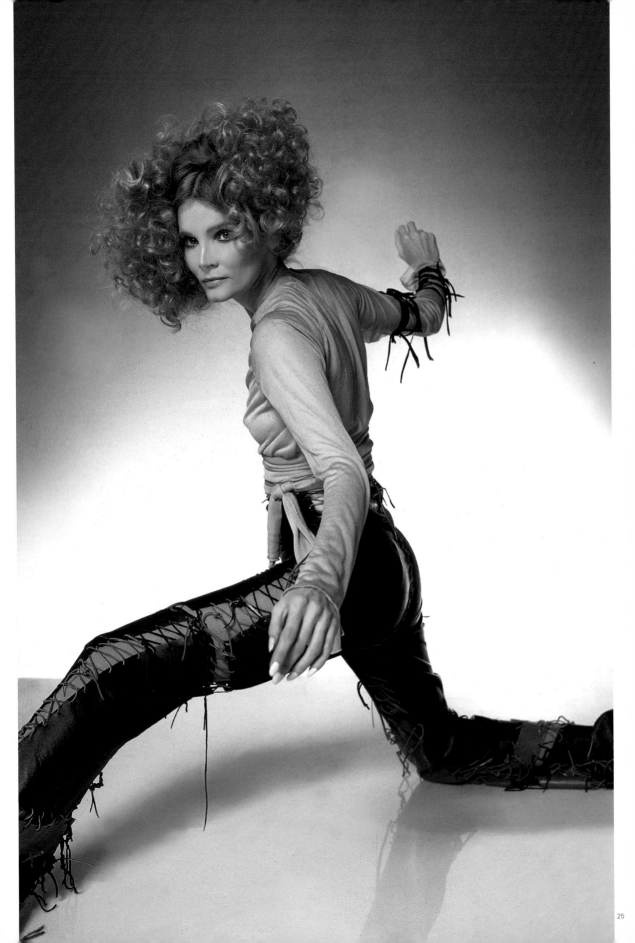

In the countercultural spirit of the late 1960s, the demure "savage" was reborn as the liberated modern-day Amazon huntress. Nowhere is this more apparent than in the work of Giorgio di Sant'Angelo, whose sense of free-spirited independence and creative spontaneity has advanced American fashion since the 1960s. Sant'Angelo's spring/summer 1971 collection, "Jane and Cinderella," epitomized his interest in an emerging feminist identity. He described his ideal seventies woman as "simple . . . earthy . . . adventurous . . . natural . . . bright . . . sensuous." The vision of eclectic hippie-chic created by this "wild child" of fashion was a response to the zippered minimalism of the mod, space-age fashion prevalent in the 1960s. The examples of Sant'Angelo's maverick style shown on page 24, a one-shouldered mini-dress and a two-piece mini-ensemble with bikini top, are both of pieced and whipstitched chamois. Embellished with "native" accents of tassels, beads, and shells, they are accessorized with a pseudo-prehistoric tooth choker and gladiatrix lace-up shoes. These "Janes" (as in "Tarzan and. . . ") wear their minis with uneven hems simulating unfinished skins at the fashionably short length of the day. During this transitional period, which was witnessing second-wave radical feminism, more of a woman's leg was exposed than ever before. Historically, the leg has been perceived as an erogenous zone, and the length of a woman's skirt (or her choice to wear trousers) was a subject of controversy during the cultural revolution.

Like Giorgio di Sant'Angelo, Stephen Burrows is renowned for his Native American and other ethnic references. His work has also spoken to the feminist goals of equality and freedom, and in the politically pivotal year of 1968, he referenced the barbarienne, presaging the punk mode of destruction of the late 1970s and the deconstructed styles of the 1980s. For his 1971 collections, exemplified on page 25, Burrows translated his signature color blocking into primitively pieced and crudely stitched leather trousers. By the late 1960s bifurcated garments, with their androgynous overtones, were symbolic of the liberated woman, but leather pants sent an edgier, even brutish, message. The open, irregular whipstitching that extends down the length of the model's legs exemplifies the newly emerging savage-chic style, creating the impression that her pants are a crudely sutured second skin. Finally relieved of the last vestiges of heavy skirts and restrictive undergarments from the first half of the twentieth century, the daughters of the women's liberation movement attempted to reject any remaining traditional constructs of femininity. By freeing themselves sartorially they projected equality, if at first only symbolically. Before the late 1960s the prehistorical trope had never been explored in fashion. In that brief period pioneering designers sought to bypass earlier references to the exotic or historical and began to look to the dawn of humankind for more potent and less predictable references.

Page 24: Giorgio di Sant'Angelo, American (born Italy, 1933–89). Ensembles, spring/summer 1971.

Photograph: Valentin. Reproduction courtesy of Martin Price

Page 25: Stephen Burrows, American (born 1943). Trousers, 1968. Model: Deanna Lambert. Photograph: Charles Tracy

At the dawn of the twenty-first century, designers from Japan to America channeled the extreme atavism instigated by their late 1960s counterparts and began fashioning a prototypical postmodern huntress. Frederic Molenac's version of the twenty-first-century barbarous androgyne, seen on page 28, wears a jagged-edged leather cuirass with loose, billowy pants. Like Stephen Burrows (see page 25), Molenac employed leather to create the appearance of a second skin. Molded to the model's form and held together in the middle with scarlike lacing, the body armor is pierced at the side with modern-primitive jewelry, hanging as talismanic and fetishlike trophies. While both Molenac and Burrows paired their leatherwork with soft, colorful, feminine separates, the coarse primitivism that their models convey has little to do with the romantic ideals of the native naïf.

As illustrated on page 29, Jean Paul Gaultier offered his vision of a postmodern huntress, which recalls the eighteenth-century woman who spread her finery over capacious panniers, or side hoops, to show the breadth of her wealth and resources. Balancing Claude Levi-Strauss's oppositional tensions of "the raw and the cooked," Gaultier juxtaposed pieced skins and elegant tulle to merge the dramatic dichotomy of the resources of nature and the creations of man. He further expressed the persistence of our basic animal instincts by superimposing the raw skins over a form of the most "well-done" artifice, the court gown from the period of Louis XIV's Versailles. By incorporating relatively unadulterated elements of nature with obvious materials of cultural production, Gaultier transformed the natural body into a fashionable abstraction, a raw and cooked alternate in a conceptual *mille feuille*. Both Molenac's and Gaultier's women represent the most contemporary incarnation of *La Belle Sauvage*. Comfortable with the contradictions they embody, they radiate an atavistic, mythologized beauty through a successful fusion of the wild and the civilized, the crude and the refined.

Page 28: Frederic Molenac, French (born 1964). Ensemble, spring/summer 2002. Photograph: copyright © MCV/Maria Valentino

Page 29: Jean Paul Gaultier, French (born 1952). Dress, spring/summer 1998. Photograph: Niall McInerney

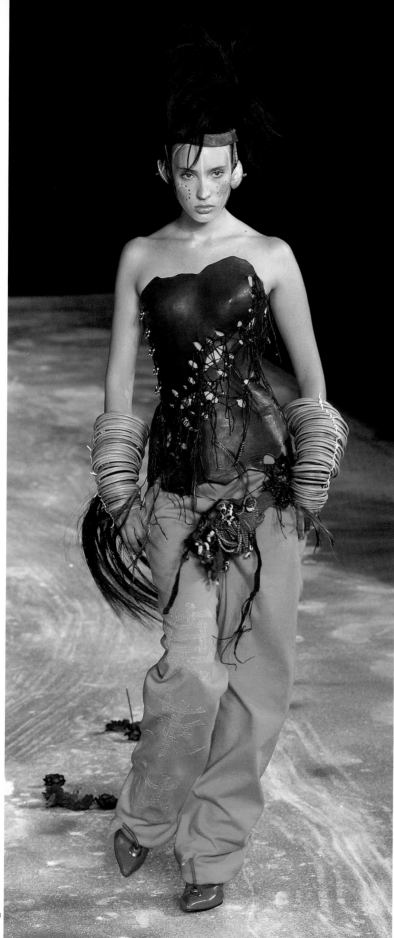

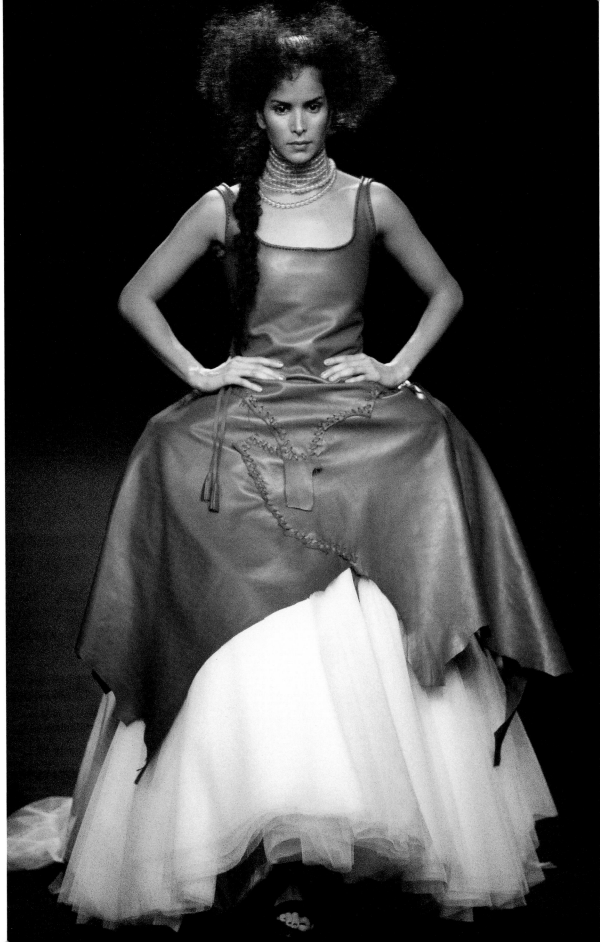

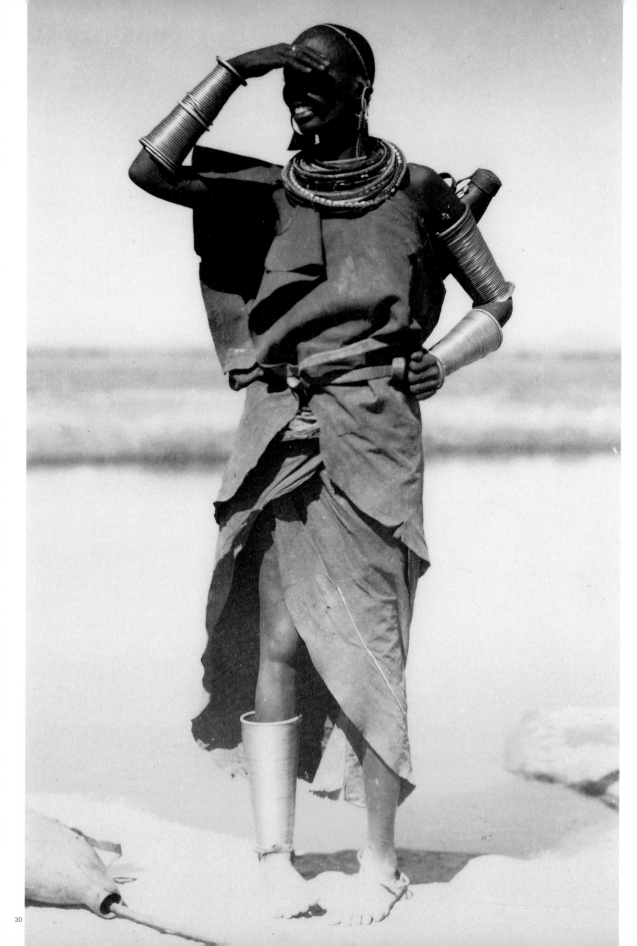

The nomadic huntress, by definition, must be at one with nature. In the portrait shown on page 30, by Casimir Zagourski, a photographer for the Polish colonial government, a Maasai woman gazes into the vast expanse of the Kenyan plains. She is wrapped in dark cowhides with roughly rounded edges that are folded and layered, then pinned at one shoulder to leave one arm free for movement, an arrangement reminiscent of the attire of the mythological Amazons. The metal coils and beaded necklaces, signifiers of her wealth and status, further accentuate her sublime beauty and heroic femininity. The Maasai are a seminomadic pastoral people subsisting in the Great Rift Valley of East Africa, where the earliest humans are thought to have evolved millions of years ago. Believing that all the cattle of earth belong to them, the Maasai live symbiotically with their livestock, on which they rely for both food and clothes.

Maasai lifestyle and adornment are reflected in the Mad-Maxian image shown on pages 32–33, an editorial styled by Grace Coddington for American *Vogue*. "Barbarian chic" is presented as "a high-concept remix of the rough and the refined." This representation of a postapocalyptic nomad on a hunting excursion through a sandy wasteland with her son at her side suggests a narrative of life-and-death challenges. Her gown by Yohji Yamamoto echoes the layers of rough skins worn by the Maasai maiden, its suede providing desert camouflage. She is a self-sufficient heroine, in the role of hunter and protector as well as gatherer and nurturer. This modern-primordial mode alludes to adjustments of gender identity imbedded in our digitally nomadic culture, with its increasingly complex ideals of femininity.

Page 30: Casimir Zagourski, Polish (1883–1944). *Maasai Woman,* Kenya, photographic postcard, ca. 1929–37.

The Metropolitan Museum of Art, Department of the Arts of Africa, Oceania, and the Americas

Pages 32–33: Yohji Yamamoto, Japanese (born 1943). Ensemble, autumn/winter 2000–2001. Courtesy of *Vogue.*

Copyright © Condé Nast Publications Inc. Photograph: Arthur Elgort

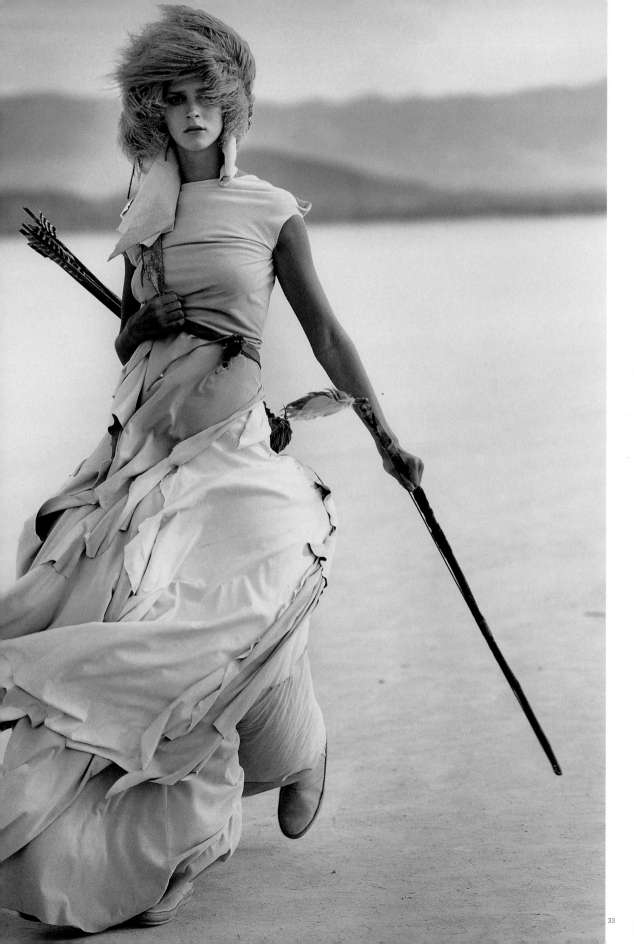

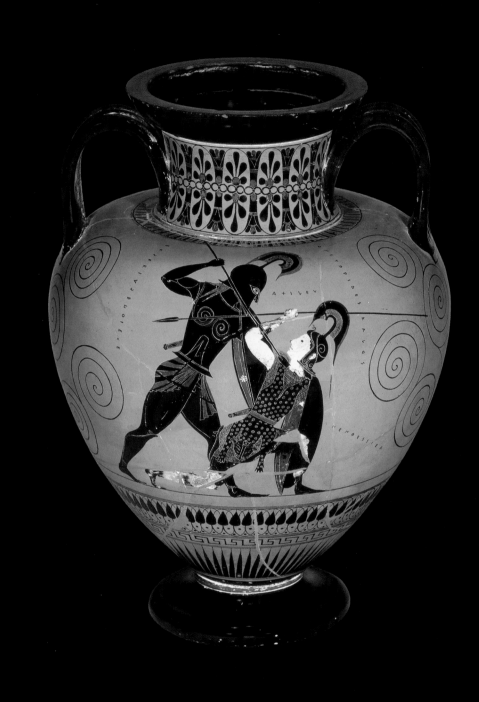

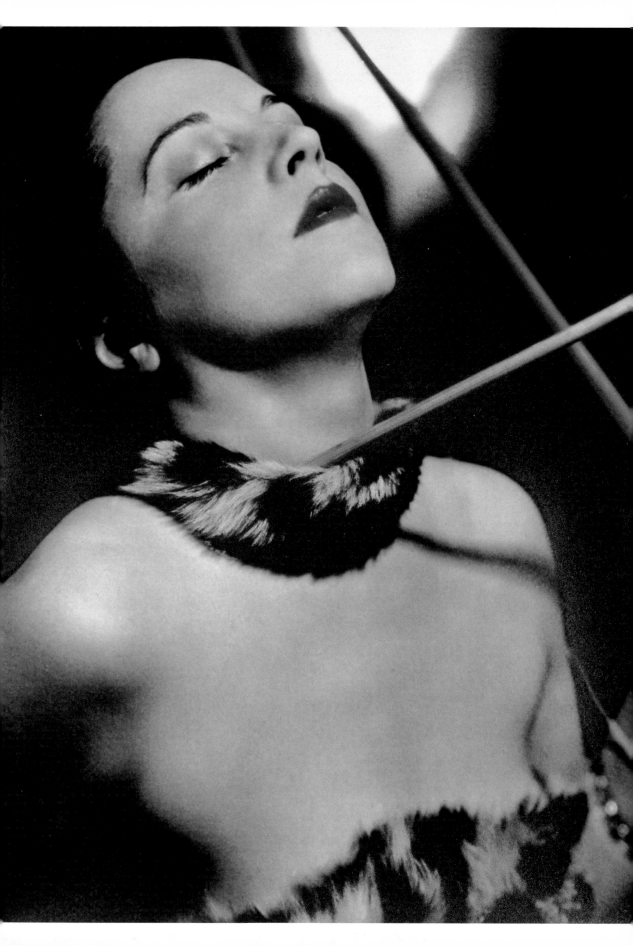

The ancient Amazon is the paradigm for our postmodern huntress. The Amazons are the embodiment of the bipolar nature of the virago, of her vacillation between the masculine and feminine. Power, savagery, barbarism, and otherness are often signified in Greek Amazonomachy by the wearing of animal skins, in particular of the leopard, as the female of the species was known to be a superior fighter. Thus the mighty Amazons are often depicted wearing spotted skins, especially in battle, as can be seen in the vase shown on page 34, which portrays a scene from the legend of Penthesilea, Queen of the Amazons. Penthesilea came to the aid of the Trojans but was slain by Achilles, the fiercest of Greek warriors. The scene illustrates the fleeting moment when their spears cross, marking the moment of Penthesilea's death, as her helmet falls back and exposes her vulnerability. Versions of the legend tell of Achilles falling in love with Penthesilea as she takes her last breath. Achilles's triumph at Troy and subsequent Greek victories over the Amazons mark pivotal points in western history, symbolizing civilization's victory over barbarism and humankind's dominion over nature.

The sexual subtexts in Amazon mythology reemerge in the early-twentieth-century photographs of Madame Yevonde, particularly in her series of portraits of society women, called Goddesses. By creating erotically charged mythic narratives, the photographer satisfied her clients' desire for fantasy. Yevonde was an early feminist, active in suffrage and eager to redefine women's role in society through her exploration of the many facets of female sexuality. In her interpretation of Penthesilea's fate, shown on page 35, the mythological Amazon with her spotted pelt is reminiscent of the imagery of the classical past. Yevonde reflected the aesthetic interests of her day, however, in her conflation of the exotic and the classical, the modernist and the historical.

The rich history of classical allusion in portraiture is also evident in Jean Marc Nattier's portrait of Madame de Maison-Rouge seen on page 37, in which she is mythologized as the Roman Diana (Artemis to the Greeks), who is thought to be the only deity worshiped by the Amazons. Although she was the virgin goddess of the hunt and protectress of animals, Diana was also associated with fertility and childbirth. Nattier situated Madame de Maison-Rouge in the classical past by depicting her gown as a simple girdled sheath with a neckline that appears to be falling off her shoulders. The gown, without an overskirt and petticoat, is a precursor to the full-blown classical revival that would take place by the end of the eighteenth century. Nattier further transfigured Madame de Maison-Rouge by accessorizing her classicized ensemble with several attributes of Diana: a bow and quiver of arrows, a crescent moon of diamonds for her hair, and a leopard skin wrapped over one shoulder *à l'Amazone*. It was a common strategy of portraitists to costume their sitters as deities, imposing a timelessness to their renderings by the avoidance of fashionable apparel.

Page 34: Greek, signed by Exekias as potter and attributed to him as painter, *Achilles Slaying Penthesilea*, terracotta, black-figured amphora, ca. 540–530 B.C. Copyright © The British Museum

Page 35: Madame Yevonde, British (born Yevonde Cumbers, 1893–1975). *Lady Milbanke as Queen of the Amazons (Penthesilea)*, photograph, 1935. Copyright © Yevonde Portrait Archive

Page 37: Jean Marc Nattier, French (1685–1766). *Madame de Maison-Rouge as Diana*, oil on canvas, 1756. The Metropolitan Museum of Art, Rogers Fund, 1903 (03.37.3)

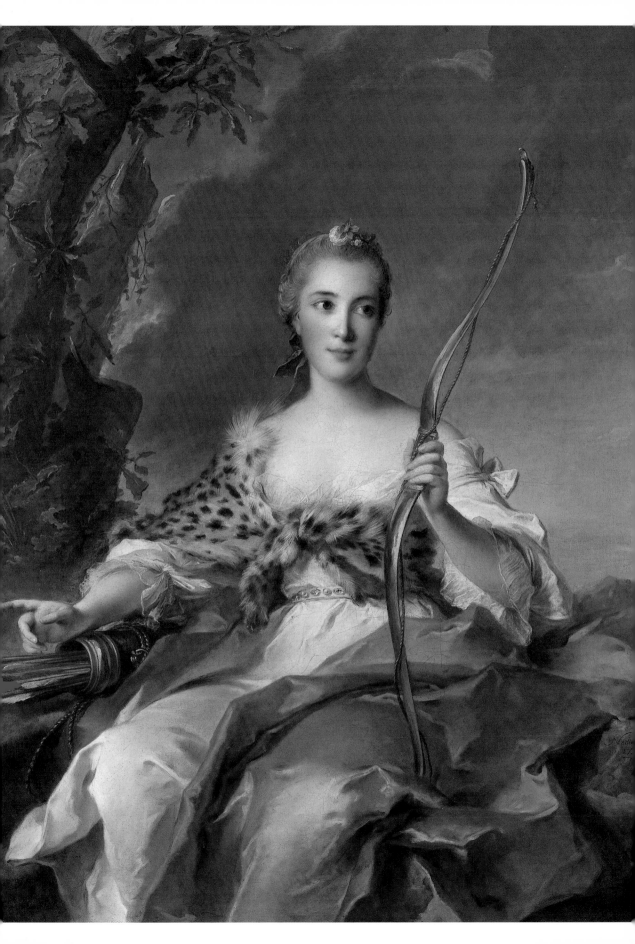

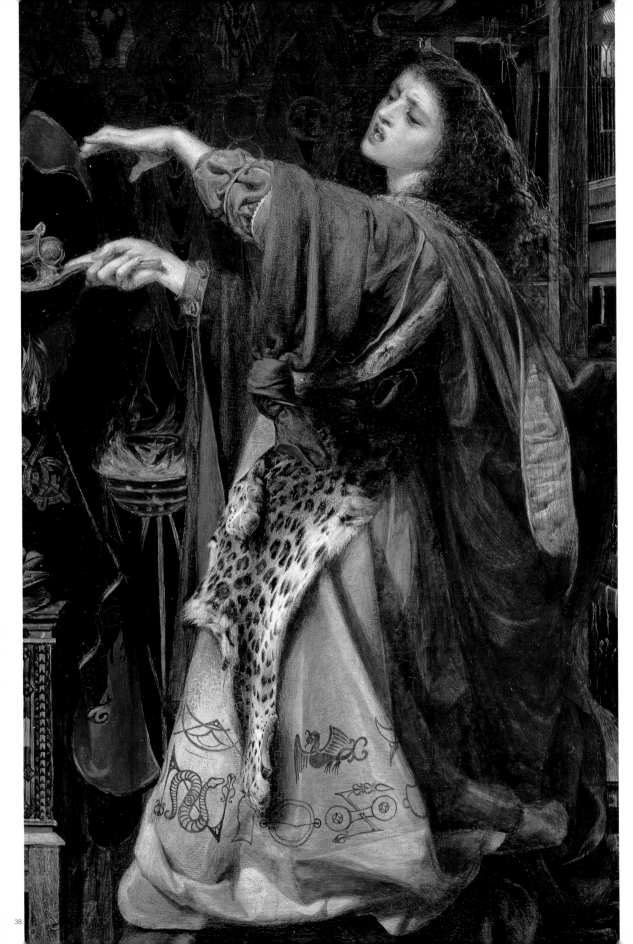

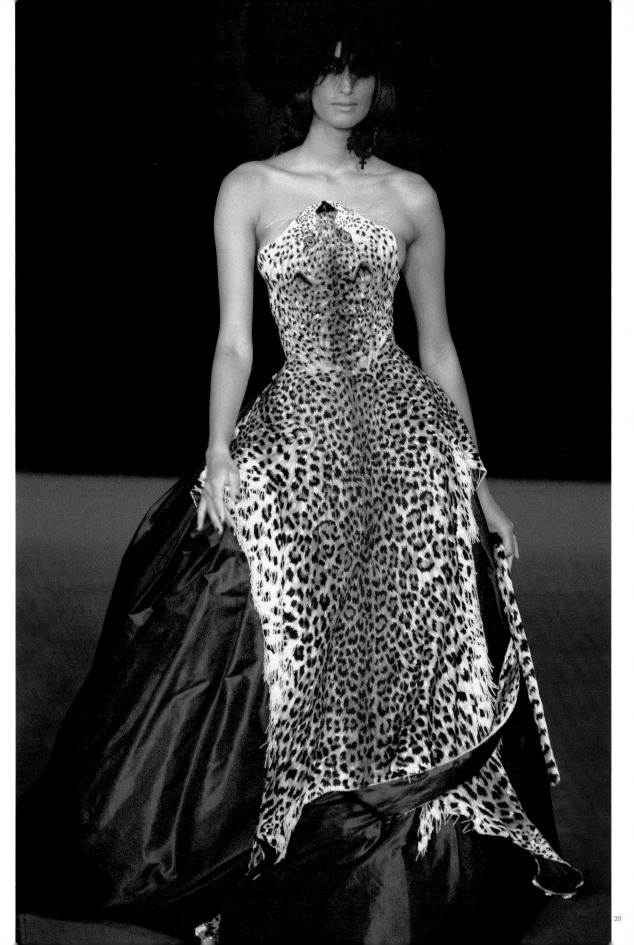

The iconography of the spotted pelt extends to the archetype of the sorceress or high priestess. In Frederick Sandys's painting of Morgan le Fay (Morgan the Fairy) reproduced on page 38, a leopard skin is draped around the waist of this vilified supernatural half-sister of King Arthur, the legendary sixth-century leader of the Britons. Like his Pre-Raphaelite mentor Dante Gabriel Rossetti, Sandys focused on Arthurian femme fatales and classical heroines. Folkloric tales describe Morgan as a treacherous sorceress, a lovely enchantress, a magical shape-shifter, and a divine healer. Her legend is grounded in Celtic pagan beliefs, and she has been cast as an unpredictable force defined by an inherent duality, the ability to bless or curse. In some versions of her story, Morgan's magical powers precipitate her alienation from civilized society and cause her to retreat to the forest. The Latin root for savage, *silvaticus*, literally translated "of the forest," suggests that the woodlands are territories beyond the control of man. Like the goddesses and maenads of Greek mythology who were often associated with the forest, Morgan is shown wearing an animal skin, a metaphor for the uncontrollable forces of nature in the shadowy woodlands. Sandys conflated historical and cultural archetypes by adorning his vision of Morgan in the pelt of a leopard, creating an image of her as a priestess both Druidic and Dionysian.

The works of designers Jean Paul Gaultier and Russell Sage (see pages 39 and 41) appear to reference the bacchante and the pagan high priestess. Their designs recall Sandys's painting in their use of patterned skins, and as in the artist's depiction, full animal pelts are draped across garments of more conventional construction. The overlay of unfinished hides over Gaultier's satin skirt or Sage's cotton dresses juxtaposes contradictory narratives of wildness and cultivation. Gaultier's gown features an opulent rendering, in exquisite beadwork by Lesage, of a leopard skin with rhinestone claws. This example of the extraordinary craft of the Haute Couture was described by Colin McDowell as "one of the most accomplished pieces of trompe l'oeil embroidery to be seen on a Paris runway. Gaultier acknowledges the eternal lure of the big cat and makes a dress of stunning power and style . . . dedicated to female power. The workmanship is so superb . . . it could almost be the real thing." Russell Sage, on the other hand, recycles authentic vintage animal skins. The designer's intention is not to glamorize his work with the exotic skins but rather to imbue it with a potent, even discomforting, political critique by, in his words, referring to the "head-hunting of young designers by the big fashion houses, where young designers became a trophy." The use of pelts for this metaphor—animals culled by fashion's whims to the point of extinction as analogous to the fate of his peers—made his message even more poignant by addressing the plight of endangered species. While the conceptual intention of their designs might differ, both Gaultier and Sage present versions of the huntress. By combining real and illusionary raw skins with tailored garments, they demonstrate the possibility of achieving a delicate equilibrium between the civilized and the savage.

Page 38: Anthony Frederick Augustus Sandys, British (1829–1904). *Morgan-le-Fay*, oil on canvas, 1862–63.

Courtesy of The Birmingham City Museum and Art Gallery

Page 39: Jean Paul Gaultier, French (born 1952). Ensemble, autumn/winter 1997–1998. Photograph: Niall McInerney

Page 41: Russell Sage, British (born 1970). Ensembles, spring/summer 2002. Photograph: copyright © Chris Moore

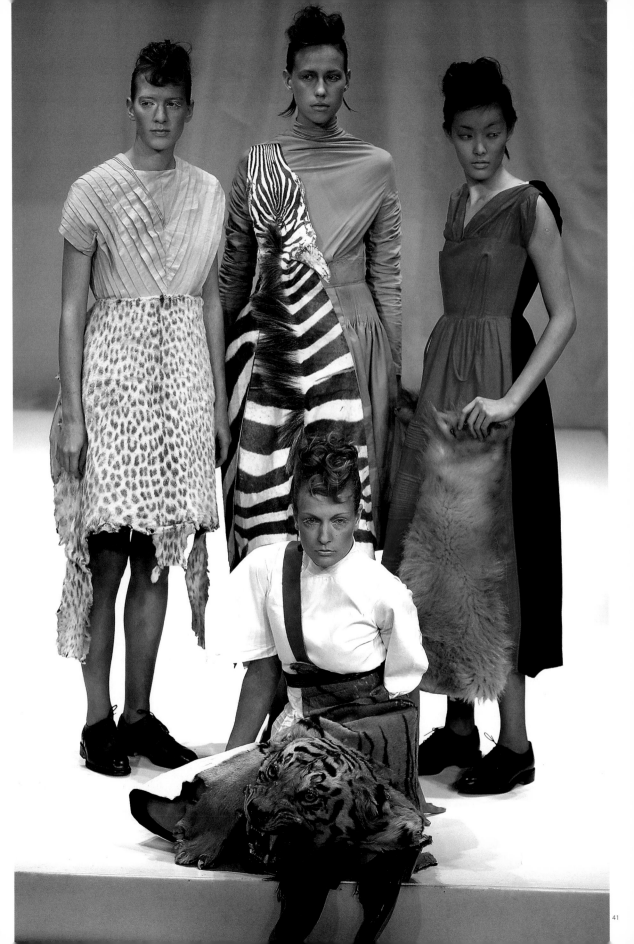

THE LION'S SHARE

Few materials have been applied to apparel as commonly and consistently as fur. Even fewer have been charged as potently and profoundly with symbolic meaning. No chronologically delineated line can be drawn to mark a shift from the practical to the symbolic values ascribed to fur. Likewise, at particular moments in history, fur's practical value has prevailed over its symbolic value. From the fourteenth to the seventeenth century however, a series of clothing or sumptuary laws, legislated in Britain and Europe, served to extend and emphasize fur's symbolic investiture. Sumptuary legislation sought to regulate the wearing of fur as a symbol of class identification. As today, furs were accorded a material value that reflected the rank and status of their wearers. Also as today, style was a predetermined factor in assigning value to fur fashions. Vair or squirrel arranged in a checkerboard pattern on a gown in the Middle Ages, for instance, finds corollaries in John Galliano's pieced mink and leather coats and Karl Lagerfeld's sable and silk reversible jackets.

Sumptuary legislation fostered not only fur's signification as an elite commodity, facilitating the construction of such stereotypes as the aristocrat, the entrepreneur, and the bourgeois man and woman, but also its signification as a sexual commodity. As Julia V. Emberley observed in *The Cultural Politics of Fur* (1997), clothing laws informed the construction of sexual differences between men and women as well as those between different types of women. Under Edward III, a statute was passed that forbade prostitutes to wear fur. This decree served to protect the morals of the community by forcing prostitutes to wear distinctive clothing so that everyone might be able, on first sight, to distinguish them from respectable female citizens. The link between fur and morality came into full force with the rise of Puritanism in the late sixteenth century. Puritan discourse, most notably that of the writer and social commentator Philip Stubbes, attempted to order and contain female sexuality. Fur became a central element in the ideology of female artifice and sexuality, an ideology that became more deeply ingrained during the nineteenth and twentieth centuries.

The economic and libidinal investments in the symbolic production of fur have been the implicit impetus behind the various animal rights organizations that have emerged since the 1970s. Indeed, the anti-fur challenge can be interpreted as a continuation of Medieval and Renaissance sumptuary legislation. During the 1980s, two of the most powerful and influential animal rights organizations, Lynx (now dissolved) and People for the Ethical Treatment of Animals (PETA), harnessed the power of the media to raise awareness of the cruelty involved in the production of furs. Their campaigns, which highlighted the immorality of killing animals for adornment, were effective not only in mobilizing public opinion against fur fashions but also in encouraging designers to reject real fur in favor of fake or simulated versions. Other designers sought ways of disguising furs to confound the boundary between real and fake. At Fendi, for instance, furs were woven, textured, and patterned to create the illusion of fabric. These "disguised" furs presented consumers of fur fashions with new styles and safer modes of representation to maintain their access to this luxury commodity. Since the mid-1990s, however, fur in its "natural" state has enjoyed a renaissance, an indication perhaps that overt symbols of wealth, status, and sexuality are again the main driving forces behind fashion's advancement.

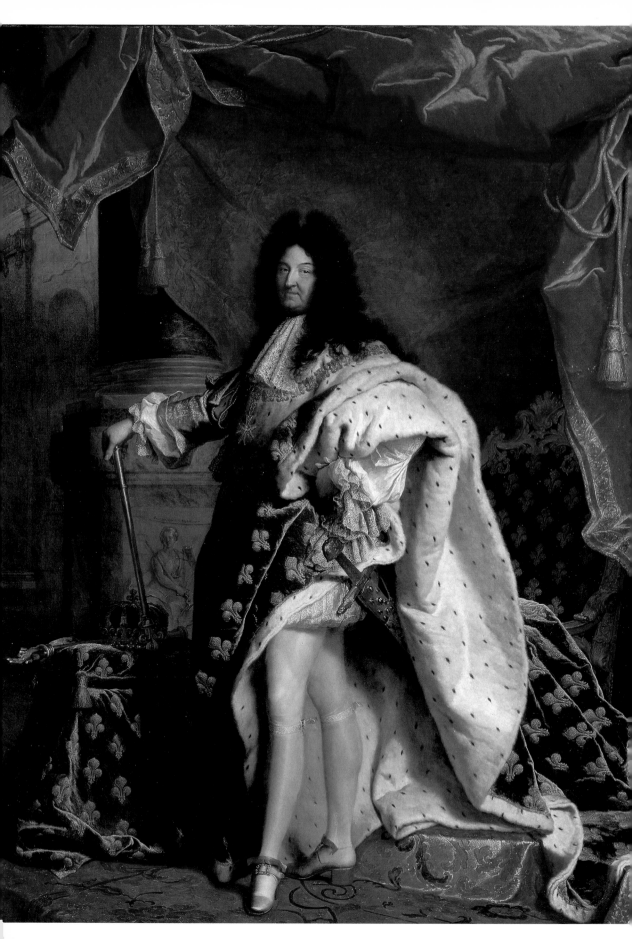

Fur fashions have come to signify wealth, prestige, luxury, decadence, and exclusivity, giving rise to one of the most enduring stereotypes of the fur-clad man or woman, namely the aristocrat. Monarchical privileges accorded fur can be traced back to Medieval and Renaissance sumptuary legislation, which ensured that the pelts of finer, rarer, and smaller animals such as gris, vair, lettice, ermine, marten, and miniver were reserved for the nobility, while coarser and more commonplace furs such as goat, wolf, badger, muskrat, and sheepskin were worn by the lower classes. Ermine in particular came to be a potent signifier of royalty. It was used lavishly in the coronation robes of kings and queens, as exemplified on page 44 in Hyacinthe Rigaud's grandiose painting of Louis XIV, that most autocratic and profligate of monarchs, who came to be known as the "Sun King." In this majestic portrait Louis XIV's robes are copiously lined and trimmed in the pure-white winter coat of the ermine, the aristocrat of the weasel family. Because of its whiteness ermine also came to signify moral purity, a symbolism compounded by its usage in the robes of high academic, ecclesiastical, and governmental dignitaries. In fashion ermine reached its apotheosis in the 1920s and 1930s, when it was used for long and short evening capes, which hung effortlessly from the shoulders of bourgeois and aristocratic women. More than any other fur, ermine has a delicacy and fineness that allow it to drape like cloth. It is this liquidity that led Karl Lagerfeld, the "Sun King" of fur designers, to declare: "To me ermine is *the* fur, because of the touch and because it is weightless, fluid."

In the visual history of fur fashions, Hans Holbein the Younger, along with Titian, Rubens, and Raphael, is conspicuous for his highly refined and naturalistic representations of the different varieties of furs included in the costumes of Renaissance aristocracy. Reproduced on pages 46–47 is one of Holbein's most celebrated paintings, *The Ambassadors*. It depicts Jean de Dinteville, French Ambassador to London, in a *schaube* lined and trimmed in lynx and Georges de Selve, Bishop of Lavour, in a *soutane* lined and trimmed in what is probably otter. As Rigaud did in his portrait of Louis XIV, Holbein manifested not only fur's aesthetic value but also its economic value by equating fur, in this case lynx and otter, with the wealth and power of the aristocracy. In *The Cultural Politics of Fur* (1997) Julia V. Emberley pointed to the interconnectivity of these two value systems, arguing: "Deeply ingrained in our reception of fur is the idea that it is equivalent in aesthetic value to the very art in which it is depicted. This perception, in turn, reifies the commodity status of fur and contributes to justifying both its economic value and its symbolic status as a luxury item." In *The Ambassadors* fur's symbolic agency is further underscored by the objects of science placed on the table between the two men. These instruments of navigation made the fur trade possible, most notably the fur trade with North America, which from the seventeenth century became the primary supplier of fur to Europe.

Page 44: Hyacinthe Rigaud, French (1659–1743). *Louis XIV*, oil on canvas, 1701. Photograph: Réunion des Musées Nationaux/Art Resource, NY

Pages 46–47: Hans Holbein the Younger, German (1497–1543). *The Ambassadors*, oil on canvas, 1533. Photograph: Erich Lessing/Art Resource, NY

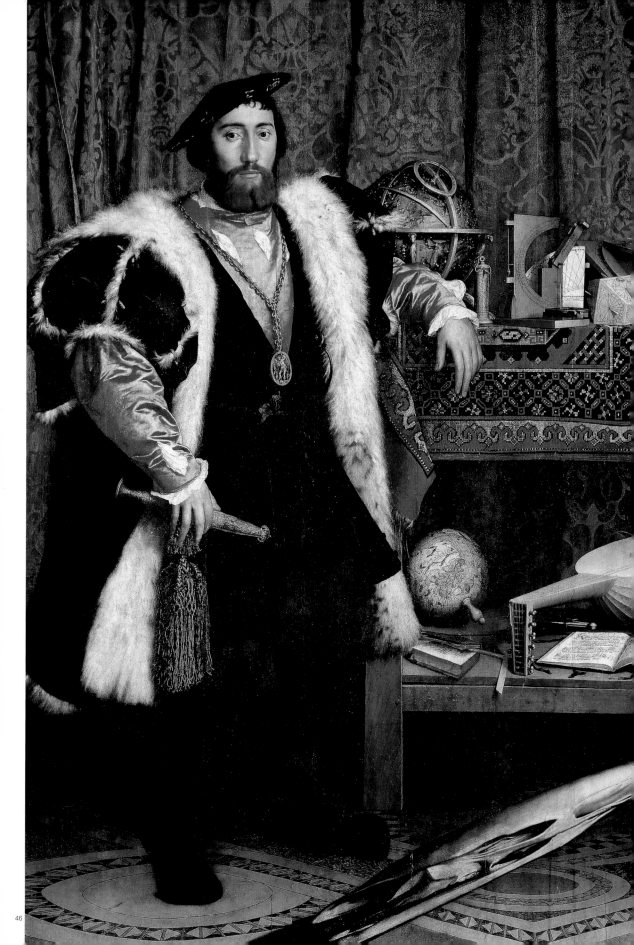

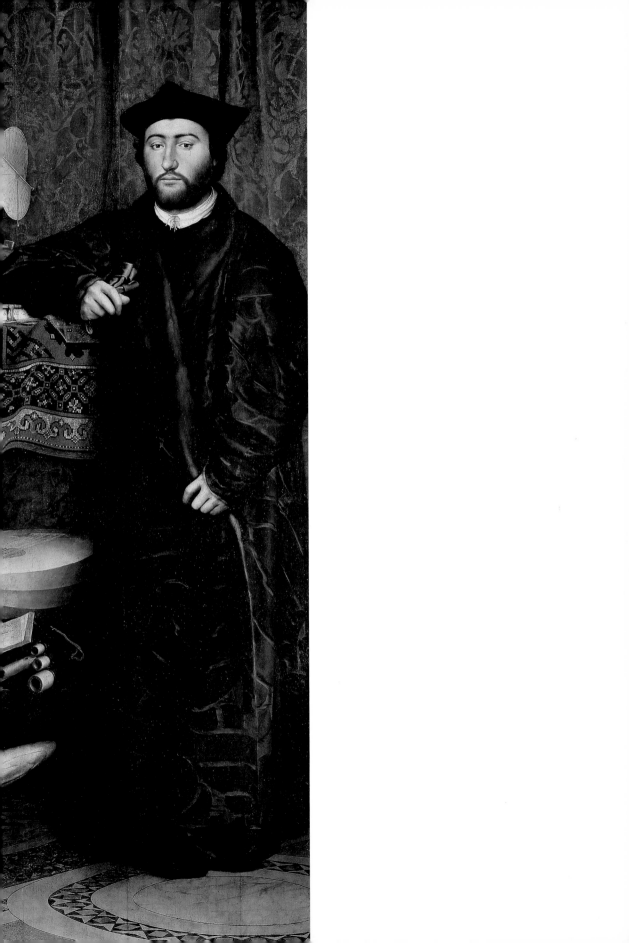

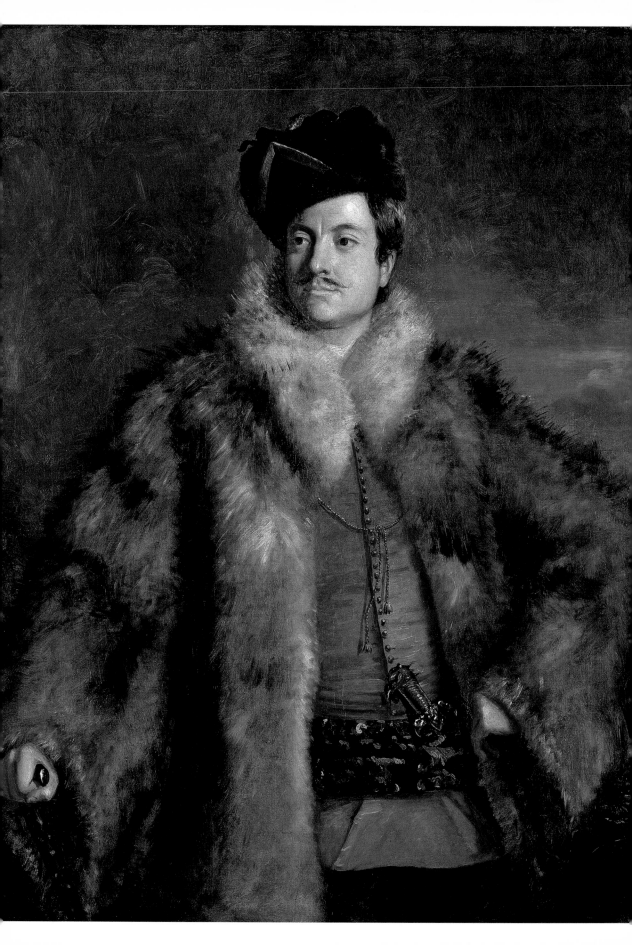

In *Captain John Hamilton*, reproduced on page 48, Sir Joshua Reynolds embodied two ideals of masculinity commonly associated with fur fashions, namely the aristocrat and the fighting or military man. Captain Hamilton, the second son of James Hamilton, the seventh Earl of Abercorn, is portrayed in fancy dress. Although he is traditionally described as wearing the costume of a Russian boyar, the dress historian Aileen Ribeiro has argued that Hamilton is depicted in the tunic or dolman of a Hungarian hussar. Over this uniform he wears a huge fur coat, possibly of fox or wolf, and on his head is a busby, probably of bearskin. Hamilton's coat is aberrational in eighteenth-century fur fashions, which, for both sexes, were typically constructed with fur on the inside. Cloaks and ponchos with exterior fur were worn in ancient times, most notably the *kaunakes* of sheepskin worn by the civilizations of Mesopotamia. However, from at least as early as the seventh century until as late as the nineteenth century, fur was more commonly used in the interiors of garments or if exteriorized was restricted to trimmings and accessories. An exception is a cloak of sheepskin similar in style to the *kaunakes*, the *suba* or *schuba* worn by peasants throughout Europe. Ironically, the fur coat worn by both men and women today, despite its haughty pretensions, is quite likely to have originated from this humble garment.

In the early twentieth century, coats of sheepskin and other types of coarse fur, most notably bear, goat, wolf, beaver, and raccoon, became the hallmark of the mogul or the capitalist, a stereotype of the fur-clad man that has endured to this day. Charlie Chaplin immortalized him in two of his most popular and comedic films, *The Gold Rush* (1925) and *Modern Times* (1936). As in Chaplin's films, this "fat cat" was often accessorized with a hat, cigar, and moustache, signifiers of wealth and status only surpassed by the motorcar. The first automobiles that appeared in the early 1900s, of an open design often without roof, doors, or windscreen, offered no protection from the elements, so that large, shaggy fur coats fulfilled a practical as well as a symbolic purpose. According to an entry in a Burberry's catalogue (early 1900s): "English gentlemen do not take kindly to the Continental monstrosities in the shape of horseskin, sheepskin, wolfskin, and variations of coats which have the hair, wool and fur outside. The more distinguished form is to use the fur simply as a lining." In the 1920s, 1930s, and 1940s, the shaggy fur coat, most notably the raccoon coat, was adopted by undergraduates of Ivy League American universities, giving rise to another stereotype of the fur-wearing man, the sportsman, or more specifically, Joe College (see page 50). So ubiquitous was the raccoon coat that it became the focus of a popular song in the 1920s, which began: "College men, knowledge men / Do a dance called raccoon / It's the craze, nowadays / And it will get you soon / Buy a coat and try it / I'll bet you'll be a riot / It's a wow, learn to do it right now!" The tune's ending, "Rac, rac, rac, rac, rac-rac-rac raccoon!" could have been the motto for John Galliano's autumn/winter 2004–2005 collection that featured virile young men in a variety of shaggy fur coats. One ensemble, shown on page 51, comprised a hefty, calf-length coat of pieced coyote, accessorized with such potent signifiers of masculinity as a stetson, cowboy boots, football socks, and a Lonsdale jock strap.

Page 48: Sir Joshua Reynolds, English (1723–1792). *Captain John Hamilton*, oil on canvas, 1746. Courtesy of The Trustees of The Abercorn Heirlooms Settlement

Page 50: Princeton undergraduate in a raccoon coat, photograph, ca. 1940. Photograph: copyright © Hulton Archive

Page 51: John Galliano, British (born Gibraltar, 1960). Coat, autumn/winter 2004–2005. Photograph: copyright © MCV/Maria Valentino

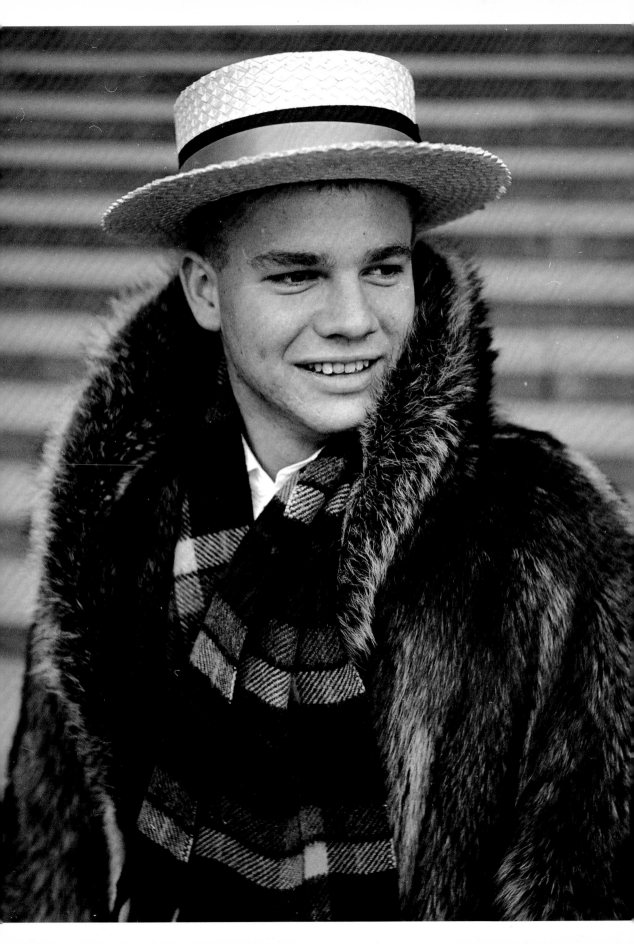

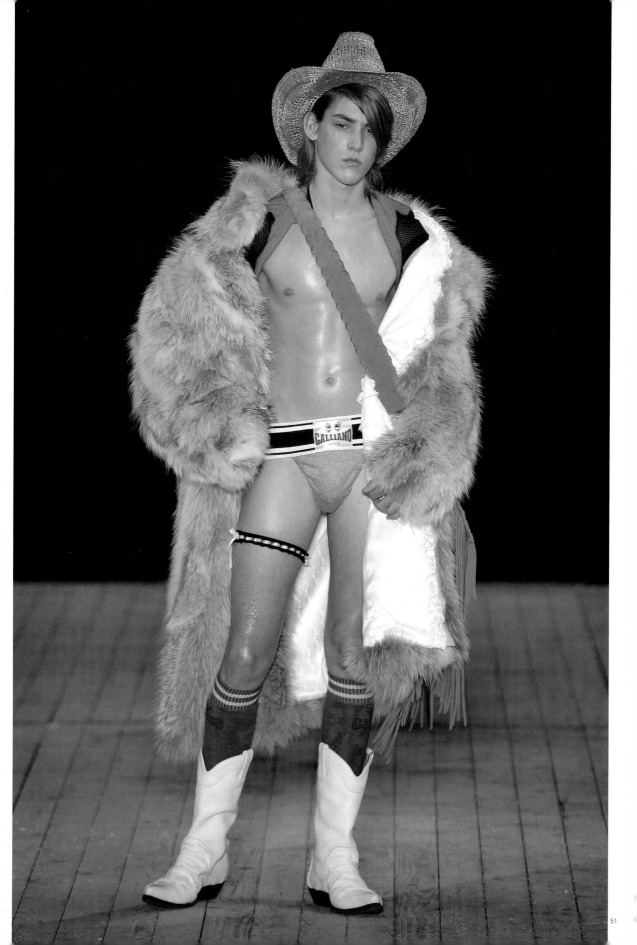

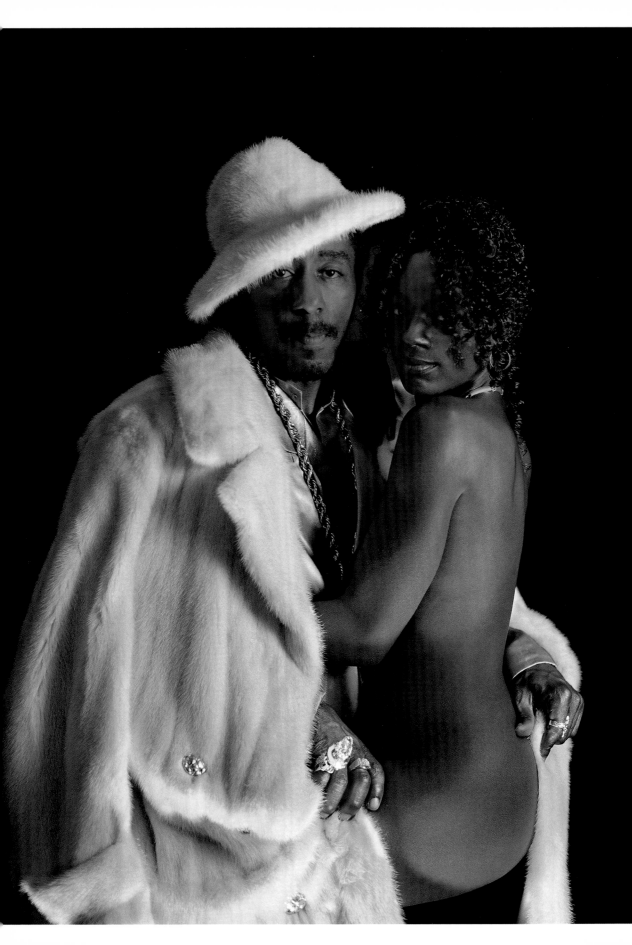

The fur coat as a symbol not only of wealth and status but also of virility, machismo, and, ultimately, male dominance is perhaps most clearly revealed in its espousal and acquisition by pimps (see page 52). These sexual entrepreneurs who live off the proceeds of a prostitute's activities embody, albeit satirically, several of the stereotypes of the fur-clad male, such as the mogul, the sportsman, and even the aristocrat. As Christina and Richard Milner explained in *Black Players: The Secret World of Black Pimps* (1972): "Pimps often call themselves 'the players' and their profession 'The Game,' although the special subculture which surrounds The Game is also known as 'The Life,' an abbreviation of 'The Sportin' Life' and 'The Night Life.' 'Sportin' Life' is an old term derived from the ironic designation of pimps as 'sportsmen' or aristocratic men of leisure." The lexicon of pimp fashion includes such blatant symbols of wealth and status as bespoke suits, custom-made hats and alligator or "gator" shoes, heavy gold jewelry encrusted with diamonds, and often, a walking stick or "pimp stick." A mink coat, however, along with a Cadillac or Rolls Royce, is a pimp's most palpable display of economic and sexual supremacy. The fur's brilliant whiteness, like a pimp's perfect coiffure and impeccably manicured nails, reveals his commitment to neatness and cleanliness, locating his suavity firmly within the tradition of dandyism.

The self-presentation of such hip-hop stars as Sean "P. Diddy" Combs and Snoop Doggy Dogg highlights the interconnectivity of pimp and hip-hop styles, the former often informing the latter. In a photograph by Annie Leibovitz (pages 54–55), styled by Grace Coddington for American *Vogue*, P. Diddy is shown in a lavish white fox fur coat by Nija Furs, a trophy of success that is paralleled by his white Mercedes and by his white girlfriend, a role played by supermodel Kate Moss. Nija Furs was founded by the late Nija Battle, who described her furs as "ghetto fabulous," a term that underscores her client base, which includes such hip-hop celebrities as Lil' Kim and Missy Elliott. Leibovitz's photograph of P. Diddy and Kate Moss surrounded by the paparazzi not only articulates fur's association with celebrity but also recalls photographs of movie stars from the Golden Age of Hollywood whose fur-clad bodies radiated sex and glamour.

Page 52: Tracy Funches, American. *Virgo Couple*, "PIMPNOSIS" series (1995–2001), photograph, 1998.

Courtesy of The Tracy Funches Studio. Photograph: Tracy Funches

Pages 54–55: Nija Furs, American (founded 1990). Sean "P. Diddy" Combs in a fur coat, photograph, ca. 1999.

Photograph: Annie Leibovitz/Contact Press Images

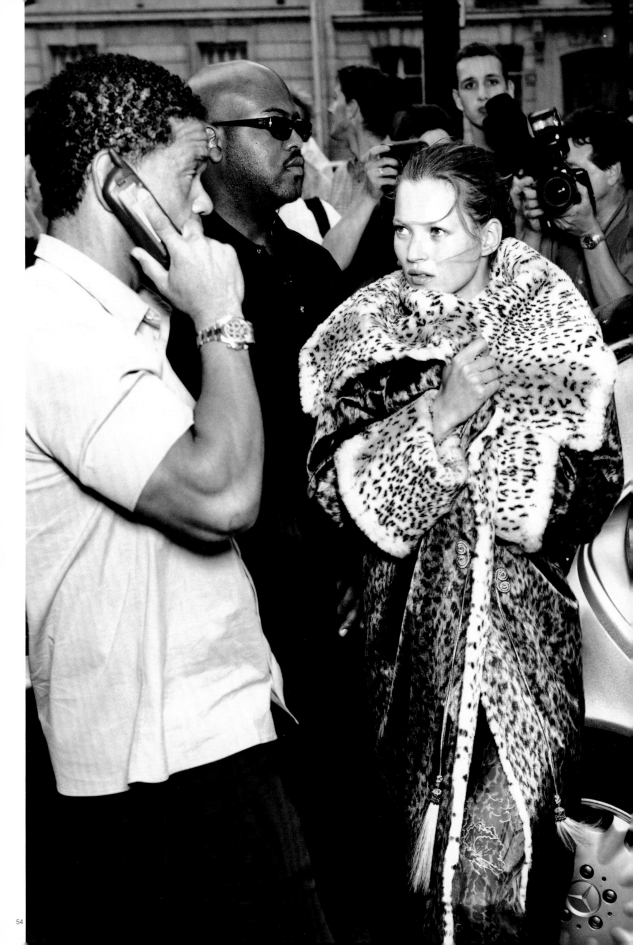

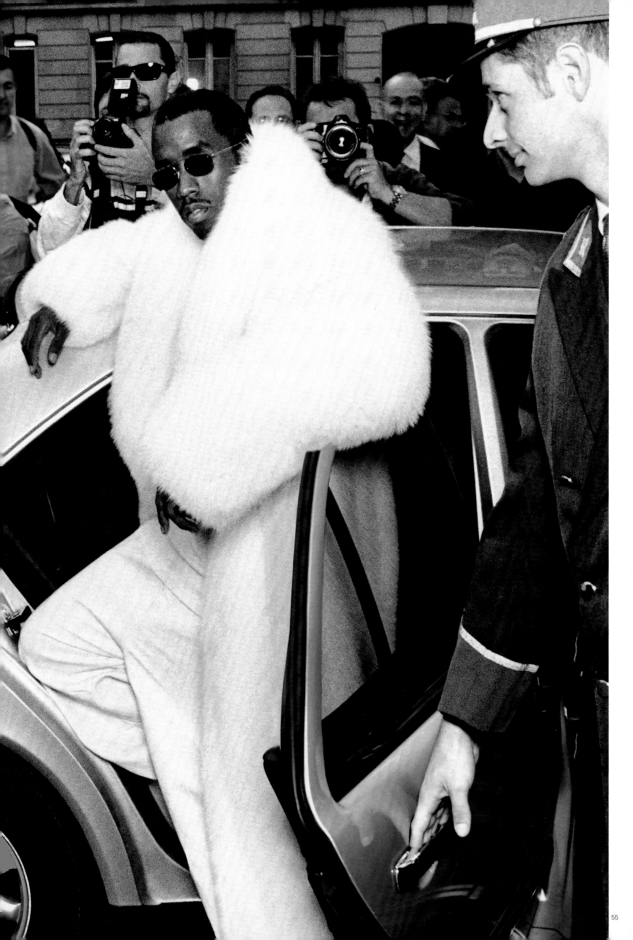

Fur's linkage to fame, fortune, glamour, and stardom was underscored in Blackglama's notorious advertising campaign, which asked: "What becomes a Legend Most?" Conceived by Jane Trahey and implemented by Peter Rogers in collaboration with the photographers Bill King and Richard Avedon, the campaign, which debuted in 1968, drew parallels between mink's iconic status and that of such legendary Hollywood stars as Lauren Bacall, Joan Crawford, Bette Davis, and Marlene Dietrich. As seen on page 56, pop diva Diana Ross lent her support to the campaign in 1973. Peter Rogers described the sitting in his book *What Becomes a Legend Most?* (1979): "When we arrived at Bill King's studio, Diana showed us everything she'd brought [including 'an Afro wig the size of a serving platter'] and said, 'Okay, I'm in your hands. Just tell me what to do.' We did, and she did it. The shoot was one of the best ever—and certainly one of the most fun. Ross sang and danced for about an hour, and Bill got an action shot so vibrant, it practically pops off the page." As with the other subjects of the Blackglama photographs, Diana Ross's heavily retouched face (which the fashion arbiter Diana Vreeland, who posed for the campaign in 1977, liked to joke was done by Michelangelo) was designed to capture the luster of the legend rather than the luster of the mink, which Trahey maintained was not attainable in a photograph. Despite its long history as a lining, trimming, and accessory, mink did not become fashionable as a fur coat until the 1950s. During that decade, mink, along with other appurtenances of wealth and elegance, such as elaborately coifed hair, flawless makeup, and ostentatious jewelry, came to define one of the lasting and most resonate stereotypes of the fur-clad female, namely the bourgeois woman. The label Blackglama was invented by Trahey to give a recognizable identity to the Great Lakes Mink Association (GLMA), an organization comprising a group of ranchers who developed and produced the characteristic black mink. Among the many designers who have used Blackglama mink over the years are such legendary virtuosos of fur manipulation as Geoffrey Beene, Gianfranco Ferre, Halston, and Karl Lagerfeld for Fendi.

Page 56: Blackglama®, American (founded 1968). Advertising campaign, "What Becomes a Legend Most?" 1973. Courtesy of The Advertising Archive. Photograph: Bill King

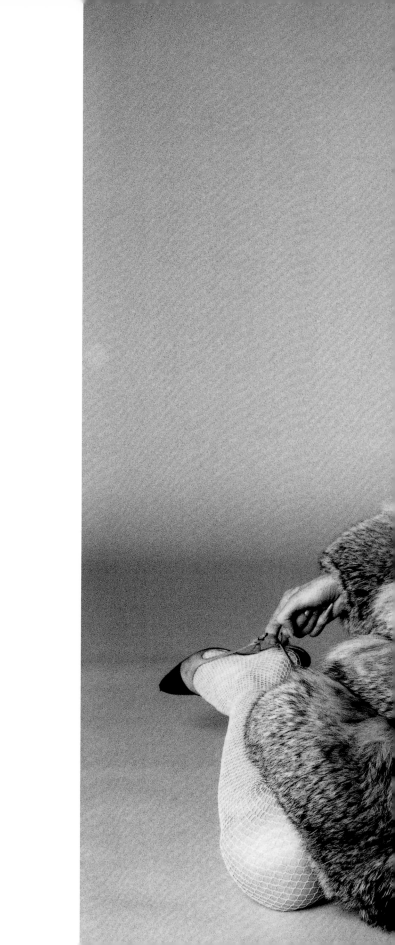

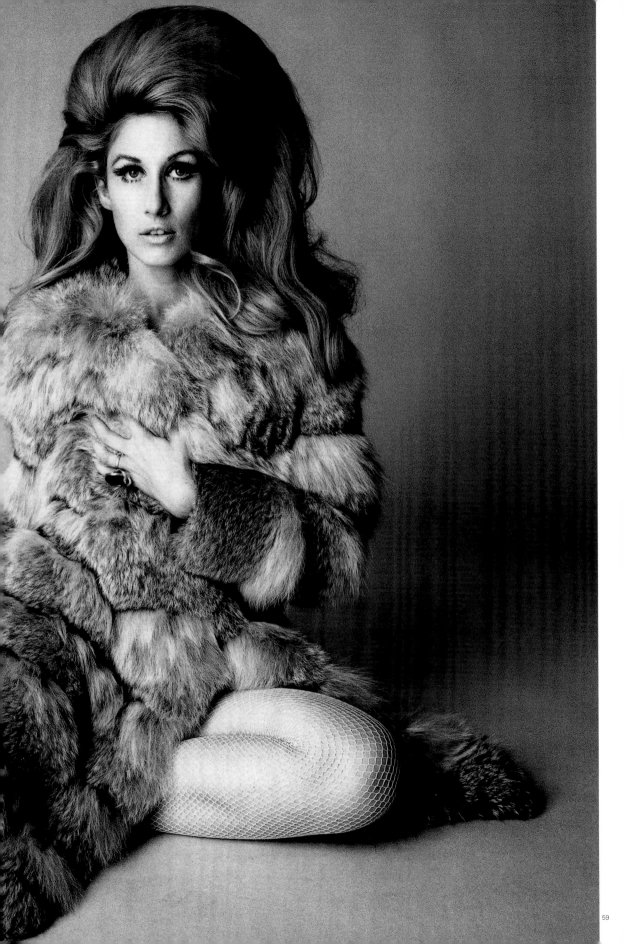

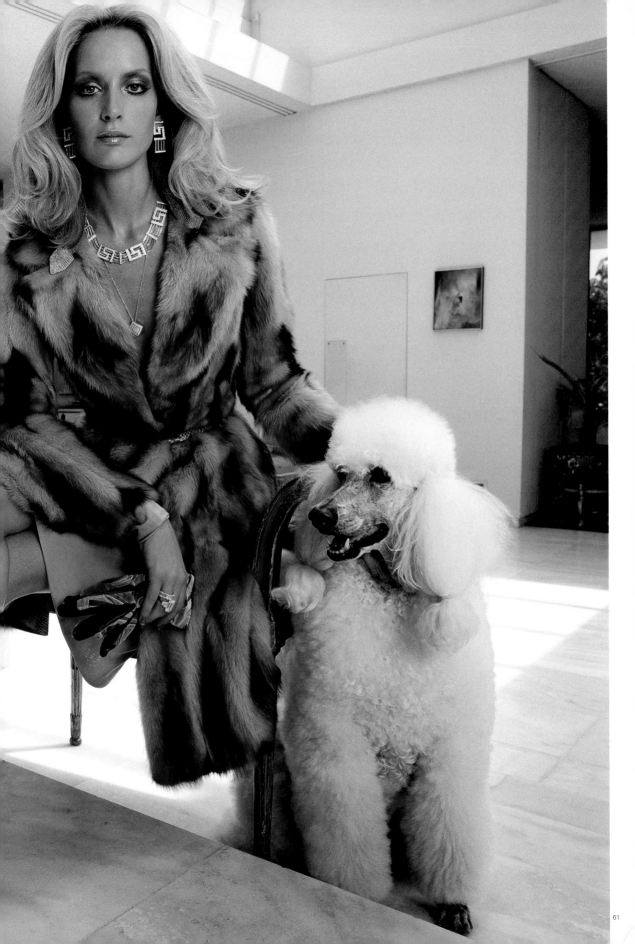

Fur's association with both the starlet and the bourgeois woman coalesces in David Bailey's photograph, shown on pages 58–59, of "Baby Jane" Holzer, who was described by Diana Vreeland as "the most contemporary girl I know" and who was immortalized by Tom Wolfe in his short story "The Girl of the Year 1964" in *New York* magazine. Holzer, whose soubriquet "Baby Jane" was conferred upon her by the journalist Carol Bjorkman after the character played by Bette Davis in Robert Aldrich's film *Whatever Happened to Baby Jane?* (1962), is considered the first of Andy Warhol's "Superstars," or at least the first to garner widespread media attention and recognition. A patent expression of Warhol's philosophy of art and celebrity, The Warhol Superstars were a coterie of New York personalities promoted by Warhol during the 1960s and 1970s to generate publicity for both himself and The Superstars. Like most of them, Holzer appeared in Warhol's artworks and film experiments, including *Kiss* (1963), *Soap Opera* (1964), and *Batman Dracula* (1964). With her trademark leonine mane of hair, which Bryan Ferry sang about in his single *Virginia Plain* (1972), the beautiful Park Avenue socialite epitomized the uptown girl with a downtown sensibility. Even in her choice of fur coat, made not from mink but from common coyote and worn in the modish mini style, "Baby Jane" oozed cool and class. In *POPism: The Warhol Sixties* (1990) Warhol recollected his first meeting with her: "Jane looked terrific standing there in the new look—pants and a sweater. . . . She was such a gorgeous girl—great skin and hair. And so much enthusiasm—she wanted to do everything."

Holzer could have been the blueprint for the impossibly glamorous sophisticate represented in Steven Meisel's autumn/winter 2000–2001 advertising campaign for Versace (pages 60–61). However, shown as she is seated in a sparsely yet expensively decorated interior of a palatial Beverly Hills mansion, the model Georgina Grenville, with her cold empty eyes, recalls the pill-popping tragediennes from Mark Robson's cult film *The Valley of the Dolls* (1967). With coifed hair, perfect makeup, lavish jewelry, and, above all, fur coat of dyed muskrat, Grenville's extravagant appearance not only contrasts with the minimalist room setting in all its chilly anonymity but also epitomizes the traditional representation of the fur-clad bourgeois woman. Like the pampered poodle by her side, she also embodies the polished celebrities and privileged socialites that have come to be associated with the Versace label.

Pages 58–59: David Bailey, British (born 1938). "Baby Jane" Holzer in a fur coat, 1965. Courtesy of David Bailey, Camera Eye Ltd.

Pages 60–61: Donatella Versace, Italian (born 1955). Advertising campaign, autumn/winter 2000–2001.

Photograph: Steven Meisel/Art + Commerce Anthology

The youth and counterculture movements that emerged in the 1960s fractured the singular, all-embracing image of the fur-clad bourgeois woman that seemed forever fossilized in the 1950s. For young women, mink became *démodé*, a benchmark of dowdy matronly status indelibly associated with an older generation. Novel furs such as rabbit, Persian lamb, and Mongolian lamb—the latter seen on page 64 worn by the model Jean Shrimpton—became *de rigueur*. In the 1960s Karl Lagerfeld, along with a handful of other designers such as Pierre Cardin, André Courrèges, Jean Kaplan, Paco Rabanne, and Yves Saint Laurent, was responsible for expanding the stereotype of the fur-clad woman to incorporate younger, hipper manifestations. In 1965 Lagerfeld was appointed creative director at Fendi, a collaboration that the American socialite Susan Gutfreund has described as "their genius and his creativity" (see page 65). Perhaps more than any other designer, Lagerfeld, along with the five Fendi sisters, has revolutionized fur design, processing, and manufacture, realigning and reinventing them in tune with fashion. Most notably he has shed the weight and bulkiness of furs like mink, an effect achieved, in part, by perforating the pelts. As the journalist Suzy Menkes has observed: "The overall Fendi achievement has been to serve up a 'fat-free' fur: slim, light, richly worked but never indigestible." In his own words, Lagerfeld "handles furs as if they were fabrics." He believes that "to ask for the impossible makes possible the impossible" and maintains that "the ideal fur coat is that of the next collection." His repertoire has included geometric furs; asymmetric furs; knitted and quilted furs; reversible coats of fur and silk; stylized flowers in various furs (applied alternately front and back); the removal of linings, buttons, and shoulder pads; the use of highborn furs like mink and sable dyed apricot or lemon yellow; the use of lowborn furs such as goat, ferret, squirrel, and even hamster; and the use of highborn and lowborn furs together in one garment. Lagerfeld's approach to fur is both playful and irreverent, as evidenced by his use of mink to trim denim and to line coats of tweed and gabardine. As Oscar de la Renta, a designer of modern, innovative fur fashions himself, has commented: "I like what Karl Lagerfeld has done—taken the fur-maker's stamp out of fashion."

Page 64: S. London of Sloane Street, British (founded 1920). Jean Shrimpton in a fur coat, 1964.

Photograph: David Bailey

Page 65: Fendi, Italian (founded 1918) by Karl Lagerfeld, German (born 1938). Advertising campaign,

autumn/winter 2002–2003. Courtesy of The Advertising Archive

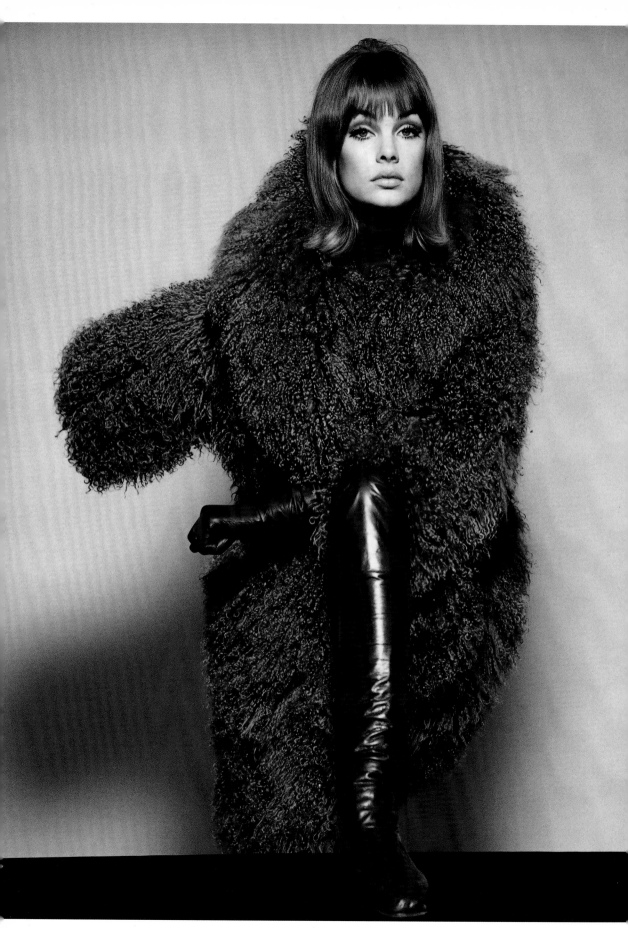

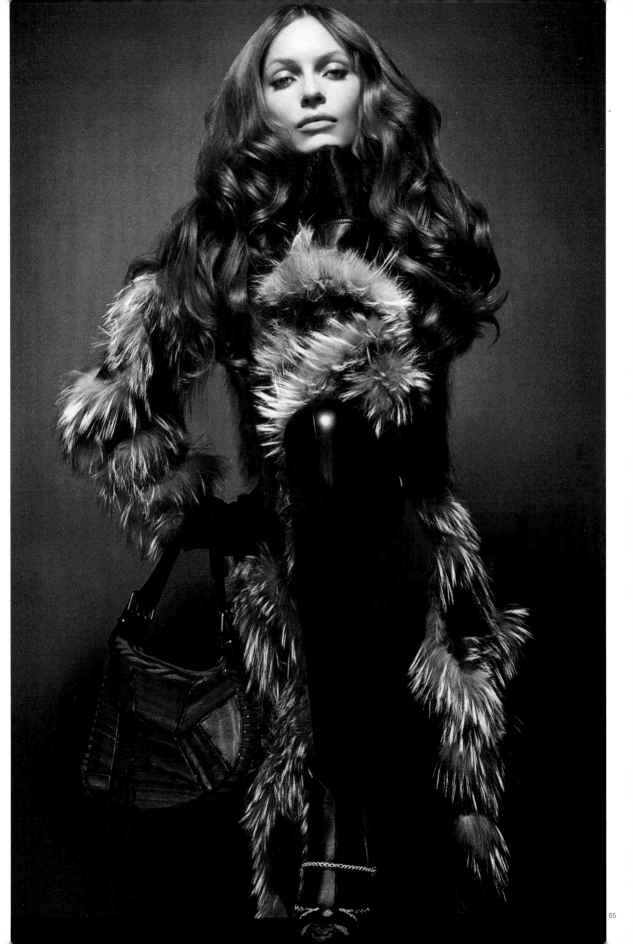

ONE FUR HAT.
TWO SPOILT BITCHES.

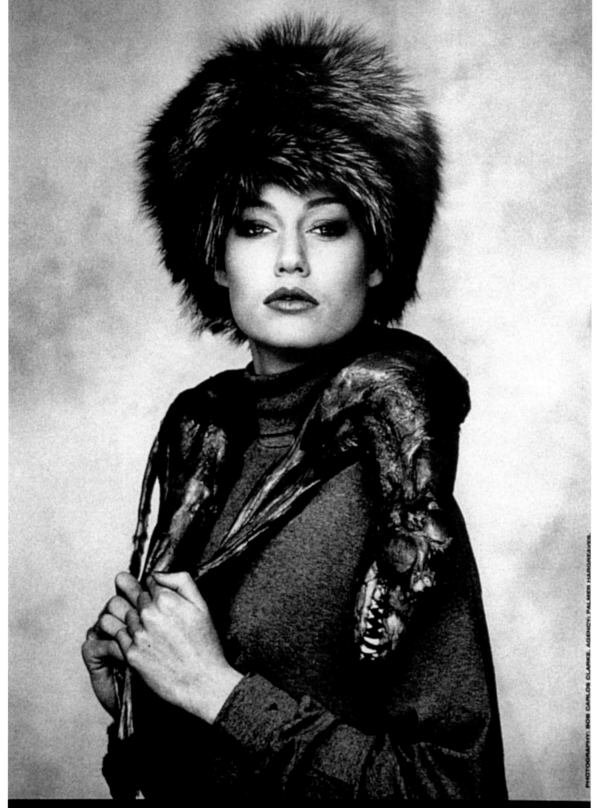

DON'T LET FUR CREEP BACK INTO FASHION respect

TO BECOME A SUPPORTER, PLEASE WRITE TO P.O. BOX 500, NOTTINGHAM

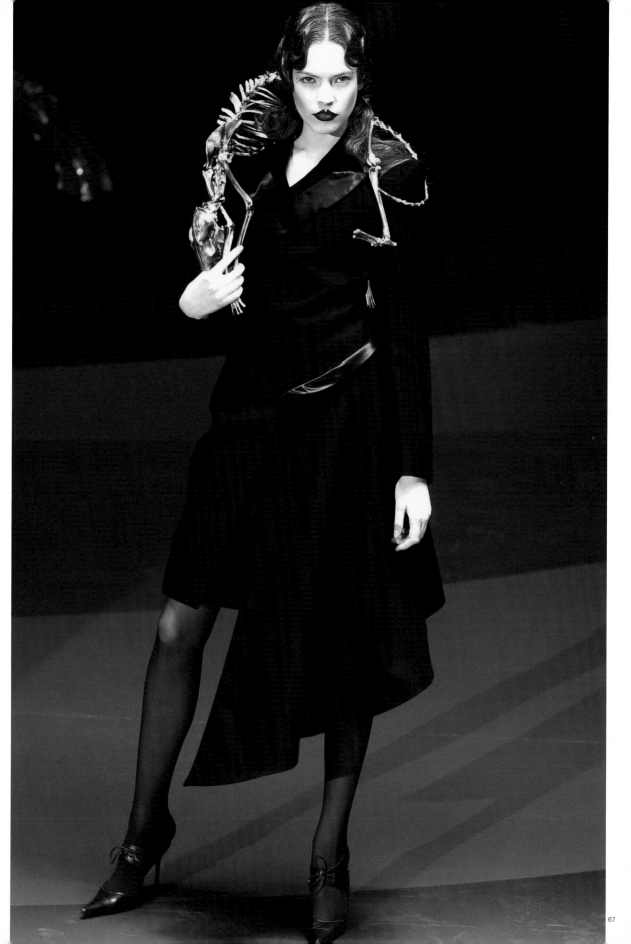

As the chief consumer of the fur coat, the bourgeois woman became the target of the various animal welfare organizations that have emerged since the 1970s. The British Lynx and Greenpeace International and the American PETA (People for the Ethical Treatment of Animals) are among the most prominent of such organizations, which have sought to regulate trapping and fur factory practices and to demystify fur's significations of wealth, power, prestige, and luxury. Their media campaigns, particularly those by Lynx, cast the fur-clad woman as the social referent for the continuation of the fur trade. As Julia V. Emberley observed in *The Cultural Politics of Fur* (1997), the fur-clad woman "comes to figure as a cold and cruel monstrosity, an accessory to the crime, who would wear her capacity for terror and violence on her sleeve." In one campaign by Lynx, shown on page 66, she is depicted in a fur hat with a skinned dog around her neck. This campaign, conceived by Linda McCartney and photographed by David Bailey, declared "One Fur Hat. Two Spoilt Bitches." Acting as a form of "guilt politics," it urged women to reject fur in order to exhibit a morally as opposed to a materially superior status, thus giving birth to a new ideal of femininity, the moral or ethical woman. Alexander McQueen, who regularly employs fur in his work, appropriated this representation of femininity for the purposes of ideological recontainment (see page 67). Showing a woman in a tailored suit with a golden animal skeleton around her neck, McQueen parodied her self-righteousness and ecological puritanism.

The pro-ecology campaigns of PETA, Lynx, and Greenpeace International were effective in mobilizing public opinion against fur fashions. By lending their support to the various campaigns, prominent celebrities such as Brigitte Bardot (Greenpeace International's anti-sealing campaign), Kim Basinger and Christy Turlington (PETA's "I'd rather go naked than wear fur" campaign), gave the anti-fur challenge momentum. High profile designers such as Todd Oldham and Stella McCartney renounced the use of fur in their collections and promoted faux fur as an ethical and aesthetic alternative. In the early 1990s, when the anti-fur debate had reached a pinnacle, even prominent pro-fur designers such as Karl Lagerfeld introduced faux fur into their work. Lagerfeld's autumn/winter 1994–1995 collection included coats and jackets in neon-bright fuzzy faux fur that are as far removed from nature as possible. Inverting the supposed socio-economic egalitarianism of simulated fur, Lagerfeld, as exemplified on page 69, presented faux fur accessories like hats, muffs, and stoles branded with the Chanel logo. Ironically, such an act of status reversal referenced faux fur's original associations with the nobility. Simulated furs in the form of plush fabrics date back to at least as early as the sixteenth century, when they were used as both linings and trimmings in the costumes of the aristocracy. Plush fabrics remained popular until the early twentieth century, when pile fabrics, which produced denser textures, were introduced. It was not until the 1950s and 1960s that advances were made in man-made fibers such as acrylics and polyesters. In couture, Madame Grès and Cristobal Balenciaga, well known for their use of innovative fabrics, fronted this initiative. However, while synthetic furs present wearers and designers with a moral alternative to real fur, their manufacture, which relies on a highly complex petrochemical process, has been criticized as a potential pollutant detrimental to the environment.

Page 66: Lynx, British. Advertising campaign, "One Fur Hat, Two Spoilt Bitches," ca. 1984. Courtesy of The Advertising Archive. Photograph: David Bailey

Page 67: Alexander McQueen, British (born 1969). Ensemble, autumn/winter 2001–2002. Photograph: copyright © Chris Moore

Page 69: House of Chanel, French (founded 1913) by Karl Lagerfeld, German (born 1938). Advertising campaign, autumn/winter 1994–1995. Courtesy of the House of Chanel. Photograph: Karl Lagerfeld

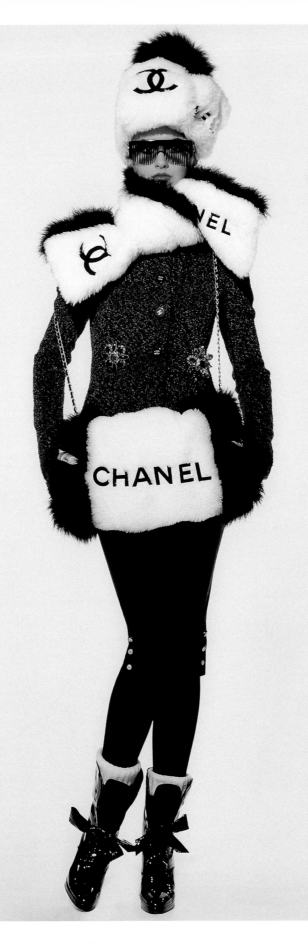

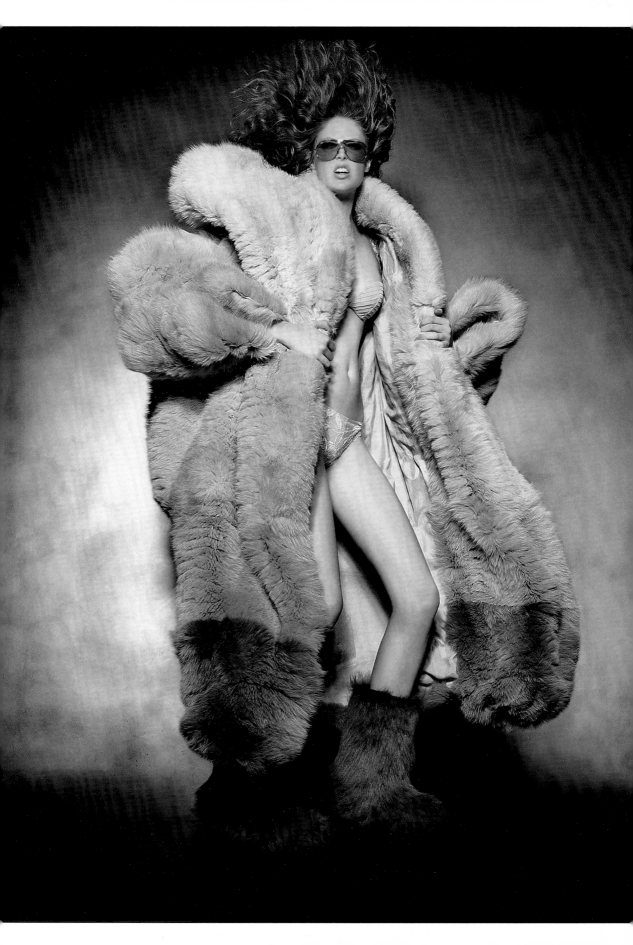

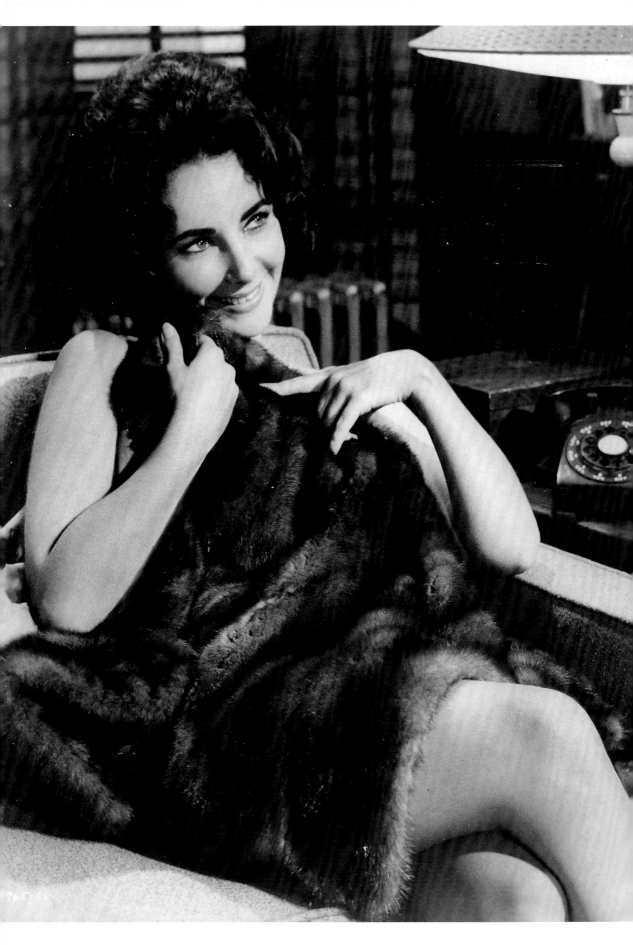

In literature the image of the fur-clad female body as sexual fetish is perhaps best represented in Leopold von Sacher-Masoch's late-nineteenth-century psychosexual dramatization of masochism *Venus in Furs*, which gave birth to the stereotype of the fur-wearing woman as dominatrix. The "Venus" in the novel is Wanda, an agent of violence and brutality in the guise of a fur-clad, whip-wielding woman in thigh-high leather boots. Masoch likened a woman in a fur coat to a "great cat, a powerful electric battery." This metaphor applies to Elizabeth Taylor's role in Daniel Mann's film *BUtterfield 8* (1960). As shown on page 76, Taylor played Gloria Wandrous, a dress model and professional escort described by one bartender as "catnip to every cat in town." Like Wanda, Gloria is originally depicted as a cold, cruel despot who, as one spurned boyfriend described, is "like a flea—hop, hop, hop from one dog to another. She bites you and she's gone." Throughout the film a fur coat figures as a symbol of Gloria's sexual transgression. After spending the night with one of her rich clients by the name of Weston Liggett, played by Lawrence Harvey, she "borrows" his wife's mink coat ("something spiteful and elegant") in revenge for being left $250 for services rendered. Later, Gloria and Liggett spend a week together and fall in love, but when Liggett discovers her deception, and Gloria attempts to return the fur coat, he throws it at her feet, saying: "[Do you think I] want to give this back to my wife after something like you has touched it." The fur coat comes to symbolize Gloria's moral degeneracy, an article of credit in a mode of sexual exchange that transforms her status from escort to prostitute. When her childhood friend Steve Carpenter, played by Eddie Fisher, asks her why the coat is still in her possession, she declares: "Because it's mine. Every skin, every thread, every hair is mine. And do you know why? Because I earned it. Pretty good pay for one week. A thousand dollars in fur a day." Ironically, a sumptuary law passed in 1355 forbade women of ill-repute to wear fur in order to differentiate them from respectable women, but for much of the twentieth century, the fur coat has come to be seen as a signifier of the hetaera or prostitute, a badge of her sexual impropriety. The fur-clad prostitute has long been celebrated in art, fashion, and photography. Helmut Newton referenced her in his photograph *Laura Dressed in a Fox Cape*, reproduced on page 78, which shows a model striding along Avenue George V in Paris with her genitals exposed in a blatant display of sexual availability. As Newton has commented: "There must be a certain look of availability in the women I photograph. I think the woman who gives the appearance of being available is sexually much more exciting than a woman who's completely distant. This sense of availability I find erotic." It is an opinion shared by Tom Ford who, during his reign as creative director at Gucci and Yves Saint Laurent Rive Gauche, gave life to many versions of the fur-clad prostitute (see page 79). Saint Laurent was also inspired by this anti-ideal of femininity, creating a traffic-stopping bright green fox chubbie or mini-coat, both flashy and trashy, for his spring/summer 1971 collection ("Collection 40"), which became known as the "happy hooker" look. Commenting on the controversial 1940s-inspired collection, which the British newspaper *The Guardian* scathingly called "A *tour de force* of bad taste," Saint Laurent said: "The street and me, it's a love story. 1971 was a great year because finally, fashion went into the street."

Page 76: Elizabeth Taylor in *BUtterfield 8*, film still, 1960. Courtesy of MGM/The Kobal Collection

Page 78: Helmut Newton, German (1920–2004). *Laura Dressed in a Fox Cape, Avenue Georges V, Paris*, photograph, 1974. Photograph: copyright © Helmut Newton/Maconochie Photography

Page 79: Gucci, Italian (founded 1906) by Tom Ford, American (born 1961). Ensemble, autumn/winter 2003–2004. Photograph: Peter Lindbergh

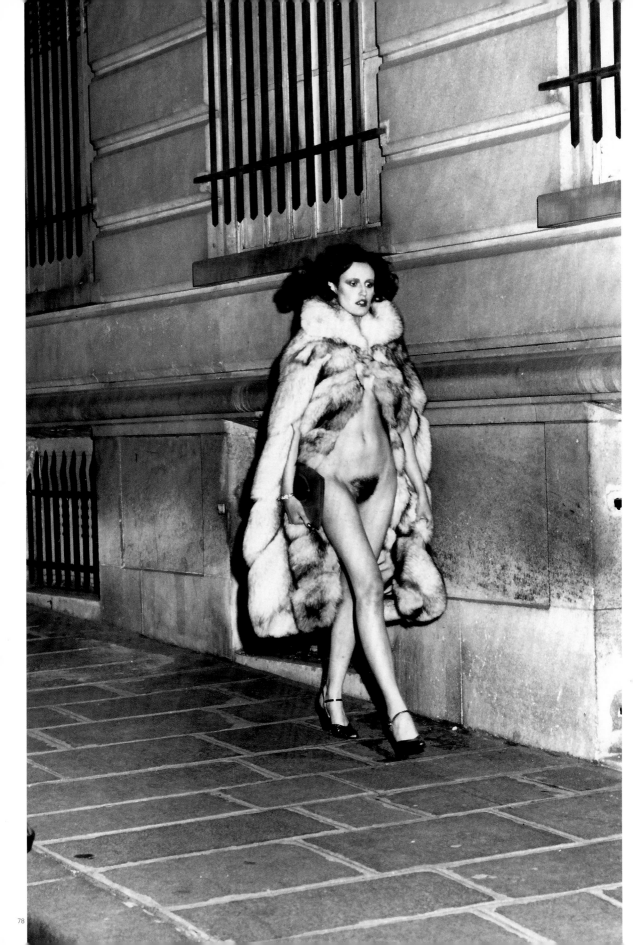

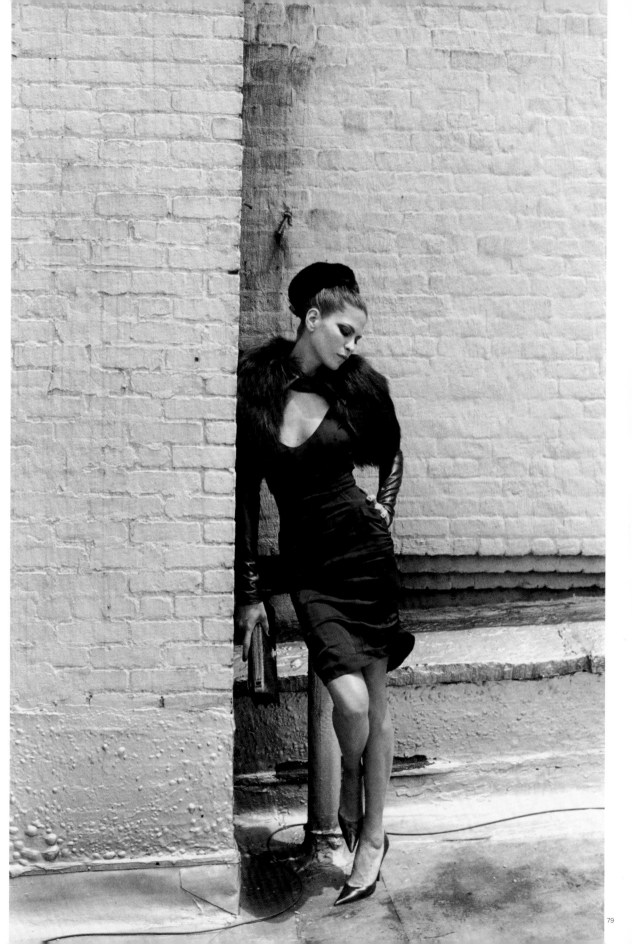

BIRDS OF PARADISE

Feathers have frequently been employed in fashion in tandem with furs, often acting as a foil, usually in the guise of trimmings or accessories. Indeed in their application to haute couture, furs and feathers share many characteristics. Both are wittingly distilled beyond their natural beauty to create a self-conscious artifice. In the case of the House of Lemarié, which since its founding in 1880 has supplied most of the featherwork for the couture, no element is left to chance or to nature's carelessness. Feathers are split, dyed, twisted, stripped, and knotted together to enhance and even surpass nature's aviary. A sample of featherwork from the House of Lemarié, like a sample of embroidery from the House of Lesage, has often been the source of inspiration for a couturier. One cannot imagine Coco Chanel, Christian Dior, Hubert de Givenchy, and Yves Saint Laurent without the tradition of Lemarié featherwork.

The appeal of feathers extends beyond aesthetics. Historically and cross-culturally, they have been used to convey both sexual and economic supremacy. In the Middle Ages noblemen sported trains or excrescences of sumptuous plumage in blatant displays of wealth and status. At the first meeting of the Order of the Garter, the highest English Order of Chivalry, founded in 1348 to celebrate the victory of Crécy, the Knights Companion wore hats with ostrich feathers to signify their sexual and military prowess. The association of feathers with a virile masculinity is perhaps most palpable in the warbonnets of Native American braves. Every eagle feather in a warbonnet represents a particular act of courage. In complete contrast, feathers have also come to be associated with a louche, dandified decadence, enjoying their greatest popularity at times of unequaled lavishness and unsurpassed extravagance in male apparel such as the 1500s and 1600s, and the 1960s and 1980s.

Until the Restoration feathers were associated primarily with displays of male erotic and economic power, but from the eighteenth century onward they have figured more prominently as signifiers of female artifice and sexuality. As noted by Robin W. Doughty in *Feather Fashions and Bird Preservation: A Study in Nature Protection* (1975), a vogue for feathers was conspicuous during the reign of Louis XVI (1774–93), a period in which "a woman's head was in the middle of her body, and society had the appearance of an extravagant fancy ball." Under the sartorial guidance of Marie Antoinette, the Court of Versailles was a riot of color. Egret, ostrich, peacock, and birds of paradise feathers rippled, swayed, and quivered on the heads of courtesans and noblewomen as they danced to courtly music and displayed their social graces. Women wearing avian coiffures and headdresses stand out in a crowd, hence their continued popularity in the nineteenth and twentieth centuries at such sites of fashionability as the races, the opera, and the theater. Feathers also project a sexually liberated persona. Indeed, feather fashions are in most evidence during periods of female emancipation such as the late 1800s, the 1920s, and the 1960s. Feathers render clothing more fluid and flexible, enhancing and exaggerating a woman's sexual attractiveness. Their fragile, tremblant delicateness allows apparel to become dynamic, animating the body and adding emphasis to gestures and movements. It is the kinetic and expressive qualities of feather fashions, as well as their inherent and inimitable beauty and sensuousness, that have enabled them to survive the caprices and vagaries of fashion.

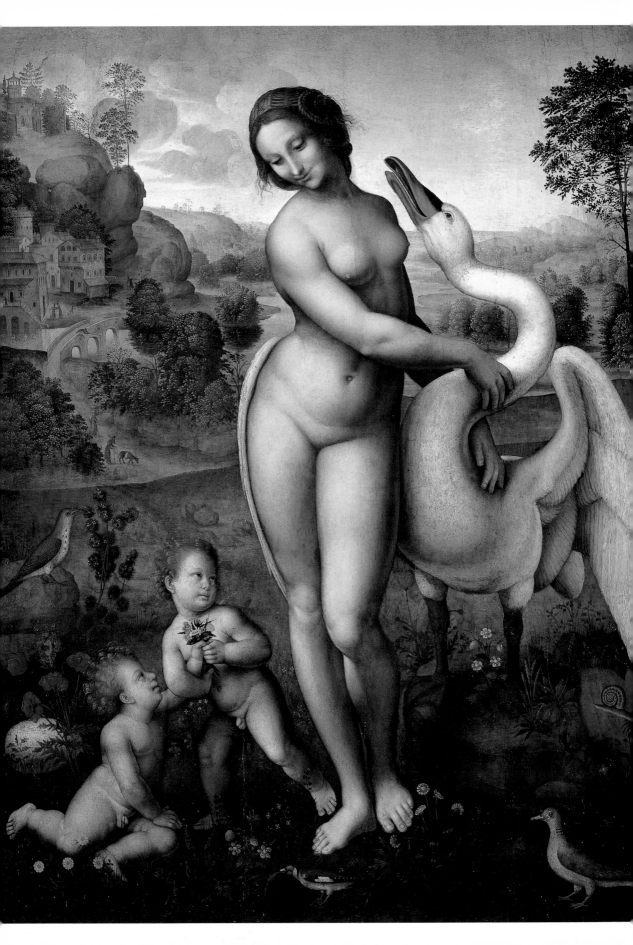

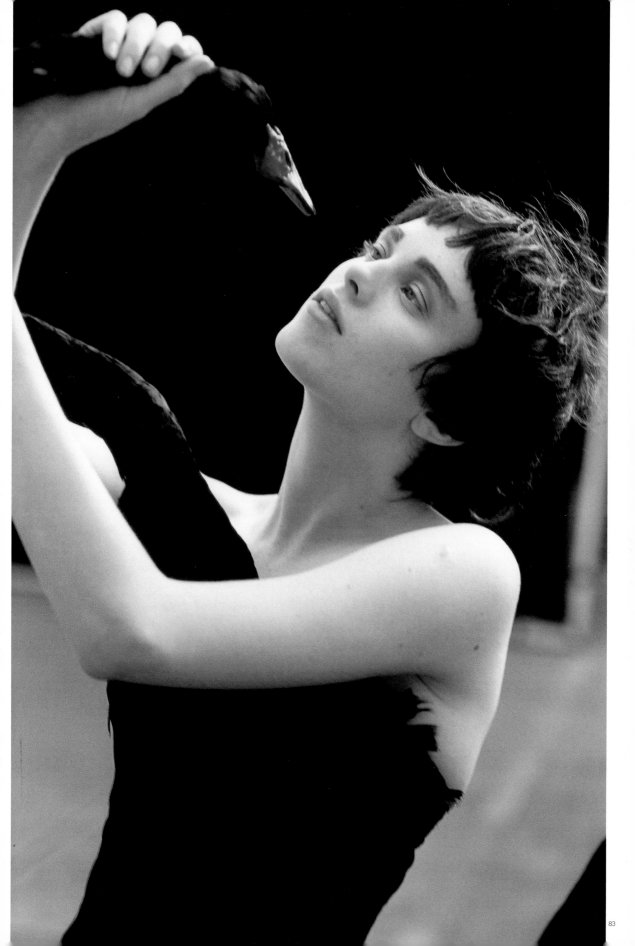

Fashion's fascination with feathers lies not only in their aesthetic appeal but also in the mythology and symbolism that surround the creatures they embellish. The swan in particular has acquired a unique and unrivaled status in fashion's historiography, a status reflected in the number and complexity of fables and allegories that, over time and across cultures, have accumulated in admiration and appreciation of this bird of most noble and majestic bearing. In Greek mythology, swans were present at the birth of Apollo, god of the sun, and of his sister Diana, goddess of the moon. As an avatar of the two celestial siblings, the swan became a potent signifier of light, the solar, male light of day or the lunar, female light of night. In the Greek myth of Leda and the Swan, the subject of a celebrated painting after Leonardo da Vinci reproduced on page 82, and later, a poem by William Butler Yeats, the swan comes to symbolize both forms of light. Recorded in Ovid's *Metamorphoses* the myth tells how Zeus makes love to Leda disguised as a swan, leading to the birth of some illustrious offspring, including Helen of Troy. According to the story Zeus changed himself into a swan only after Leda "had turned herself into a goose to escape him." The goose is another manifestation of the swan in its female, lunar incarnation. As such, swan-Zeus and goose-Leda represent the bipolarization of the swan symbol, which, bearing the synthesis of the male diurnal meaning and the female nocturnal meaning, becomes hermaphroditic.

In fashion, swan symbolism lends itself to a more feminized interpretation, one that evokes the grace, strength, and beauty of Diana. Channeling the myth of Leda and the Swan, Alexander McQueen's Givenchy Haute Couture autumn/winter 1997–1998 collection breathed new life into the incandescent goddess. On the catwalk this ideal of femininity was conveyed by the model Shalom Harlow in a black "swan dress" that brought to mind the evil swan Odile in Tchaikovsky's *Swan Lake*. The gown comprised a long, trailing, tutu-like tulle skirt and a figure-hugging feathered bodice with a halter neck in the form of a swan's neck that curled sensually around Shalom's own swan-like neck. In a photograph by Peter Lindbergh for *Vogue Italia*, seen on page 83, the model Karen Elson releases the swan's erotic clench and stares longingly into the swan's eyes. It is a gesture that contrasts with that of Leda in the painting after Leonardo da Vinci, in which her head turns away from the swan-Zeus. This coy gesture is at variance with her explicitly provocative pose, which is loosely based on an S-curve (and echoes the swan's limber neck), with the upper and lower body simultaneously flexed, twisted, and thrust in different directions.

Page 82: After Leonardo da Vinci, Italian (1452–1519). *Leda and the Swan*, oil on wood, ca. 1505–10.

Photograph: Scala/Art Resource, NY

Page 83: Givenchy Haute Couture, French (founded 1952) by Alexander McQueen, British (born 1969).

Dress, autumn/winter 1997–1998. Photograph: Peter Lindbergh

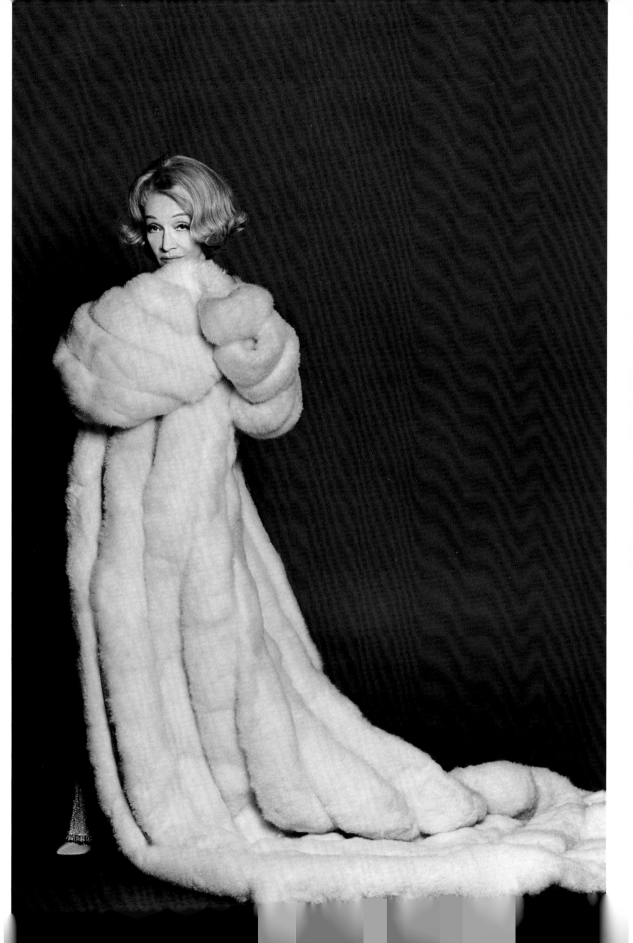

n the photograph by Milton H. Greene reproduced on page 85, Marlene Dietrich, like Leda in the painting after Leonardo da Vinci on page 82, projects the opposing characteristics of innocence and carnality. Dietrich wears the famous swan's-down coat in which she often closed a performance. Designed by the renowned costumier Jean Louis, it consisted of a silk chiffon known as *soufflé*, upon which was sewn, in an endlessly undulating design, the down of male swans. Worn over a provocative, figure-revealing, semi-transparent gossamer silk sheath dress emblazoned with crystal bugle-beads, the coat depended on the stillness of the wearer for its full visual impact. On tour, Dietrich traveled with two such coats. Before being worn, they were fluffed and primped until they resembled whipped cream. The swan's-down coat was based on an earlier costume that Dietrich wore to the actor Basil Rathbone's 1935 costume party with the theme "Come As One You Most Admire." Dietrich went as Leda in a dramatic, leg-revealing silk chiffon and swan feather costume (not too dissimilar from Alexander McQueen's fanciful confection shown on page 83) designed by the celebrated Paramount costumier Travis Banton. The legendary actress had a predilection for feathers. As the actress and gossip columnist Hedda Hopper pointed out: "Marlene loved feathers—paradise, ostrich, egrets, even stuffed birds. Banton once made her an evening gown trimmed with four thousand dollars worth of black paradise feathers. It was a knockout. Every star in town wanted to duplicate it, but they couldn't buy the feathers. When an agent of the federal government swooped down on the studio and snatched away all the paradise feathers, I wondered if a certain star's jealousy hadn't got the better of her discretion. The agent said it was against the law to import or even buy paradise. Heaven forbid! These had been bought years before, but thereafter Marlene had to be content with the plumage of lesser and drabber birds."

Page 85: Milton H. Greene, American (1922–1985). Marlene Dietrich in a swan's-down coat, photograph, 1973.

Photograph: Milton H. Greene Studios/copyright © Condé Nast Publications Inc.

While Marlene Dietrich's swan's-down coat conveyed an ideal of femininity based on a classical archetype, Yves Saint Laurent's coat of ostrich and ringneck pheasant tail feathers, which brings to mind the arresting and enveloping feather capes worn by Maori and Hawaiian chieftains, projects a more exoticized identity (pages 88–89). Exoticism is a recurring leitmotif in Saint Laurent's work, expressed in his vivid color palette, lavish beading and embroidery, and use of unusual materials like wood and raffia. Saint Laurent's feathered apparel, however, which reveals his deep commitment and appreciation for the traditions of the couture, is perhaps his most blatant display of an exoticized femininity, conjuring up images of his muses Paloma Picasso and the French singer and dancer Zizi Jeanmaire. The wife of celebrated choreographer Roland Petit, Zizi Jeanmaire was not only one of the most popular entertainers of her day but also one of the most stylish. As the journalist Christopher Bowen observed: "Nobody has ever shifted so stylishly from toe-shoes to stilettos like Zizi Jeanmaire." With her tiny frame, short, cropped hair, and long, elegant legs, she had a birdlike beauty that Saint Laurent exploited when he designed the fantastical feathered confections for her annual revues and spectacles. He reinterpreted these dazzling costumes for the runway, always respectful of his client's needs and his own design mantra, "to render clothing poetic, but to preserve its dignity as clothing." In his autumn/winter 1969–1970 collection, Saint Laurent presented a series of evening dresses made entirely of bird of paradise feathers, which the dress historians Richard Martin and Harold Koda described as "gossamer creations both airy and aery, a rara avis of creativity." Respecting the natural beauty of the feathers, each one, like those in Saint Laurent's coat of ostrich and pheasant feathers shown here, had been individually hand-stitched to a base material. The full force of Saint Laurent's flights of fancy, as Pauline de Rothschild discovered when she ordered a short-sleeved version, could only be truly appreciated in motion, the feathers flickering and fluttering in synchronization with the wearer's jauntily elegant movements.

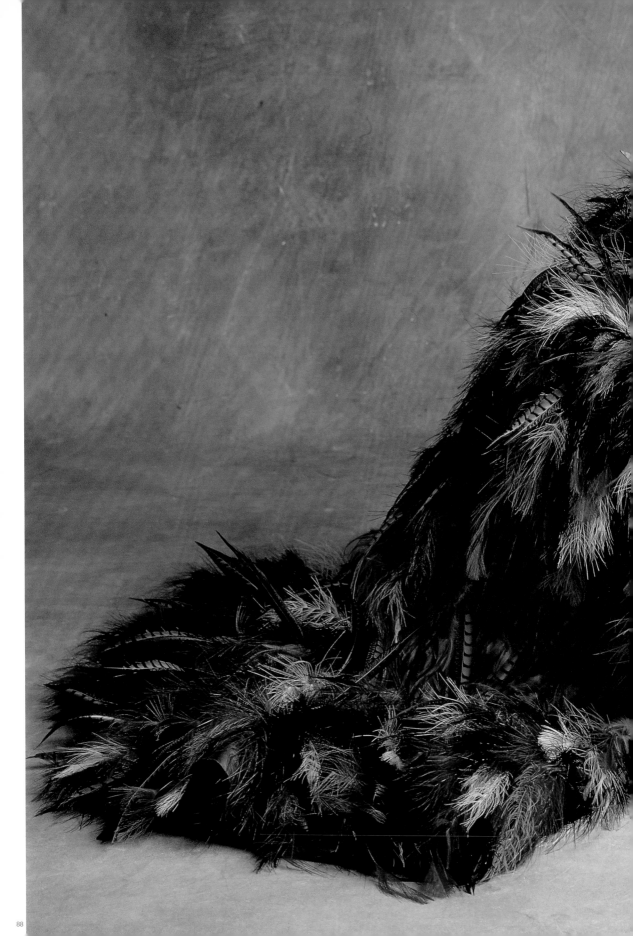

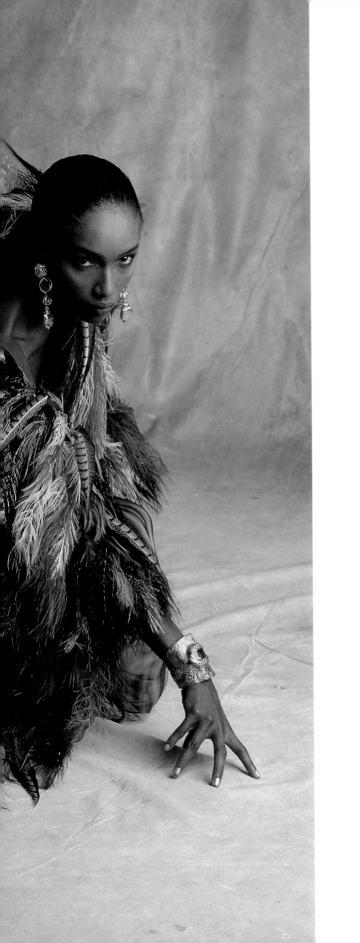

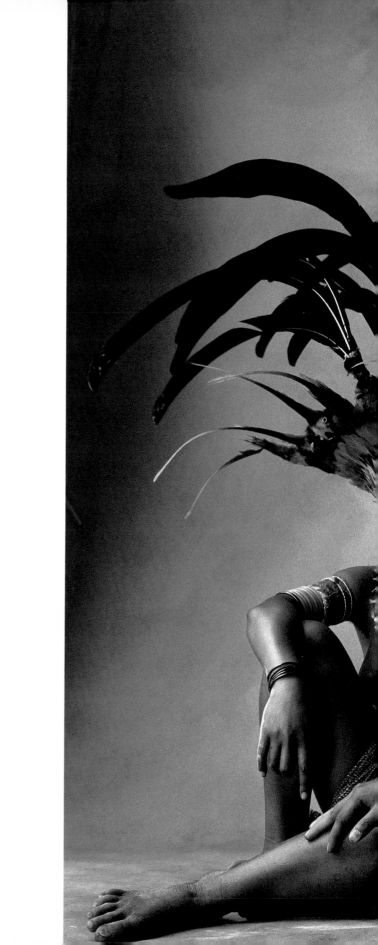

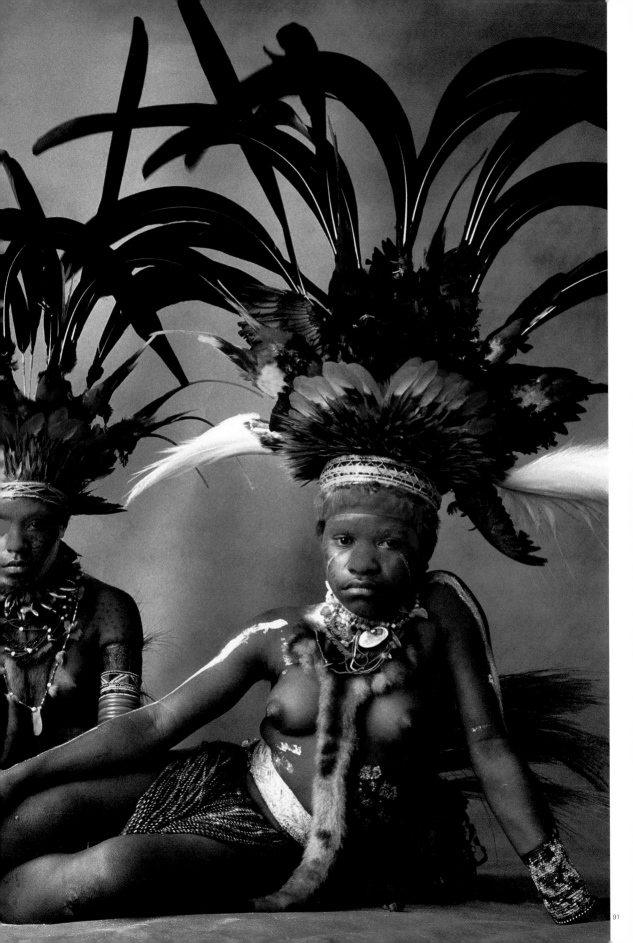

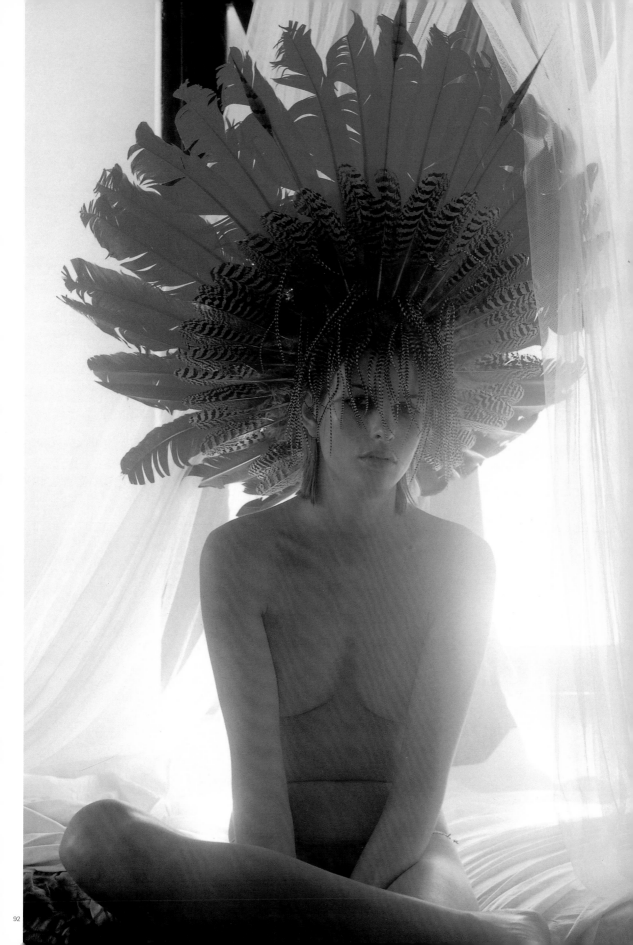

The plumage of birds of paradise, which the famous English naturalist Alfred Russel Wallace described as "the most extraordinary and the most beautiful of the feathered inhabitants of this earth," has long been used to adorn the heads of stylish women. In Europe the use of bird of paradise feathers as ornamentation dates back to at least as early as the sixteenth century, when explorers such as Ferdinand Magellan brought back specimens from their circum-global expeditions. Along with egret, ostrich, and peacock feathers, the plumage of birds of paradise was a favorite of Marie Antoinette's. The resplendent Queen of France, nicknamed "featherhead" by her brother Joseph, set the Court of Versailles aflutter with her poufs, or piled hairstyles, of feathers, flowers, and objets d'art, which were fashioned by her talented dressmaker Rose Bertin and her temperamental hairdresser Leonard. As noted by Robin W. Doughty, these unique extravaganzas, which could reach upwards of a foot high, were likened to "a moving garden of bright-colored flowers, gently caressed by the zephyrs." Worn by courtesans and noblewomen alike, they projected an exoticized and eroticized identity, one that has come to be associated with the most enduring and prevalent stereotype of the befeathered female, namely the coquette. This ideal of femininity came to the fore in the second half of the nineteenth century, a period in which women's apparel boasted every type of avian trim imaginable. With the decline of the bustle and the crinoline toward the end of the century, even more attention was centered on the upper body, neck, and head. The coquette could be seen sporting hats and bonnets with hummingbirds perched on artificial flowers and birds of paradise in attitudes of earnest incubation, provoking criticism from ornithologists and bird preservationists and leading to the formation of two bird protection organizations, The Audubon Society in America and The Royal Society for the Protection of Birds in England. As is so often the case in fashion, however, these feats of millinery find corollaries in other cultures, most notably those in which exotic birds like birds of paradise are plentiful, such as Papua New Guinea, where they feature in a number of origin myths and are worn by both men and women in the form of extravagant headdresses in various rites of passage. Irving Penn took a series of photographs of these dazzling headdresses for American *Vogue*, underscoring their fashionable status in the West. The photograph reproduced on pages 90–91 shows a version in which a headband of beetle wings is used to bind together an array of bird of paradise plumage. The caption to the original photograph read: "Nondugl girls in full courting regalia," an avowal that in Papua New Guinea feathered headdresses, like their equivalents in the West, serve not only to enhance the wearer's attractiveness but also to announce her sexual availability. Philip Treacy, a designer well versed in the libidinal implications of millinery, created headpieces inspired by the ones worn in cultures like those of Papua New Guinea for Alexander McQueen's spring/summer 2003 collection (see pages 92–93). Like other notable milliners of the twentieth century, such as Mitzah Bricard, Lily Daché, Paulette, and Suzy, Treacy creates mobile atriums that serve as beacons of allure and sexual magnetism. Lending height, dignity, and elegance to the wearer, his radiant head sculptures frame the face like glowing halos, accentuating its charms and celebrating its idiosyncrasies.

Pages 90–91: Irving Penn, American (born 1917). *Two Young Nondugl Girls*, New Guinea, photograph, 1970. Courtesy of American *Vogue*. Photograph: copyright © 1974 by Irving Penn

Pages 92–93: Alexander McQueen, British (born 1969) by Philip Treacy, British (born Ireland, 1967). Headdress, spring/summer 2003. Photograph: Tiziano Magni

While feather fashions have come to be associated with female artifice and sexuality, they have figured prominently in the history of male apparel. Since at least as early as the fourteenth century, feathers were used to adorn men's caps, hats, and bonnets, often worn at a jaunty angle. In the sixteenth century, men of fashion could be seen sporting low-crowned caps or hats with slashed and cocked or turned-up brims lavishly decorated with plumes and jewels. Plumed hats conveyed ideologies of political and religious preferences in the seventeenth century, when Royalists or Cavaliers adopted them in the English Civil War (1642–49). These proto-dandies favored low-crowned, broad-brimmed beaver hats, so called because they were made from the "fur-wool" of the beaver (the layer of short, downy hairs found close to the skin), decorated with jeweled hatbands and large, flowing ostrich feathers. The ability of hat styles to convey symbolic meaning is particularly significant in Native American culture. Among the styles of hats worn by Plains Indians, the most emblematic is the feathered warbonnet, which Sitting Bull, or Tatanka-Iyotanka (1831–1890), wears in the photograph reproduced on page 96. The warbonnet, which only the most exceptional of braves were accorded the right to wear, was made from eagle wing feathers attached to a leather skullcap and two long side-strips of buckskin. Each feather denoted a particular war exploit, such as killing or harming an enemy in battle or saving the life of a fellow brave. At the tip of each feather was a strand of horsehair, which represented the scalp-locks of their victims. Plains Indians revered the eagle because of its fierce hunting skills. To Native Americans the eagle is a messenger of the Great Spirit, the most powerful sky deity represented by the sun. With its concentric circles of eagle feathers, the warbonnet came to be regarded as a potent sun symbol. As Lois Sherr Dubin explained in *North American Indian Jewelry and Adornment* (1999): "These radiating lines of feathers represented both the sun's rays and the spiritual power of the bird messenger [the eagle]. Wearing the eagle-feathered bonnet, the warrior actually became the eagle and identified himself with the Great Spirit." The warbonnet, like its millinery counterpart the stetson, has become a potent symbol of American culture or, rather, a symbol of one of the many and diverse sartorial traditions that have come to define American style. That most patriotic of American designers, Bob Mackie, whose ironic approach to his cultural heritage has made him a favorite among such pop icons of American style as Madonna, Diana Ross, and Liza Minnelli, has re-presented and re-interpreted the warbonnet as an item of female apparel. The lavish example seen on page 97 is made not of eagle feathers but of dyed turkey wing feathers, the horsehair tips having been replaced with maribou fluff. Such a headdress recalls not only images of his muse Cher but also those of LA showgirls, whom Mackie dressed and promoted as archetypes of American glamour.

Page 96: *Portrait of Sitting Bull*, photograph, ca. 1888. Photograph: copyright © CORBIS

Page 97: Bob Mackie, American (born 1940). Headdress, ca. 1987. Photograph: Gideon Lewin

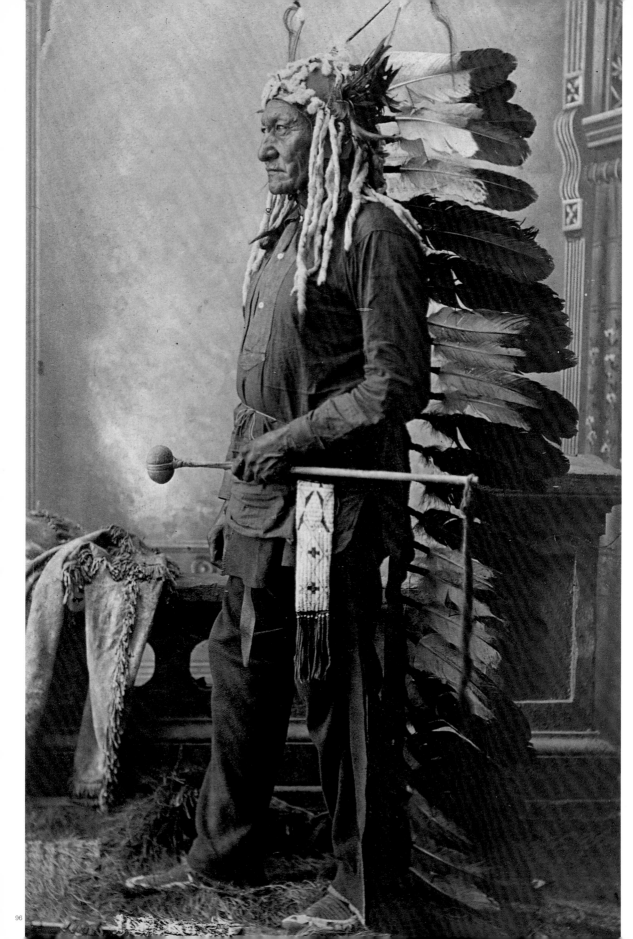

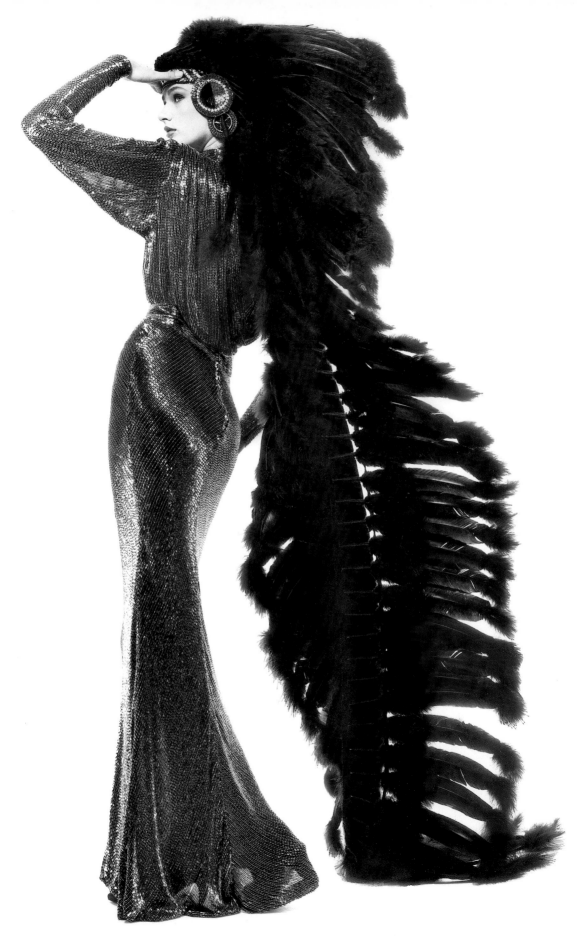

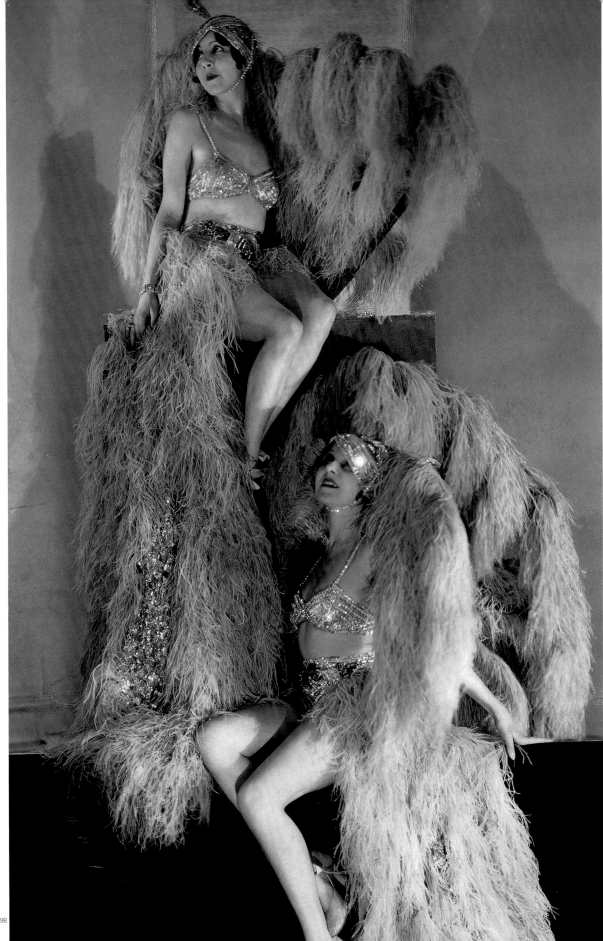

The showgirl is one of the most resilient and recognizable icons of the befeathered female. Like her equally high-spirited, pleasure-seeking sorority sister the Playboy Bunny, she is the product of a tradition of entertaining exhibitionism that dates back to antiquity. As Andrea Stuart pointed out in *Showgirls* (1996): "Only the word is new. She has evolved as civilization has evolved." The showgirl is heir-apparent to the dancing girl of ancient Egypt, the posing beauty or *figurante* of Renaissance Italy, and the ballet girl or *danseuse à l'ópera* of eighteenth-century France. In her present incarnation she burst into song and dance in the cafés and theaters of the Belle Époque. A product of the exigencies of modern urban life, this symbol of leisure and pleasure shares both an individual and a collective identity. She is Colette and Mistinguett, glittering luminaries of cabaret and vaudeville, as well as the faceless and nameless girl of the music hall chorus line. The showgirl is a social and sexual barometer, a cipher onto which men and women project their desires and anxieties. Andrea Stuart observed: "She is a veritable diviner's cup, reflecting what each era wants to see—needs to see—in its entertainers." Her body is quite literally shaped by society. It is a site for resolving male and female sexual power relations and for revealing prevailing ideals of beauty and femininity. Since her reincarnation in the mid-to-late nineteenth century, she has morphed from the buxom *Folies Bergère* star of the 1890s into the statuesque *Ziegfeld Follies* mannequin of the 1920s and the lean and surgically enhanced Las Vegas showgirl of the 1990s. While her costumes changed in tandem with her corporeal transformations, certain elements remained unchanged, such as ostrich feathers and sequin- or rhinestone-covered bra and panties, as can be seen in the photograph of Beth and Betty Dodge on page 98. The American sister act Les Dodge Sisters sang, danced, and whistled their way through Europe in the 1920s and 1930s, appearing at the *Folies Bergère* in Paris and at the *Admiralspalast* in Berlin. In this photograph by George Hoyningen-Huene, they wear the costumes for the revue *A Night in Venice*, staged in America. With their lavish ostrich feather fans, tailpieces, and headdresses, they epitomize the male fantasy of the kept or caged woman. Their coy expressions and erotic posturings exemplify the showgirl's enduring appeal. This ability to convey the dual characteristics of girlish innocence and worldly experience led the writer Albert Camus to pronounce: "It hurts me to admit it, but I'd give up the chance of ten conversations with Einstein for a first meeting with a pretty showgirl."

Page 98: George Hoyningen-Huene, Russian (1900–1968). Beth and Betty Dodge in showgirl costumes for *A Night in Venice*, photograph, ca. 1920. Photograph: copyright © Condé Nast Archive

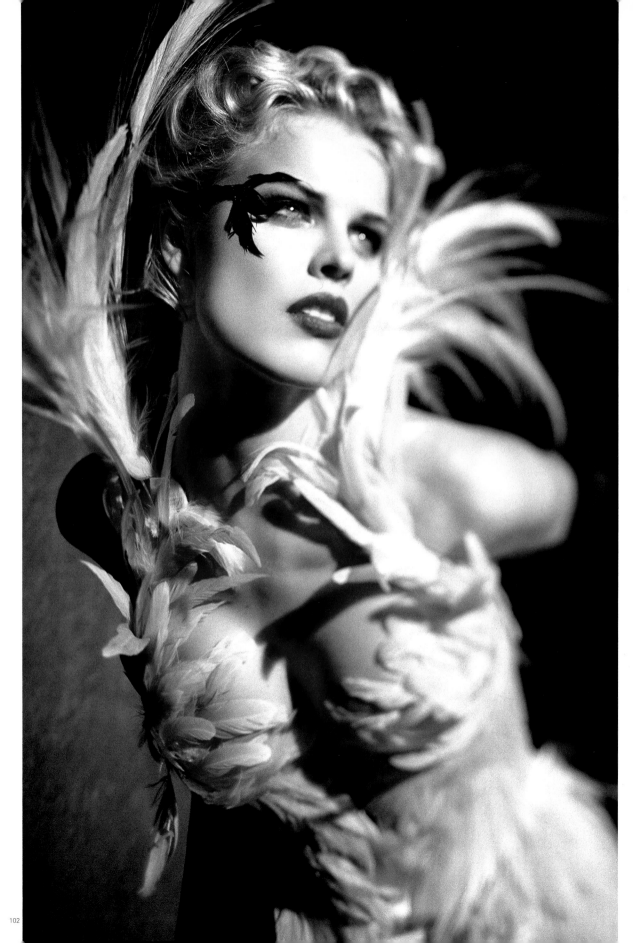

Since she exploded into action in the mid- to late-nineteenth century, the showgirl has been both reified and deified in art, film, and literature. As the exuberant Jane Avril, "queen of the can-can," she cavorted her way across the louche canvases of Toulouse Lautrec. As the vivacious Elsie Marina, played by Marilyn Monroe, she captured the heart of the austere Prince Regent of Carpathia, played by Lawrence Olivier in the film *The Prince and The Showgirl* (1957). And as the ebullient "Blonde Venus," she took her audience's breath away with the power of her raw sex appeal in Emile Zola's novel *Nana* (1880). These artistic, filmic, and literary references coalesce in John Galliano's vision of the befeathered showgirl, played to perfection by the stork-like supermodel Nadja Auermann (pages 100–101). With her garter, sheer silk stockings, rooster feather corset, ostrich feather tailpiece, and in particular, her rooster feather headdress made by the British milliner Stephen Jones, she presents the image of an aroused cockatoo. To underscore this avian metamorphosis, she is depicted on a swing or trapeze, a classic showgirl prop that was used to great effect in Baz Luhrmann's film *Moulin Rouge* (2001). It was an act favored by the female impersonator Barbette, one of the most famous entertainers of the 1920s and 1930s. Christened "the exquisite Barbette" by the Parisian critic Gustave Fréjaville, he was an acrobat, gymnast, and showgirl par excellence. Describing his trapeze act, the poet and critic Gérard d'Houville enthused: "I have the feeling that he is a winged being with wings we can not see." In preparation for his work on the trapeze, Barbette undertook a mini-striptease that Jean Cocteau called "a scabrous little scene . . . a real masterpiece of pantomime, summing up in parody all the women he has ever studied, becoming himself the woman—so much so he eclipses the prettiest girls who have preceded and will follow him on the programme." In *Showgirls* (1996), Andrea Stuart proposed that all showgirls are female impersonators, literally "performing" their femininity. She asserted: "A drag queen before the term was invented, the showgirl at once highlights women's sexual power and reduces it to burlesque, with her shimmering fetishistic appearance and her exaggerated behavior." Parody and extravagant femininity come together in Thierry Mugler's showgirl-inspired costume seen on page 102. Shown as part of his autumn/winter 1994–1995 collection, it comprises a white satin gown with a rooster feather bodice and high egret feather collar. The costume was worn on the runway by Eva Herzigova, herself a blown-up, exaggerated version of femininity. With its sumptuous decorativeness, it represents a visual manifestation of the showgirl mantra expressed in the words of Oscar Wilde: "Illusion is the first of all pleasures."

Pages 100–101: John Galliano, British (born Gibraltar, 1960). Ensemble, autumn/winter 1994–1995. Headdress by Stephen Jones, British (born 1957). Photograph: Irving Penn, American (born 1917). *Nadja on a Swing*, New York, 1994. Model: Nadja Auermann. Copyright © Condé Nast Publications Inc., 1994

Page 102: Thierry Mugler, French (born 1948). Ensemble, spring/summer 1997. Photograph: Dominique Issermann

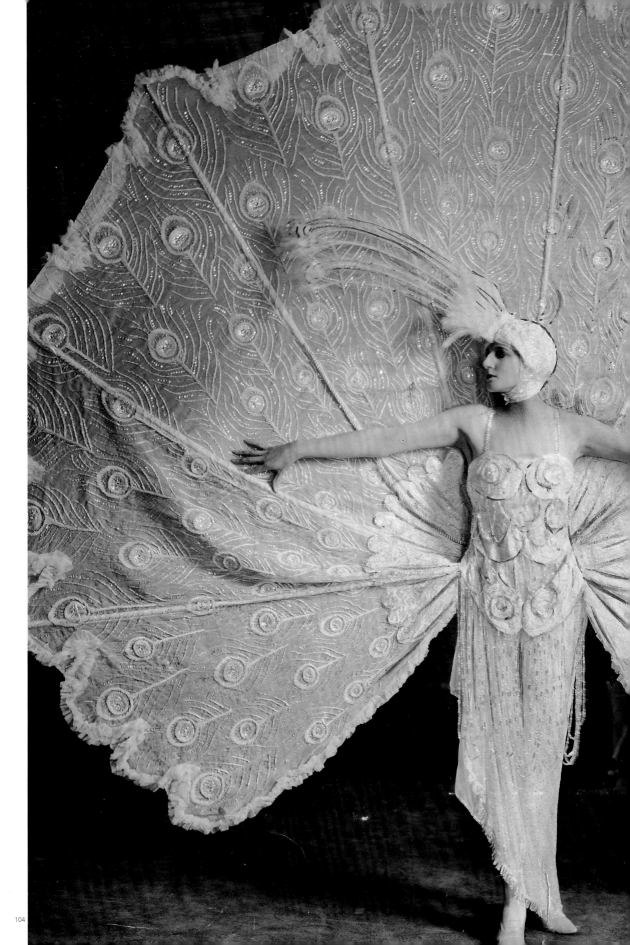

Showgirls have long served as mannequins both on and off the stage, not only for costumiers but also for couturiers. In the early years of the twentieth century, Paul Poiret and Lady Duff Gordon, known professionally as Lucile, were among the first designers to co-opt the services of showgirls and actresses in a bid to raise their visibility. Lucile, who is credited with inventing the live fashion parade, shaped the public and private personas of several well-known showgirls of the 1920s and 1930s. One of her more celebrated customers was Dolores, a house model of Lucile's and a featured performer in Ziegfeld's *Midnight Frolic*, a post-theater revue with dinner and dancing. For the *Midnight Frolic* of 1920, Dolores wore Lucile's "white peacock" costume, made from silk tulle and embroidered with silver and chenille thread and brilliants (pages 104–5). By means of gold rope cords attached to the edges of the train, Dolores raised her "tail feathers" so that they fanned out around her fragile frame. After shuffling them for their best arrangement, Dolores would set them aquiver in an act of erotic (and comedic) enticement. The dramatic display of the power and danger of female sexuality mimicked the peacock's elaborate courtship ritual.

The beauty of peacock feathers has assured the bird a mythical status with near-magical properties. To the Hindus the peacock is associated with the god of thunder, Hinra, who became a peacock to escape the demon Ravana. The peacock hails from India and Sri Lanka, where, in addition to having mythical and religious associations, it is a potent signifier of royalty, as manifested in the gold and bejeweled peacock throne made for the Emperor Shah Jahan in the early seventeenth century (later pilfered by the Persian conqueror Nader Shah when he captured Delhi in 1739, thereafter becoming a symbol of Persian monarchy). Lady Curzon, the wife of Lord Curzon who became Viceroy to India in 1899, referenced these royal associations in the famous peacock dress she wore to the State Ball of the Delhi Durbar of 1903, which proclaimed King Edward VII as Emperor of India (see page 107). Like her fellow-American First Lady Jacqueline Kennedy, Lady Curzon possessed an extraordinary skill for manipulating her image according to the specificities of the occasion. Designed by Jean-Philippe Worth, the dress was made from silk with silver embroidery in a peacock-feather design hand-stitched in India. The peacock "eyes" were highlighted with bright blue-and-green beetle wings (not emeralds as has been claimed). One observer exclaimed when she caught a glimpse of the stately Vicereine of India: "Such beauty is not given to one woman in a million." The dress, which inspired the peacock feather cape worn by Hedy Lamar and designed by Edith Head in Cecil B. DeMille's film *Samson and Delilah* (1949), had all the more impact because of the corseted, hourglass silhouette popular at the turn of the century. John Galliano used the silhouette to great effect in a peacock dress from his Christian Dior Haute Couture autumn/winter 1997–1998 collection, shown on pages 108–9. Appliquéd with a peacock design, the dress not only captures the bravura of the Belle Époque but also evokes the peacock's loftier associations with the Aesthetic, Art Nouveau, and Pre-Raphaelite movements, in which sinewy, arabesque forms echo the graceful lines of the peacock.

Pages 104–5: Lady Duff Gordon (Lucile), British (1863–1935). Showgirl costume, 1920. Courtesy of Culver Pictures

Page 107: Attributed to William Logsdail, English (1859–1944). *Lady Curzon*, oil on canvas, ca. 1902–3.

Courtesy of the National Trust Photographic Library/John Hammond

Pages 108–9: Christian Dior Haute Couture, French (founded 1947) by John Galliano, British (born Gibraltar, 1960). Dress, autumn/winter 1997–1998. Photograph: Peter Lindbergh

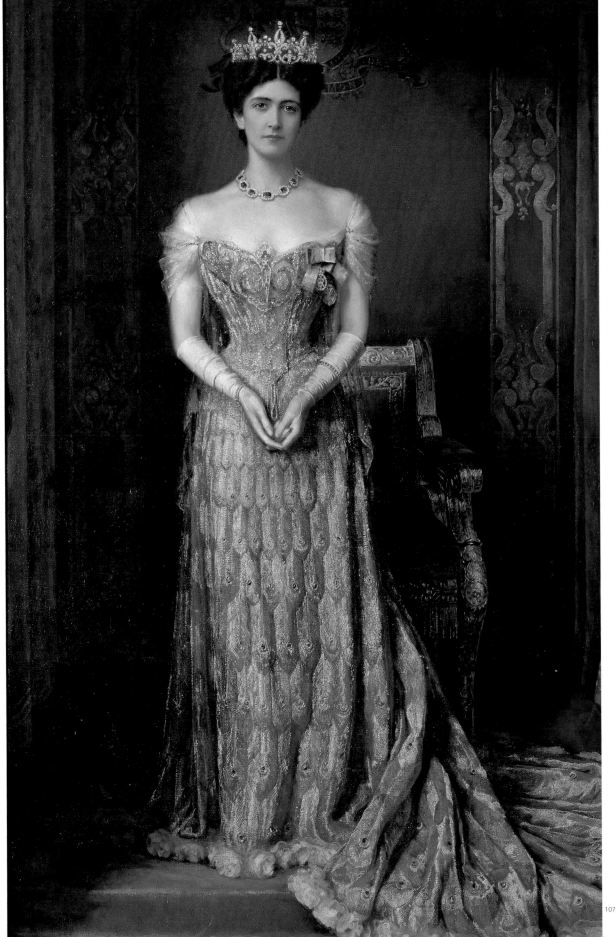

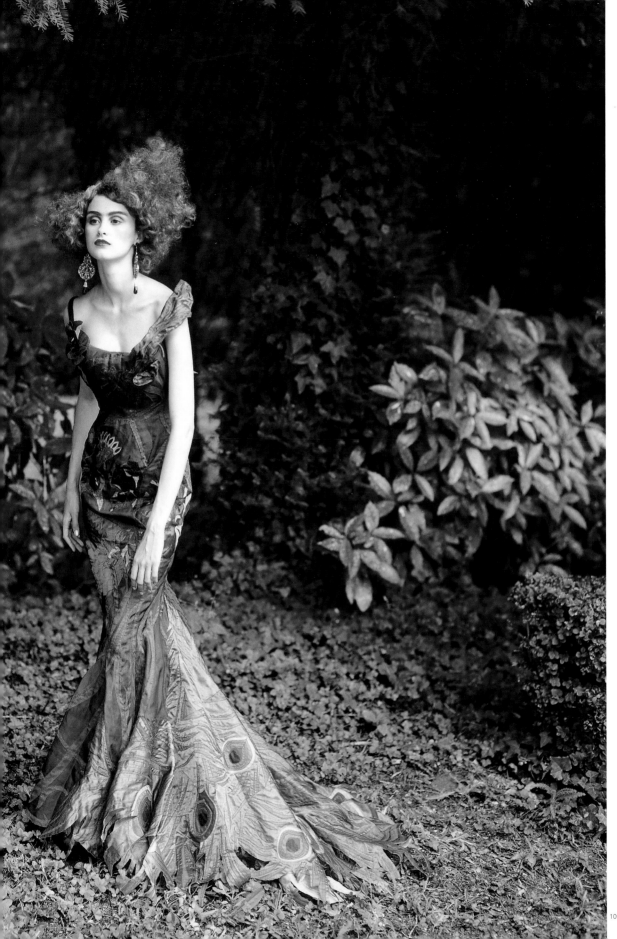

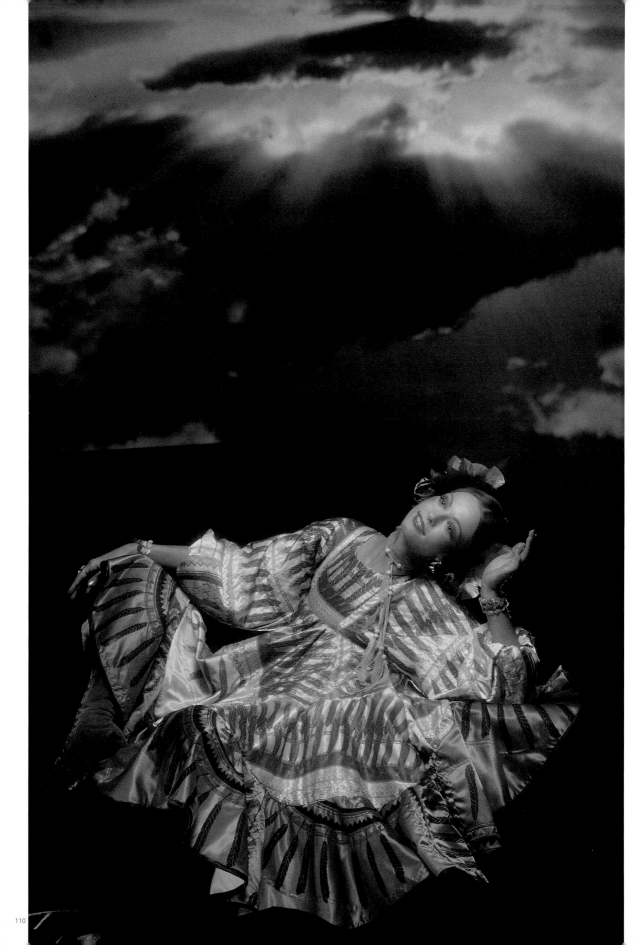

The peacock became a fitting emblem of the flamboyant and free-thinking 1960s, an era that coincidentally witnessed the revival of the Art Nouveau and Pre-Raphaelite styles. Its lustrous iridescence found a natural expression in the psychedelic fashions of the period, particularly those of such directional designers as Rudi Gernreich. In 1966 Gernreich presented a peacock-printed matte-jersey mini-dress with matching stockings and a peacock tail-feather headdress as part of his "total look" (see page 136). The bold graphic nature of peacock feathers, particularly their glinting, mesmeric "eyes," epitomized the self-assured, "look-at-me" fashions of the 1960s. Reflecting the confidence of their wearers, men's and women's apparel boasted a veritable menagerie of feathers, either real or in the form of prints, in exotic colors that pulsated with sexual energy. In 1970 Zandra Rhodes, who trained as a textile designer and whose fashions are both defined and propelled by the strength and singularity of her textiles, produced a range of gossamer silk chiffon tunic dresses in her famous "Indian Feather" print of stylized feathers based on Native American feather headdresses (see page 110). The design was inspired by a trip to the National Museum of the American Indian in New York City. Describing the print's visual impact, Rhodes asserted: "I wanted to give the impression in the print that the feathers were sewn or embroidered onto the fabric with cross-stitch." It was a progression from her earlier work in which she had attached real feathers to her dresses. Jonathan Saunders, the young British designer who created the extraordinary "bird of paradise" prints for Alexander McQueen's spring/summer 2003 collection exemplified on pages 112-13, works in the textile tradition of Rhodes and her contemporaries Bill Gibb, Ossie Clark, and Thea Porter. He specializes in second-skin dresses and bodysuits with sharp-angled geometric patterns that the journalist Sarah Mower has described as "a look that could only have been imagined by a child of the digital age." While a more painterly sensibility is reflected in Roberto Cavalli's equally vibrant prints, their infinite nuances are nevertheless derived from digital photography. "He likes to walk about outdoors with a digital camera in hand, capturing whatever captures his eye," explains the writer Javier Arroyuelo. Cavalli is drawn to patterns that are reiterated from one species to another, commenting: "I'm amused by the idea that God repeats himself." The printed feather pattern shown on page 114 is typical of Cavalli's "fully fashioned" technique, in which the design covers the article of clothing in its entirety. It is a technique that A. F. Vandevorst employed in a number of dresses from their spring/summer 2004 collection that were printed with a feather pattern. The Belgian husband-and-wife team Arickx Filip and An Vandevorst are known for their conceptual yet hyper-feminine clothes. The dress shown on page 115 reveals A. F. Vandevorst's trademark caped sleeves, a detail that transforms its wearer into a "bird of paradise." This metaphorical metamorphosis is underscored by the use of silk chiffon, which suggests the fragility and weightlessness of feathers. Chiffon's fluid, flimsy filminess animates both the dress and the body within, resulting in a dynamic synchronization that reflects the kinetic quality of real feathers.

Page 110: Zandra Rhodes, British (born 1940). Ensemble, 1970. Photograph: Clive Arrowsmith/*Vogue*. Copyright © Condé Nast Publications Inc.

Pages 112–13: Alexander McQueen, British (born 1969). Advertising campaign, spring/summer 2003. Photograph: Stephen Klein/CPi

Page 114: Roberto Cavalli, Italian (born 1940). Ensemble, autumn/winter 2001–2002. Courtesy of Roberto Cavalli. Photograph: Mario Testino

Page 115: A. F. Vandevorst, Belgian (founded 1997). Dress, spring/summer 2004. Photograph: Viviane Sassen

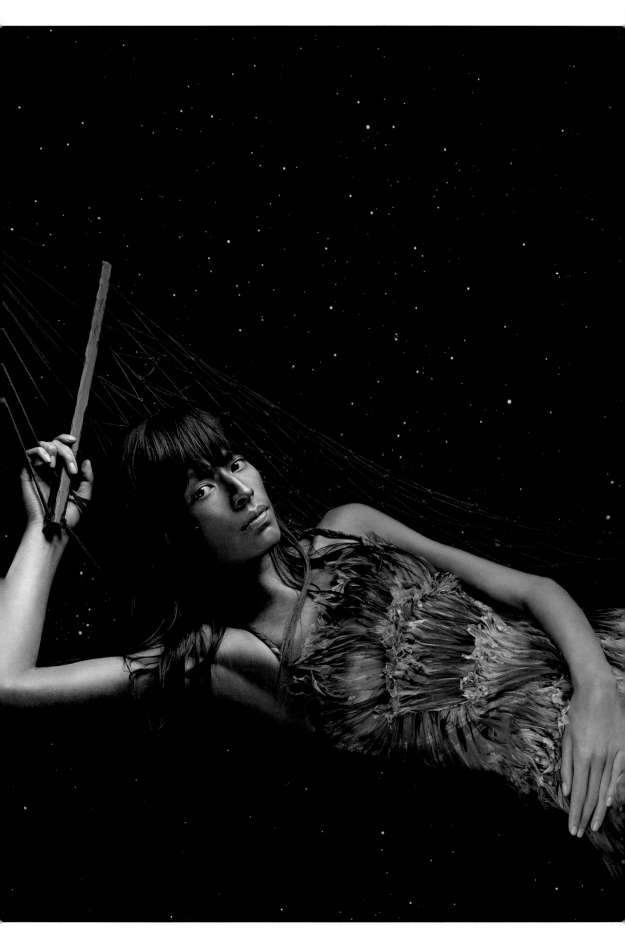

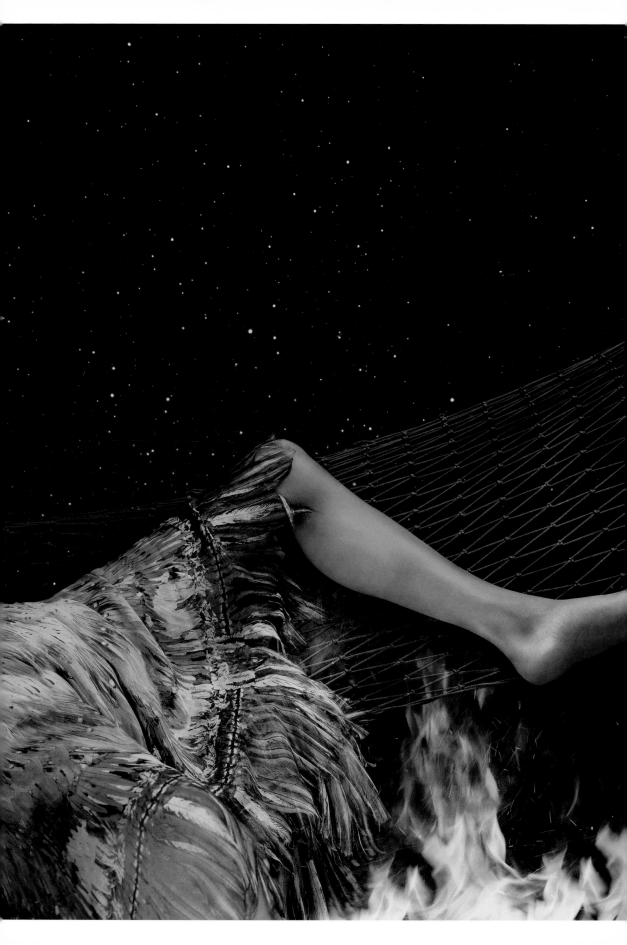

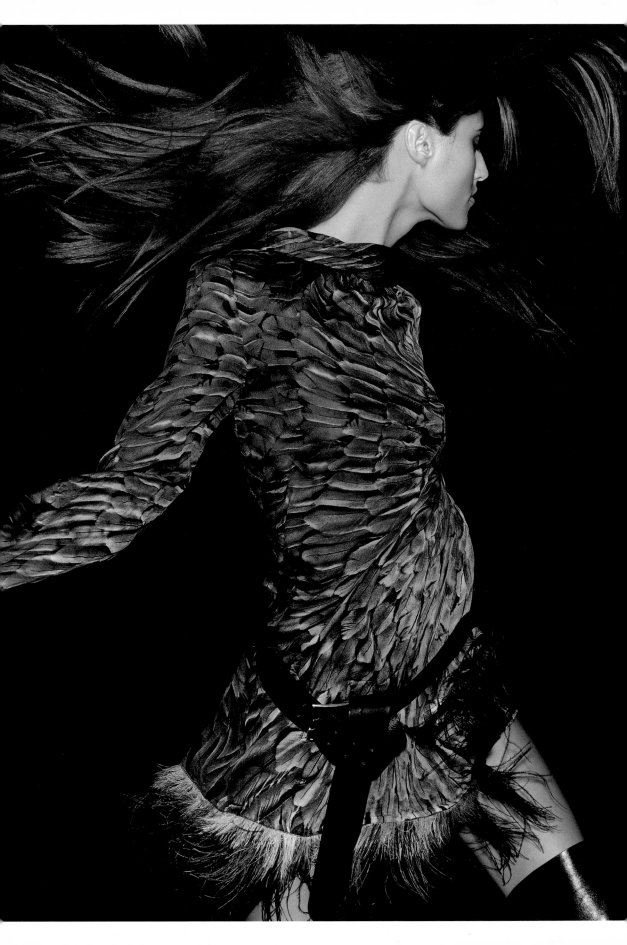

The spots
the woven
ostentatiou
the "divine
Many fem
association
which a div
instinct and
were increa
cat-woman
and their fe

With th
resulting m
signifier for
(1993), docu
metaphor,
professional
western soc
perceived fa
referenced
terminology
woman to h
50s but was
freedoms of
woman and

Feline s
interest in a
independen
feminist idea
attributes as
pacifistic rep
Gabbana, Az
abstracted r
newfound er
clothe its clie
invoking the
beauty for th

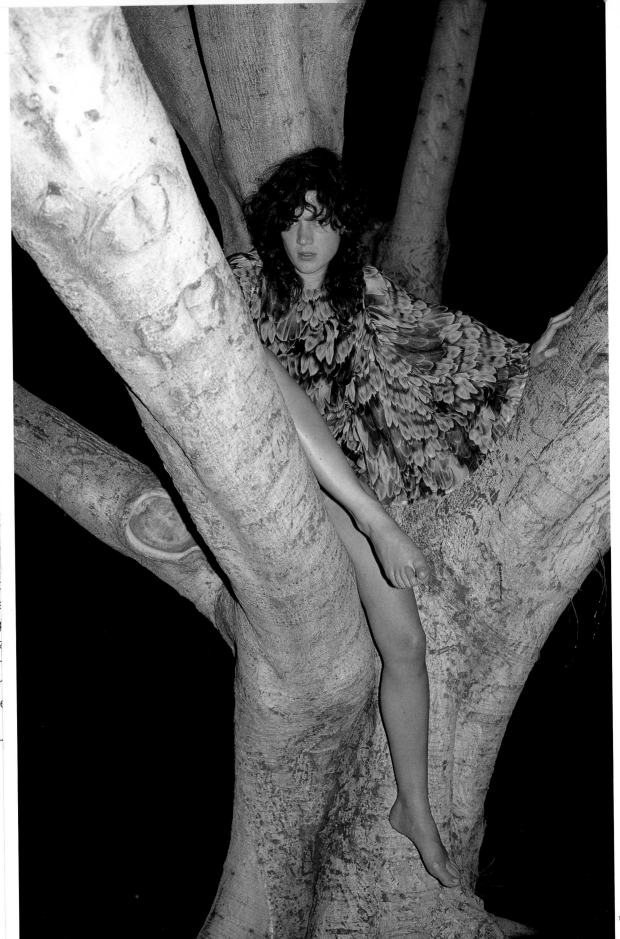

111

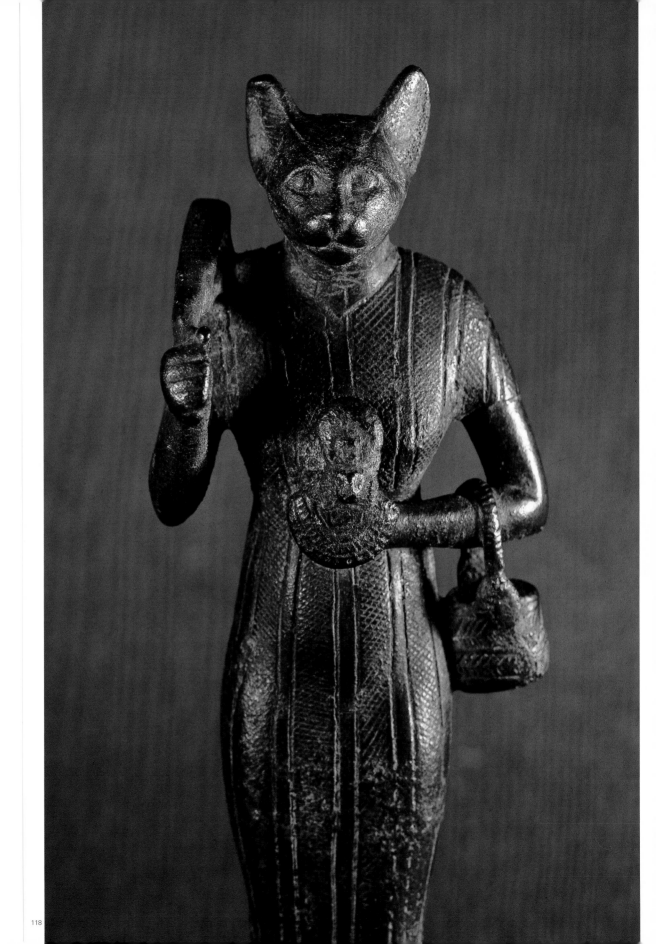

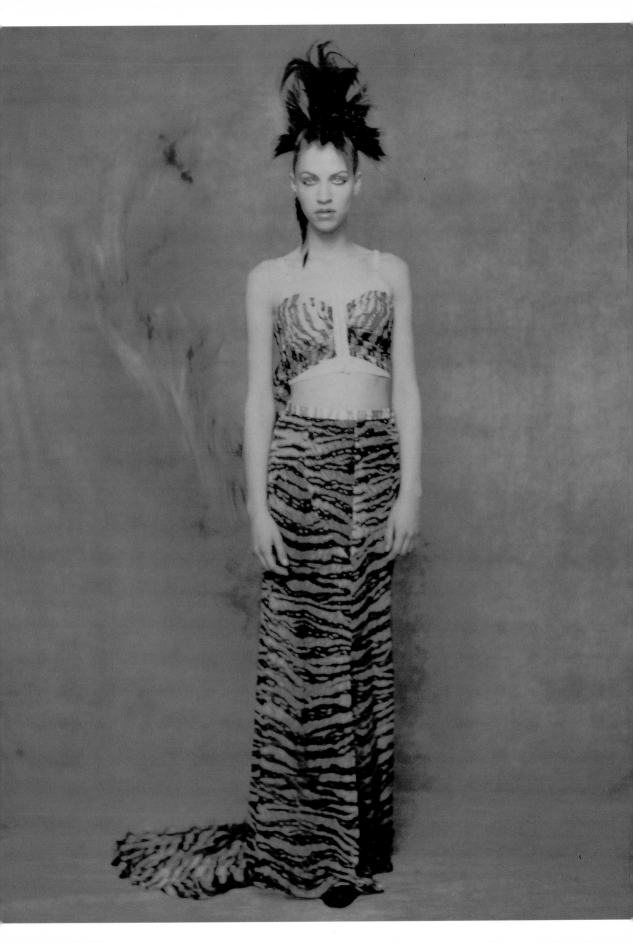

The imagery of the tigress in contemporary fashion can be traced to ancient Egyptian works of art such as the bronze statuette of the Egyptian goddess Bastet shown on page 118 in her common form with the head of a cat. Bastet emerged in the Old Kingdom period (3rd millennium B.C.) but was most revered in the Egyptian pantheon nearly two millennia later. In this sculpture Bastet wears a clinging striped robe that might suggest the markings of the cat, her sacred animal and special attribute. This benevolent protectress of home, mothers, and children was the chief deity of the ancient city of Bubastis, and mummified cats were buried within her temple precincts in rituals carried out in her honor. For the Egyptians, Bastet and the goddess Sakhmet were two aspects of divine power. Sakhmet, the lioness whose name means "the powerful one," represented dangerous, potentially destructive forces—war, violent storms, and pestilence. The Egyptians associated the lioness with several goddesses who had violent sides to their natures, perhaps because she is such a renowned hunter.

Contemporary designers have employed the iconography of the cat to invest the modern woman with attributes that hark back to such ancient goddesses. Domenico Dolce and Stefano Gabbana are recognized for their celebration of the wilder manifestations of modern women through the use of animal prints. In their words: "Without animal prints there could be no divas, or even divinities." The regal woman portrayed in the Dolce & Gabanna editorial on page 119 evokes the ethereal beauty of an exotic felid goddess. While ancient Egyptian portrayals fused the head of a cat with the shapely form of a woman, this image invests the female form with feline essence. The piercing eyes of the nocturnal cat and the mane of disheveled black hair manifest a feral nature. With her hieratic pose and train trailing behind her like a tail, Dolce & Gabbana's tigress exudes both the alluring and the intimidating hauteur of the cat goddess. Her bandeau and sheath skirt recall the construction of the cloak in the slab stela shown on page 120 of Nefret-iabet, a Fourth Dynasty princess. Nefret-iabet wears a leopard cloak over the usual female sheath dress with straps. The actual cloak could have been made of real leopard skins, of linen with the dots painted on the fabric, or of wool with woven decoration. It is thought that all these versions occurred, and it can only be said for sure that it is not skin when there is a fringe (which is sometimes depicted). Neither Dolce & Gabbana's contemporary fashion tigress nor the ancient Nefret-iabet are represented in a literal feline form, yet both effectively communicate the persona of the cat woman. Proudly displaying the majestic spots of the wild cat, their wrapped garments are in themselves convincing signifiers.

Page 118: Egyptian (Late Period). Statuette of the goddess Bastet holding a basket and a sistrum, bronze, ca. 664–332 B.C. Courtesy of Réunion des Musées Nationaux/Art Resource, NY

Page 119: Dolce & Gabbana, Italian (founded 1982). Ensemble, autumn/winter 1996–1997. Photograph: Jeffrey Licata

Page 121: Egyptian (Old Kingdom). Slab Stela of Princess Nefret-iabet (detail), painted limestone, Fourth Dynasty (reign of Khufu), ca. 2551–2528 B.C. Courtesy of Réunion des Musées Nationaux/Art Resource, NY

The patterns of the varied spotted panthers, or leopards, are the most often cited of the world's big cats in Western fashion. Leopard prints became especially popular in eighteenth-century France, where they were used as trimmings and accessories on modish styles. Napoleon's archaeological discoveries in Rome, Greece, and Egypt inspired an interest in all things ancient and classical and spurred a popularity in the use of animal prints in textiles. In addition, the increasing contact with other cultures through scientific exploration and imperialist encroachments in distant places, including the Far East and Africa, fueled an interest in the natural world. These expeditions fostered the popularity for the decorative patterning of the cat, which in the print shown on page 122, is echoed in the leopard-patterned trim of a flirtatious beauty's petticoat hem and the interior facings of her overskirt. The abandon of her hair, the froth of her stomacher and *matinée*, and the peek-a-boo revelation of the leopard pattern expose her licentious nature and erotic intention. The sexual innuendo conveyed by the feline symbolism is reinforced as she climbs onto her master's lap for a "pet" and her suitor avidly strokes her hank of hair as one might the tail of a cat.

The roots of feminism, including the loosening of sexual mores, were planted in revolutionary France, and it may be that an increased use of leopard-spotted textiles occur in conjunction with periods that witness a destabilizing shift in the roles of women. The penchant for classic motifs, including the leopard spots characteristic of the end of the eighteenth century, were expressed more flamboyantly during the Empire period and recurred periodically in clothing and upholstery textiles until the fin de siècle. Produced during the period of first wave feminism, the 1901 fashion plate shown on page 124 depicts a woman whose corseted pouter-pigeon shape is sartorially overlaid with the markings of the spotted cat. Her S-curve posture could not be more different from the Grecian ideals of beauty alluded to by her gown's band trim of Greek key meanders. Her sinuous lines, however, are an effective evocation of the undulating grace of the big cats whose spots have been appropriated. Philosophies of feminism have habitually shifted between denying and embracing the animal within as symbolic of woman's psychosexual association with the natural world. This print therefore communicates a veiled sexuality, despite the artifice of the fashion of the day and the static rendering of pattern and form. In its conflation of the classical and the exotic, the gown evokes the pelt-swagged Greco-Roman goddess of the hunt, Artemis.

Christian Dior, together with some of his mid-century peers like Norman Norell and Pierre Balmain, is among the first twentieth-century designers to use leopard print extensively in his work. In 1947, he created the "Africaine" dress seen on page 125 out of silk chiffon, referencing the neoclassical Empire look of the early nineteenth century. The body-cleaving drape of yards of exotically patterned chiffon conveys the luxury and glamour of the designer's influential postwar "New Look." The dress recalls the opulence and decadence of the classical dress of Imperial Rome as seen through the theatrical filter of Napoleon's Empire France. Both Dior's "Africaine" dress and the pouter-pigeon gown communicate the twentieth-century aesthetic of the leopardess as a graphic manifestation of feminine erotic allure.

Page 122: Louis Bosse, French (active ca. 1770–1790). *La Matinée (L'heureuse Union)*, etching, after 1789.

The Metropolitan Museum of Art, Department of Drawings and Prints, Harris Brisbane Dick Fund, 1933 (33.6.37)

Page 124: Fashion Plate, graphite on paper, 1901. The Metropolitan Museum of Art, The Irene Lewisohn Costume Reference Library

Page 125: Christian Dior, French (1905–1957). Dress, spring/summer 1947. The Metropolitan Museum of Art, The Irene Lewisohn Costume Reference Library

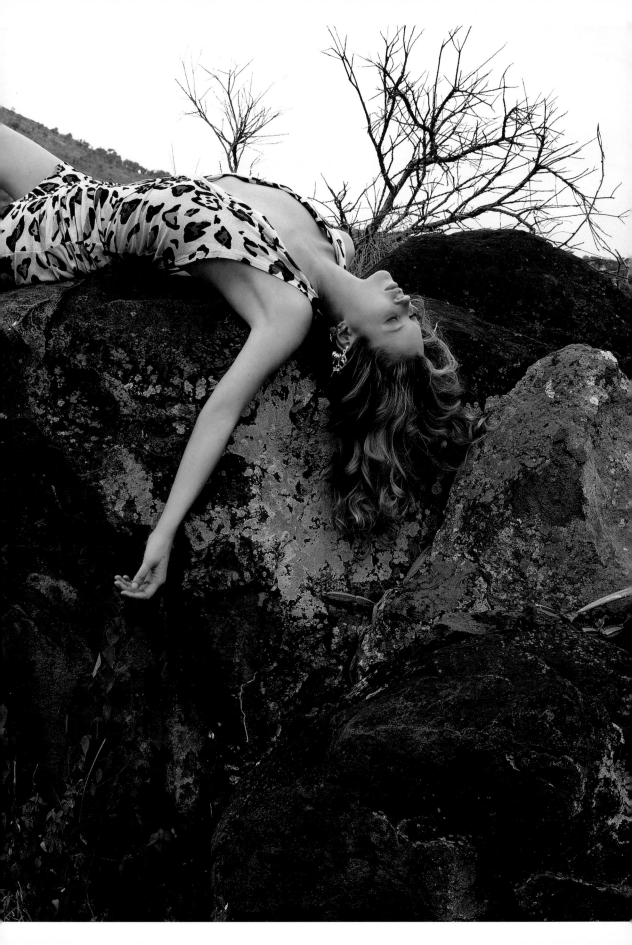

Attributions of animalistic traits to women were especially prevalent in fin de siécle art, encouraged by the period fascination with Aestheticism and Orientalism. Additionally, scientific and geographic exploration precipitated an interest in the philosophical inquiry into the natural state of man and his place in the animal kingdom. Bram Djikstra described a curious anomaly of male and female anthropomorphic visual expression: "The animal remnant in man was to be represented graphically. As it almost always did in turn-of-the-century art, mythology offered the visual means. It was clear that such half-bestial creatures as satyrs and centaurs were the perfect symbolic designation for those males who had not participated in the great evolutionary spiral, who had been content to be coddled in the bosom of effeminate sensuality. Since women, being female, were . . . already directly representative of degeneration, there was no need to find a symbolic form to represent their bestial nature; their normal and preferably naked, physical presence was enough." Such images abounded at the turn of the century and coincided with the increased visibility of feminist ideology. Arthur Wardle, a British painter of the time who specialized in animals, drew from classical feminine-feline mythology dating back to the Egyptian Bastet and the Greek Artemis. Bastet was celebrated in an annual festival that included the drinking of wine and partaking in ritual sacrifices. Historically, that practice has been related to the Maenads or Bacchantes, followers of Bacchus, the Greco-Roman god of wine and the fertility of nature. Wardle's painting seen on pages 126–27 is indicative of the infamous unbridled frenzy of these women, who in their state of wine-induced reverie could turn to murderous savagery. The Bacchantes are almost always pictured frolicking with animals or wearing their skins, and the panther has long been associated with them. In the breast-exposing chiton of his Bacchante, Wardle also introduced an allusion to another diety of nature, Artemis (Diana) as well as her loyal worshippers, the legendary Amazons, all of whom are iconographically associated with the leopard.

The Missoni Spring 2004 collection was inspired by the company's avant-garde innovations of the 1970s, when Tai and Rosita Missoni revolutionized knitwear with their new combinations of color and pattern. Recently, Angela Missoni, playing on her parents' signature palette and patchwork montages, created abstracted, playful animal prints in body conscious silhouettes. In the editorial shown on pages 128–29, a feral Kate Moss wears a halter cotton jersey dress that sheaths her like a loose skin as she basks in the sunny savannah like a lone leopardess sated after a hunt. Separated from her pride, she is exposed but unconcerned, as she has no higher predator to fear. In this environment, the camouflage of the spotted cat is especially vivid. The differences in coloration and patterning in wild cats, who are otherwise nearly identical genetically, result from natural adaptation to their environment. The characteristic known as concealing coloration is crucial to both the survival of the hunted and the efficacy of the hunter. Whereas Wardle's Bacchante can be seen as an enchantress surrounded by "amorous beasts," with a subtext of animalistic desire, Missoni's goddess of nature is no longer inhibited by fin-de-siècle insinuations of degenerate animality. She is an empowered cat woman proudly ruling the urban jungle.

Pages 126–27: Arthur Wardle, British (1864–1949). *A Bacchante*, oil on canvas, 1909. Courtesy of Sotheby's with permission from the Bridgeman Art Library

Pages 128–29: Missoni, Italian (founded 1953). Dress, spring/summer 2004. Photograph: Mario Sorrenti

The 1950s saw animal prints emerge on a popular level as a cultural signifier for the Hollywood screen siren. Addressing the link between the starlet and the leopard, film historian and critic Richard Schickel explained: "There is something playful in the sinuosity of the exotic and enigmatic leopard—if not sinfully, then at least suggestively so . . . one imagines the possibilities of gently clawing entanglement . . . or the thought occurs that in the right hands she could become what any properly domesticated cat becomes—a bit of prettily purring plush, a pussy galor(ious)." In the 1952 publicity still for MGM Studios shown on pages 132–33, Ava Gardner strikes the seductive pose of the period pinup girl. Her voluptuous figure is accentuated by her leopard-printed swimsuit, and in a detail that suggests that her attire is intended not for the beach but for other more intimate precincts, she covers her legs with fishnet stockings, a style associated with the vamp, the stripper, and the woman for hire. Her one-piece maillot, although tame by contemporary standards, epitomizes an early-fifties idea of explicitly erotic allure. The suit merges visually with the matching leopard-print background around her, emphasizing her bare skin. The embodiment of animal magnetism, she is accessorized with primitivistic jewelry—fang-like fragments of bone, trophies taken from her prey. The conventions of her pose emphasize the profile of her breasts, the slimness of her waist, and the contours of her legs, but even presented as sex symbol, Gardner is not simply the passive object of the male gaze. By placing her in the upholstered environment that camouflages her, she is positioned not as caged wild cat or domesticated kitten but rather as the wily predator in her own lair.

In 1991, Azzedine Alaïa sent his nouvelles amazones down the runway dressed in exotic second-skins of figure-hugging leopard-patterned stretch knits and spotted body-stockings woven with new synthetics. He is responsible for reinventing the provocative feline sexuality of the 1950s pinup as a post-feminist Amazon. This heroic femininity and unabashed sexuality is visible in the Thierry Mugler editorial on pages 134–35. Eva Herzigova adopts a posture that mimes a jungle cat's stalk. She crawls on all fours in Mugler's spotted bodysuit, which like Alaïa's precedent is fitted as tightly as a second skin. Mugler's stretch ensemble recalls the appeal of the mid-century pinup, but unlike the carefully composed shape of the 1950s that enhanced the body through structural artifice, it exposes its natural contours. The inviting backward-leaning tilt of the movie actress has given way to the aggressively predatory prowl of the slinking supermodel, who is rendered both intimidating and unabashedly attractive.

Pages 132–33: Ava Gardner, photograph, 1952. Courtesy of MGM/The Kobal Collection. Photograph: Virgil Apger

Pages 134–35: Thierry Mugler, French (born 1938). Ensemble, spring/summer 1995. First published in *Elle*

(French Edition) 1995. Model: Eva Herzigova. Photograph: Jean-Marie Perier

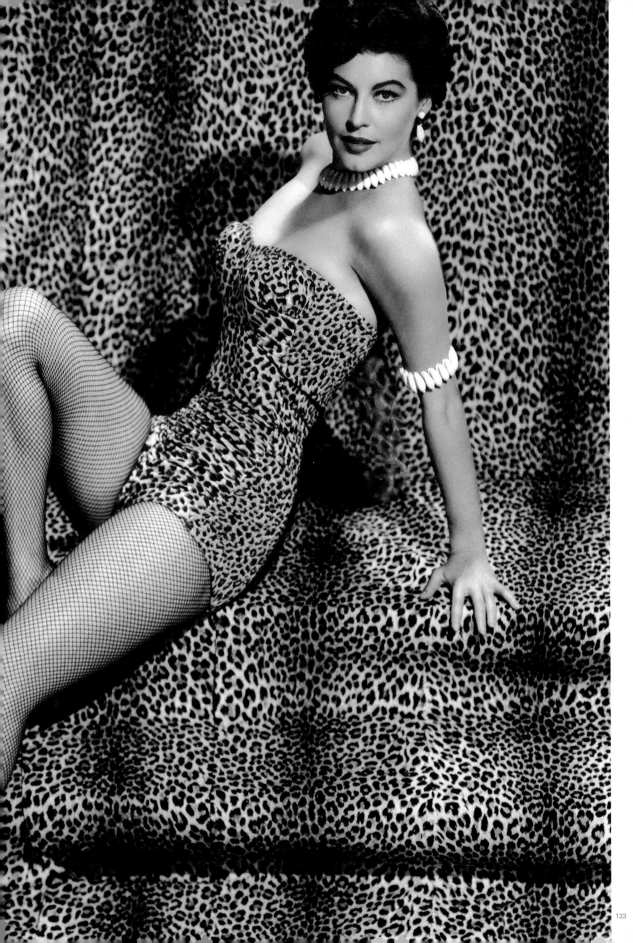

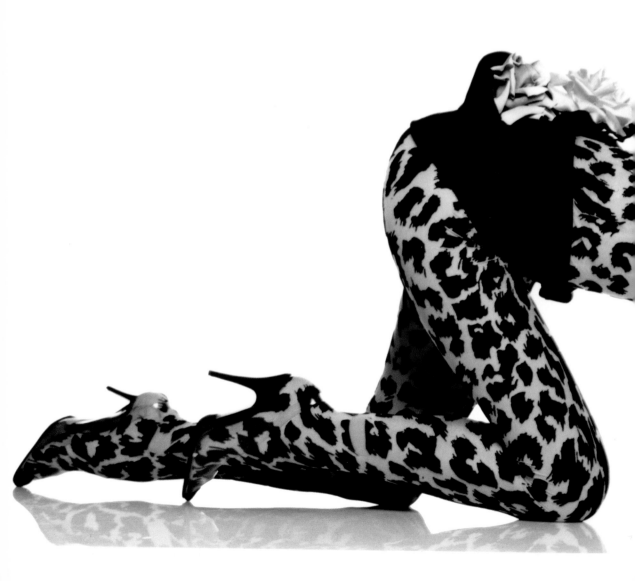

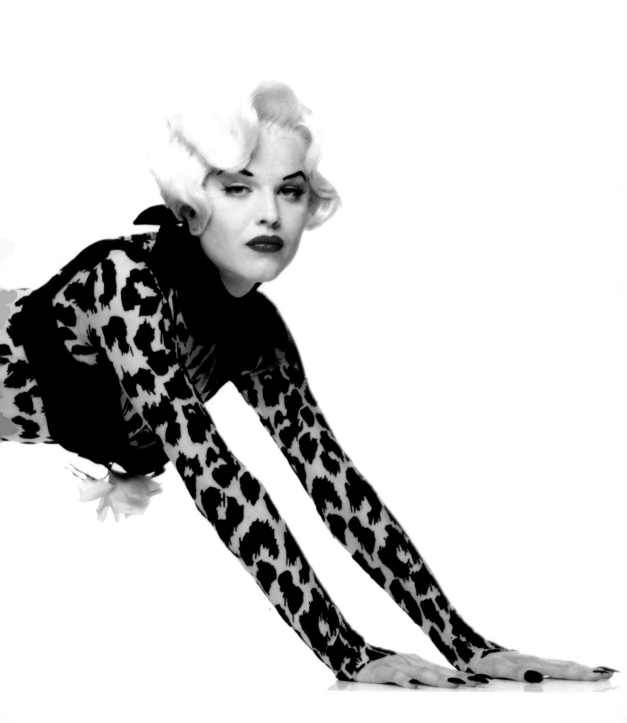

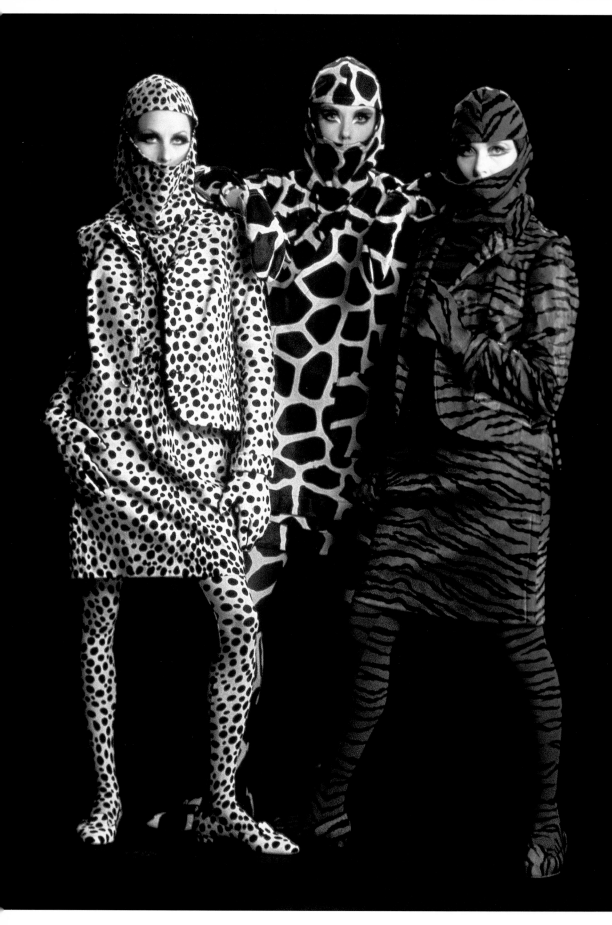

Rudi Gernreich, with Gabrielle "Coco" Chanel, has often been cited as one of the two most influential designers of the twentieth-century. In the mid-sixties, Gernreich began to explore the idea of clothes as a second skin, at one point marketing the novel idea of adhesive ornaments in every conceivable shape, which were to be pasted all over the bodies of those who wore his scanty bikinis. The results were similar in effect to body painting or tattooing and were suggestive of animal markings. Gernreich also experimented with bold graphics in contrasting colors, now considered a hallmark of sixties Mod fashion, in the form of animal prints. In 1965 John Fairchild called him a "fashionable savage." With his evocative animal citations and avant-garde skin ornamentation, Gernreich effectively blurred the line between the human and animal and introduced to his utopian vision of design a peaceable kingdom where man is no longer estranged from the beast. Gernreich had a modern, even futuristic, sensibility. He was often seen as an anti-fashion advocate, not simply as a fashion maverick. In 1966, he produced a video called "Basic Black," a first use of the medium for fashion. With all the wit and irony he had come to be known for, Gernreich featured a veritable zoo, including the three animal-patterned ensembles seen on page 136. Anything but basic, these head-to-toe designs exploded in pop-arty camouflage-cheetah, giraffe, and tiger prints—representing opposite ends of the jungle's food chain coexisting in a Edenic harmony. Along with his well-known peacock ensemble, these creations were part of a "total look" concept, designed by coordinating each animal pattern to emphasize the sense of a complete second-skin transformation. From jacket to dress, hood, tights, and shoes, every component, even the bra and underwear beneath, matched. The caption to the advertisement for these declared that Gernreich "has not been tamed by the success of his wild innovations. . . . He wants women to look like jungle beasts." The appealing animalism of his vivid creations took the fashion world by storm and provided the progressive 1960s woman with a new uniform for the cultural revolution, with its evolving identities for the increasingly sexually liberated woman.

Page 136: Rudi Gernreich, American (born Austria, 1922–1985). Ensembles, 1966. Courtesy of Demont Photo.

Photograph: William Claxton

Pl. 312

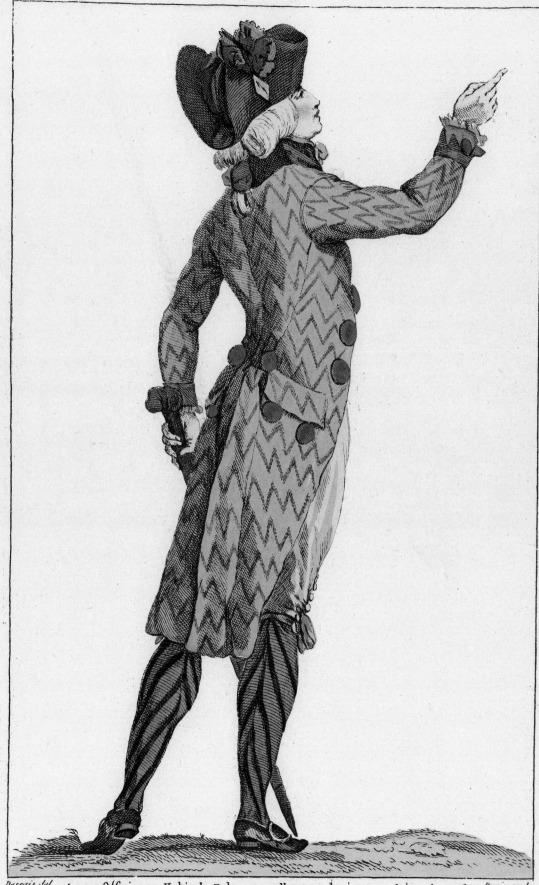

Desrais del.

Dupin sculp.

Jeune Officier en Habit de Zebre, appellant quelqu'un pour lui rendre raison de ses services.

The "total look" of the 1960s was not the first instance of allover animal-patterned ensembles. A 1787 zebra-print suit, championed as the "aristocratic stripe," was described in 1788 by L.S. Mercier, in *The Waiting City: Paris, 1782–1788:* "Coats and waistcoats imitate the handsome creature's markings as closely as they can. Men of all ages have gone into stripes from head to foot, even to their stockings." Prior to this late eighteenth-century fad, geometric stripes in clothes appeared on the uniforms of convicts and on working-class men's vests and waistcoats, signifying a pedestrian patterning appropriate to the socially peripheral. In the last two decades preceeding the French Revolution, at the height of the Enlightenment, the stripe also entered the sartorial vocabulary of the elegantly dressed, through the taste for the neoclassical. The irregular, naturalized striping that alluded to animal skins, however, added an exotic flourish on the more rational linearity popularly embraced. In strict Platonic geometry and in wilder savage style, stripes in menswear were experiencing a last breath of flamboyance before the uniform adoption of the dreary dark suit of the nineteenth-century man.

The trend toward the *habits de zèbra* was inspired by a period fascination with nature's beasts and was heightened by Louis XIV's acquisition of a zebra as the newest addition to his exotic and growing bestiary. The fashion plate shown on page 138 portrays the zebra suit's organic stripes as they were often represented, as chevrons or even simple lines, abstract interpretations of the eccentric Equus graphic pattern. This is a universal recurrence in the history of prints, as leopard, zebra, tiger, and giraffe are often interpreted in textiles in their most reductive form. The taste for stripes was especially embraced by the dandies of the late eighteenth century, the English macaronies and the French *élégants* who wore narrowly cut coats with vertical patternings to accentuate their lean figures. Because any bold pattern, especially stripes, stands out against a plain background, an attention-seeker clad in the bold beauty and symmetrical harmoniousness of the zebra stripe was sure to find his audience. Unlike his feminine counterpart, this exquisite prerevolutionary dandy embraced the patterning of the gentle herbivore rather than the carnivorous cat. The aesthetic and emotive differences between the two emerge from the very composition of nature's divergent disguises; while the spots of the cat, confusing and camouflaging, are intended to elude the defenses of their prey, the striking stripes of the zebra identify the animal's fellow herd members and warn them to take flight if necessary. Whether the patterning of the predator or the prey, allusions to animals are fraught with all the prejudices and cultural constructions associated with gender and sexuality.

Page 138: *Jeune Officier en Habit de Zébra*, watercolor on paper, 1787. The Metropolitan Museum of Art,

The Irene Lewisohn Costume Reference Library

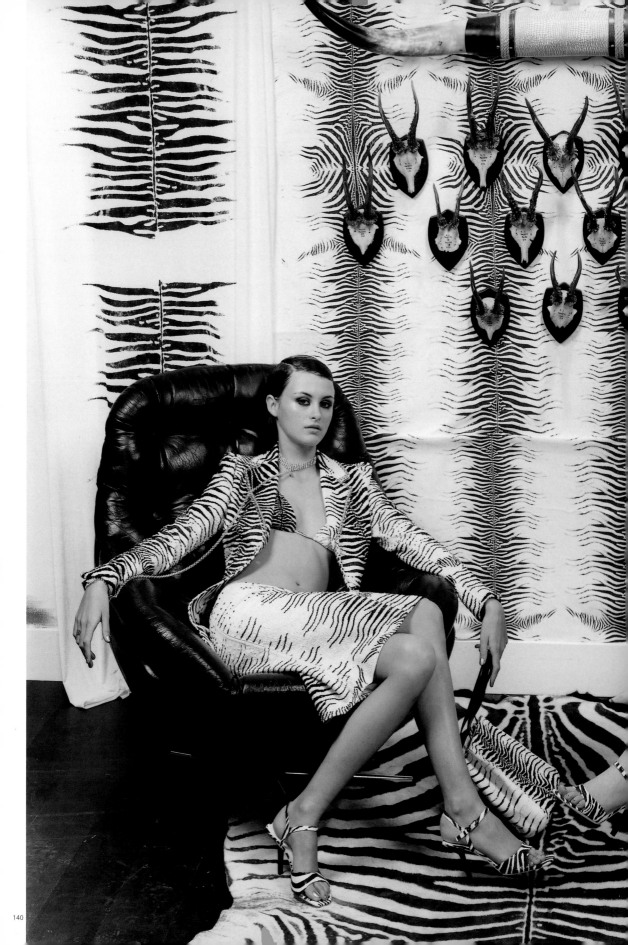

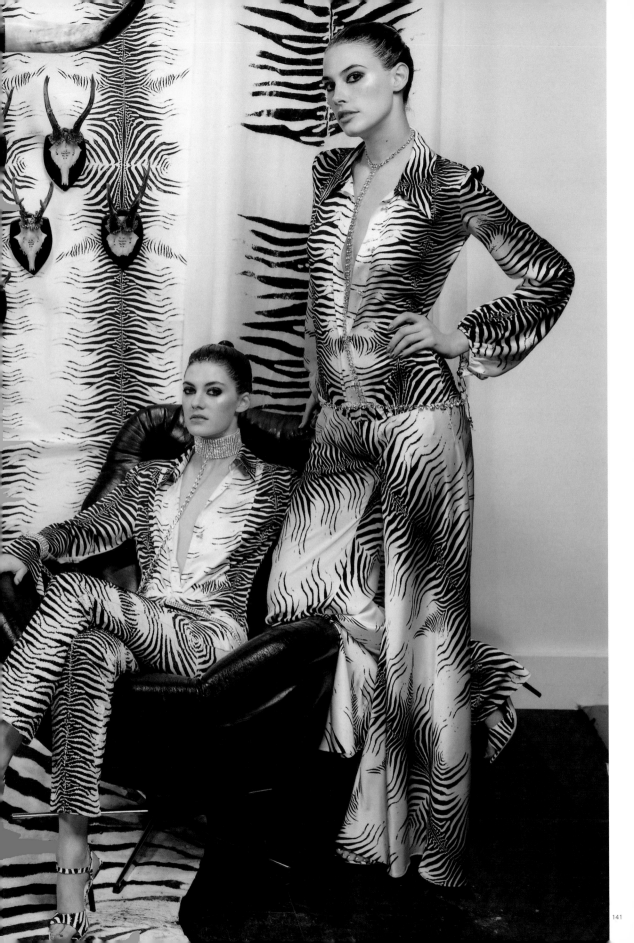

Roberto Cavalli has celebrated the wild beauty of the jungle like no other designer, continually revisiting and renewing our enchantment with the flamboyant patterning of the animal kingdom. His spring/summer 2000 collection included a true twenty-first century head-to-toe *habit de zèbra* for the latter-day dandy as well as the contemporary woman. Cavalli's signature animal prints all begin with a hand-painted design on silk that only later is adapted for textile production. In the examples seen in the editorial on pages 140–41, the designer took the contrastive black and white zebra-pattern and shrunk its scale. The effect of the final designs, especially as seen against a backdrop of similar but differently scaled prints, is a filibrating visual agitation worthy of Op artist Brigit Riley. Cavalli's zebra-women, with studded collars at their necks and leashed with gold chains that encompass the waist, suggest the barely controlled wild animal. Everything in the room is a trophy, from the mounted antlers and horns on the wall to the full zebra skin rug on the floor and the glamorously restrained beauties. Like the image of Ava Gardner as a leopardess in her lair, these women reiterate the patterning of their environment, but the trappings of bondage, no matter how glittering, introduce the darker narratives of sadomasochism to imagery already heavily laden with the complex, perhaps problematic, implications of sexist fantasy. Paradoxically, within the overtly eroticized designs with their décolleté necklines, clinging jersey, and bra top, Cavalli presented a near anthology of the more liberating women's garments of the twentieth century: the blazer suit, the pant suit, and the jumpsuit.

Bill Blass's 1966 advertising campaign, exemplified on page 143, is a document predating the shift from the hedonistic male-dominated imagery of the early years of sexual liberation and the increasing feminist critique rallied against sexually exploitative depictions. The featured model is the extraordinary Baroness von Lehrdorff, known by one name, Verushka, and seen in her heyday on the cover of *Life* Magazine. Verushka and such other distinctive beauties as Jean Shrimpton and Twiggy were creative pioneers in a changing fashion environment in which the model might be both muse and collaborator, not just a puppet to be manipulated. In this arresting campaign, Verushka, dressed in zebra and tied to the front of a vintage Rolls Royce, plays the role of "bagged" game. The caption reads: "Don't Wear Bill Blass During the Hunting Season," suggesting that the eye-catching allure of the design risks attracting the dangerous attention of the hunter. The tongue-in-cheek advertisement underscores the patriarchal authority of capitalism by positioning the sports jacketed, Rolls Royce driving, supermodel snagging establishment male against a skyline of church and state, in which a particularly phallic skyscraper is clearly asserting itself. With her zebra-striped ensemble, accomplished through a lavish and exquisite application of sequins, Verushka is an especially exotic prize. During this period of political, cultural, and social agitation, iconoclasm and rebellion ruled, making the portrayal of women as quarry to be hunted and captured seem archaic. Still, the appeal of women in the guise of the vividly patterned animals persists, even after decades of feminist theory and critique. The decorative skins of exotic creatures have the ability to free women to express a more assertive, even predatory, sexuality. Through the transformative power of the totemic beasts of the wild, women once limited to the passive role of the hunted can now project the power to attack of the huntress without any diminishment of allure.

Pages 140–41: Roberto Cavalli, Italian (born 1940). Ensembles, spring/summer 2000. Photograph: Lee Jenkins

Page 143: Bill Blass, American (1922–2002). Ensemble, 1966. The Metropolitan Museum of Art, The Irene Lewisohn Costume Reference Library, with permission from Bill Blass

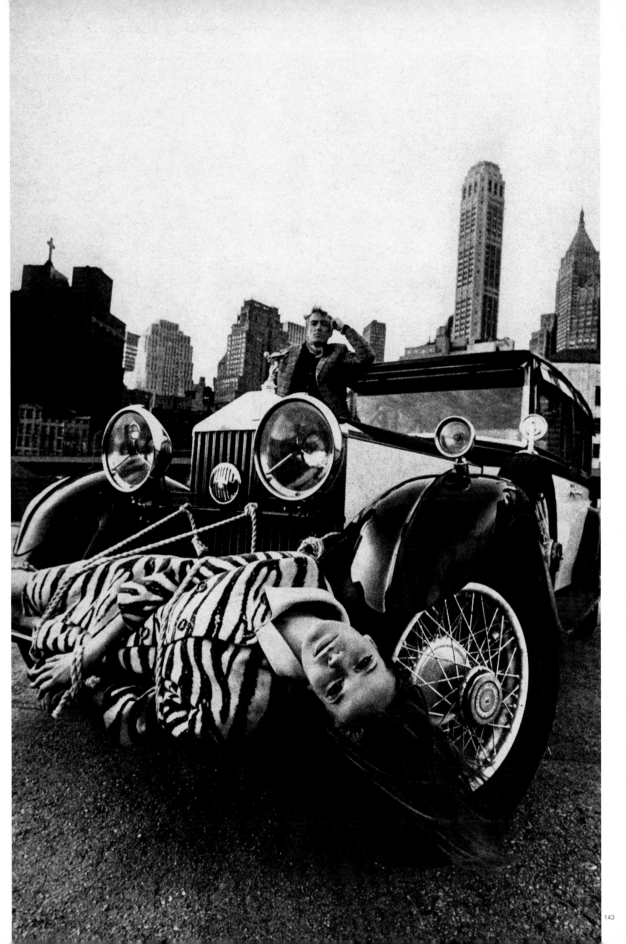

MAN-EATER

In the nineteenth century, art, fashion and literature connected femininity to the more insidious predators of the animal kingdom. As is typical of periods that witness significant growth in women's sociopolitical advancement, fashion alluded to notions of the seductress or dominant matriarch as represented in ancient history. Such metaphors for the empowered woman served to inspire the cultural identification of an archetypal femme fatale. Victorian art and literature referenced the Biblical portrayal of the serpentine woman as fatal temptress and reinvented the fearsome she-creatures of Medusa and Siren of Greco-Roman mythology. From Pre-Raphaelites to fin-de-siécle *Décadents*, nineteenth-century aesthetes promoted narratives that championed a conceptual fusion of woman and beast.

Concurrently, the frequency of and attention to female sexual crimes such as abortion, infanticide, and poisoning increased in both Europe and America, fostering a more potent societal fear of women, specifically of their so-called "passionate" instincts. In *Female Criminality in Fin-de-Siècle Paris* (1996) Anne-Louise Shapiro described the late nineteenth-century female sexual criminal as "perverse," "hidden," "cunning or invisible," inherently "duplicitous" in moving between ostensible helplessness and aggressive predation. The animal's armaments that she employed to physically lure her prey became the emblems of this persisting *criminelle*. The webbed spider dance hall dresses of the late 1910s and early 1920s reincarnated *les grandes empoisoneuses*, Victorian-era killers who used small doses of arsenic as weapons in revenging the indifference of uncaring and faithless husbands. The frightening persona of the "black widow," while identifying a specific form of murderess, in fact cast a far larger shadow on any woman whose reputation was unprotected by the conventional precincts of marriage and motherhood. The barren wife and the spinster by their mere existence could in certain instances be seen as a repudiation of Victorian marital and familial expectations. Her vilification was expressed in the popular nineteenth-century fables of the Brothers Grimm, whose portrayal of the female antagonist was often a fusion of spidery spinster and evil witch.

By mid-twentieth century, animal-skin camouflage and leather had become popular in high fashion and clothed the empowered, unattainable man-eater. The tight-laced corseted silhouette of the nineteenth century, which insinuated physical domination and sexual control, resurfaced in Christian Dior's wasp-waisted "New Look" collection of 1947. Taut or pinched leather fashions that employed Dior's corseted shape emerged from fetishist subculture, which had developed in a marginal sexual underground through black leather boot and corset photography in the 1930s and confronted more general audiences through representations of the filmic noir fatale in the 1940s. They were eventually further popularized to a rather circumscribed cult following by John Willie's Bizarre publications in the early 1950s.

The adoption of leather and its synthetic surrogate fabrics in womenswear has coincided with the transformation of feminine identity over the last half-century. Impeccably tailored into second skins, apparel in black leather has negated prior notions of women as the weaker sex by projecting an image of physical dominance and sexual predation. Cloaked in lavish sheaths and pelts that display a material success on par with her male counterpart, thereby threatening traditional economic gender designations, the leather-clad woman has become a paradigm of sexual and social intimidation. Transforming the once all-purpose "little black dress" with the accompaniments of the black leather fetishist and branding garments with avian, reptilian, and entomological iconography, contemporary fashion is championing the aesthetics of the man-eater.

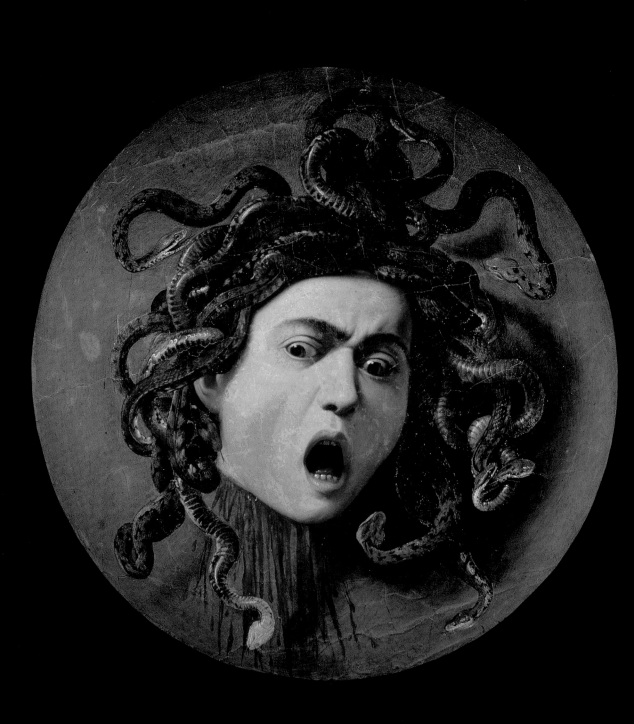

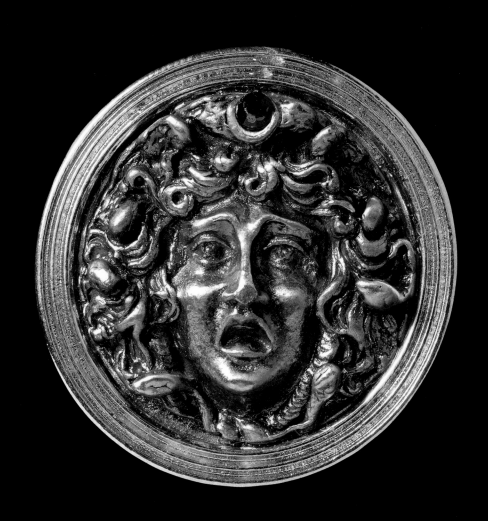

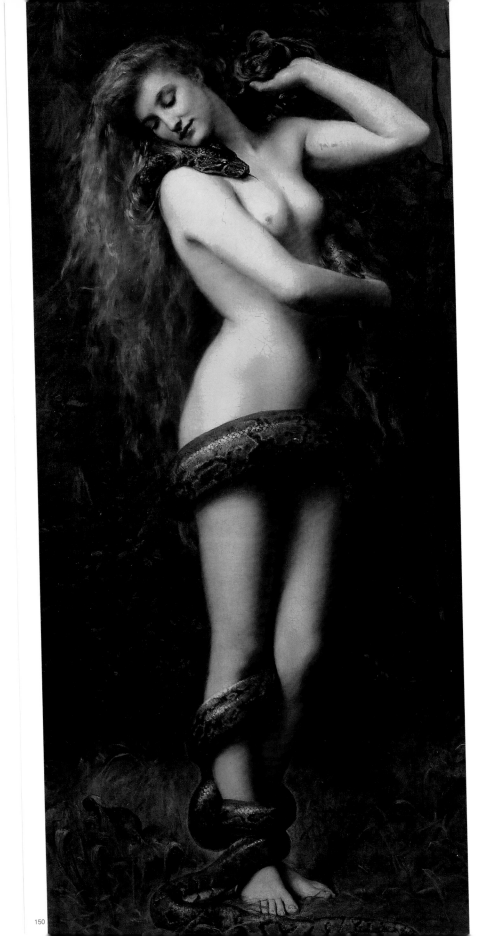

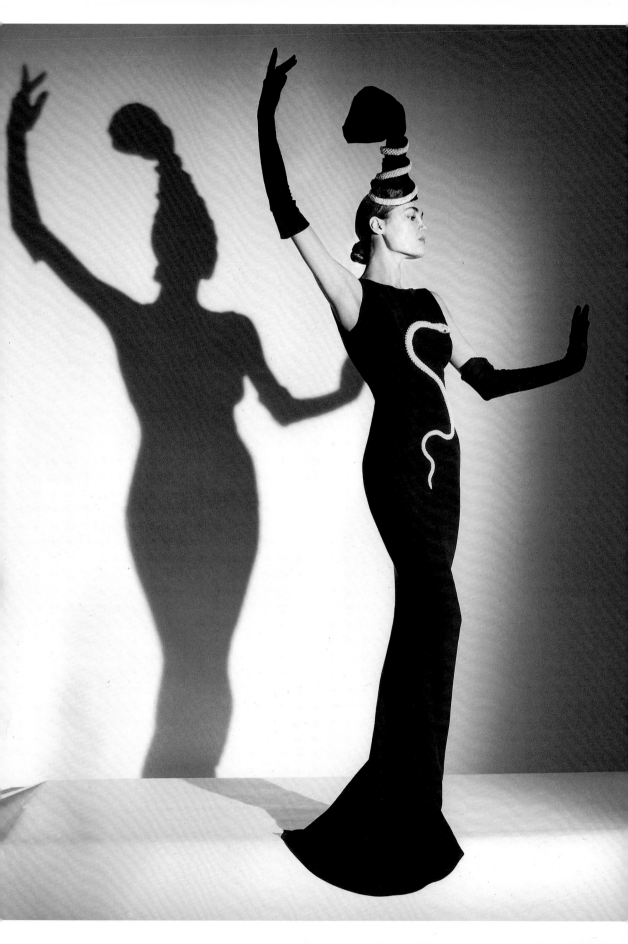

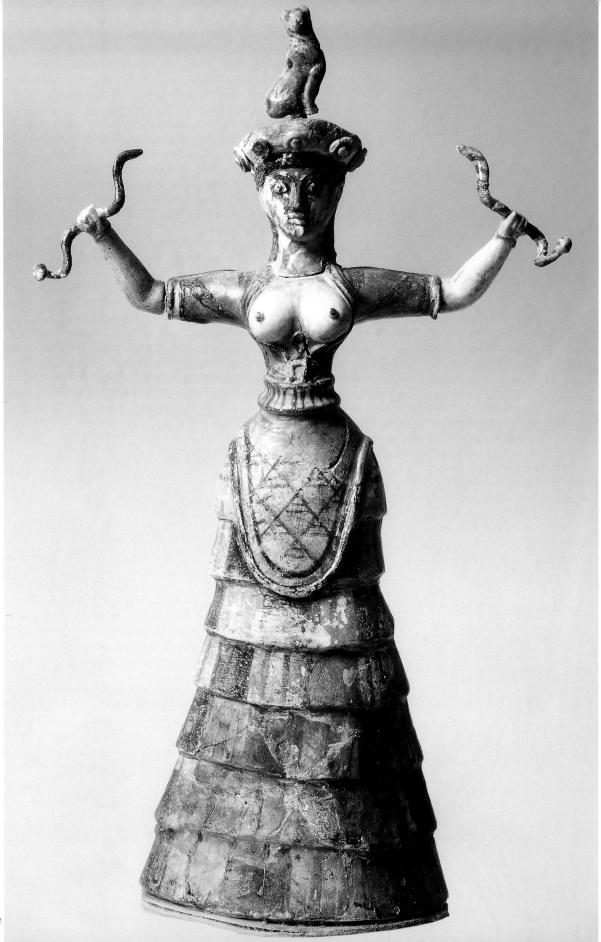

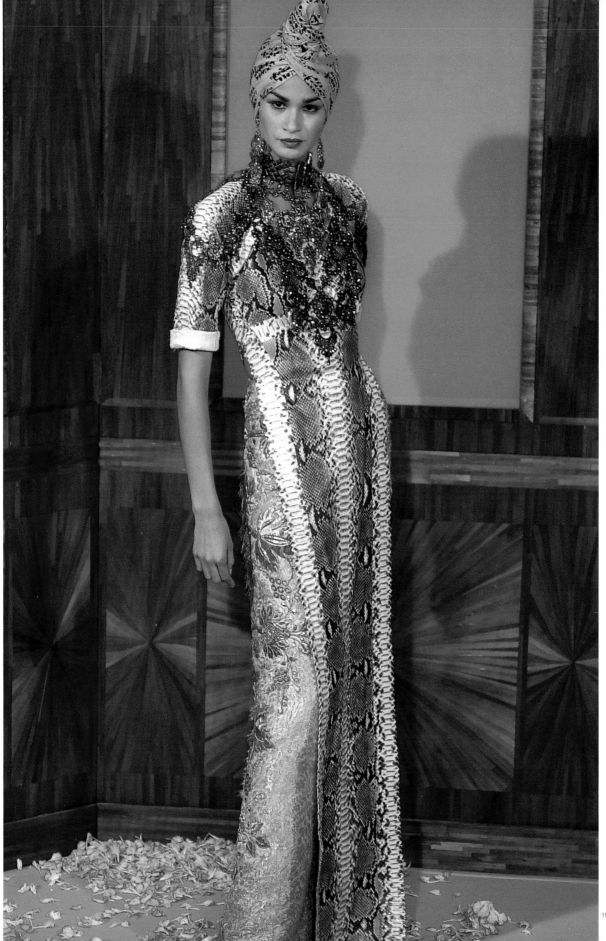

As exemplified on page 152, the Late Minoan idols of ancient Crete express a sexual and regenerative female strength that was not yet effected by the negative associations conveyed in Christian doctrine. British archaeologist Arthur Evans was among the first to excavate the palaces of Knossos, and he recovered a religious symbology that centered on the "Snake Goddess," a term he coined in 1903. Evans posited that a strong matrilineal hierarchy was championed at Knossos and that the Snake Goddess was the foremost figure of worship in that spiritual system. This protectress of the sky and waters of Crete asserted a divine femininity and evidenced a strong cult association with and reverence for the snake. Coiled around her arms and entwined in her avian crown, the serpent encompassed her and supplied her with the ability to regenerate the vegetal and human populations of Knossos. While the emphasis on the Snake Goddess's breast and hips fortified the symbolism of her fertility, the ominous bird perched atop her head and her constricted waist, suggestive of barrenness, communicate her contrary death-dealing capabilities. In Cretan religious ceremony, she was often referenced as the Lady of the Dead.

Jean Paul Gaultier's millennial ensemble, shown on page 153, echoes both the diagonal scale-like hackings of the Snake Goddess's apron and the avian pillar of her headpiece. Employing the darker shades of the python around the garment's bust, Gaultier emphasized the matronly woman's breast as a universal symbol of fertility and sexual power. The ensemble amalgamates the decorative and the deadly, as the taut python sheath appears to consume the runway model. Conversely, with her serpentine curves and python-patterned form, the model seems ready to shed her sartorial skin to reveal a regenerated body beneath. The ensemble is accessorized with glittering jewelry and lavish gilt brocaded underpinnings, which contrast sharply with the utilitarian forms employed by Cretan sculptors to communicate authority and divinity. Gaultier hyperbolized his image of the alpha woman. He coalesced contemporary manifestations of sexual and social empowerment with telling details of wealth, status, and physical perfection, evoking the awesome matriarchal authority of the ancient Minoans and the prototypical strength of Lilith. Gaultier's hypnotic python-woman revisits the imagery of a fecund female power for the new millennium.

Page 152: Cretan, Knossos (Late Minoan Period). Snake Goddess figurine, polychrome terracotta, 1700–1400 B.C. Courtesy of the Archaeological Museum, Heraklion, Crete. Photograph: Nimatallah/Art Resource, NY

Page 153: Jean Paul Gaultier, French (born 1952). Ensemble, spring/summer 2000. Photograph: copyright © MCV Maria Valentino

While the ancient civilizations of Crete associated the snake with fertility and rebirth, Egyptian magico-religious texts emphasized its deadly and destructive capabilities. In *The Cult of the Serpent* (1983), Balaji Mundkur explained: "Egyptians tended to imagine all threats to light or the sun as serpent demons, and the archenemy of the sky/heaven . . . was seen as a mighty serpent which the sun god had to conquer in a fierce struggle that recurred every morning." The "evil one," manifested in alternate forms as the divine serpent Nehebka or the Nile crocodile, "Devourer of the Dead," was viewed as the gatekeeper to the underworld. The most commonly depicted Egyptian crocodilian deity was Sobek, or Sebek, a male god characterized by volatile passion and a treacherous nature (see page 156). The ancient Greek historian Herodotus wrote of Sobek's deceased children, who were buried with various high-ranking mortals and cradled in individual tombs in temples at Faiyum and Kom Ombo. Those sanctuaries venerated Sobek, portraying him as half-human, his crocodile head ornamented with a domical crown to symbolize his relative discordance with the sun. The tombs at Kom Ombo have revealed crocodilian carcasses decorated with gold jewelry and wares, accoutrements of wealth intended to appease the deadly instinct of the villainous crocodile.

John Galliano has frequently drawn from the intricate aesthetics of Egyptian costume. In his spring/summer 2004 collection for Christian Dior, he presented gowns rendered in translucent organdies and accessorized with serpentine pharaonic crowns. The most extravagant pieces in the collection evoke the luxury and lavish artistry of Egyptian dress with a fevered imagination, in which the Queen of the Nile is the acme of beauty and power. In his autumn/winter 2002–2003 Dior collection, Galliano was inspired by the armored skin of the ferocious and predatory Egyptian crocodile. His design shown on page 157 incorporates some characteristics of the ancient Egyptian's linen *kalasaris*, worn in its most ornamental form by queens and goddesses. During the Egyptian Late Period the more elaborate *kalasaris*, gathered through pleating and pinning, featured a prominent knot at the breast. Galliano's black gown is constructed from cut squares of reptilian-patterned leather applied to a black silk tulle base fabric, which has been gathered along the center seam to construct a *kalasaris* knot. Painted with thick black eye makeup, Galliano's model affects the threatening glower of an ominous predator, a nocturnal reaper. The silver star and moon charms affixed to Galliano's black feather headpiece allude to the fanlike crown of Sobek and also recall the ancient Egyptians' fear of the monstrous serpent demon Apopis, who emerged to hunt as night fell. With these symbolic references to Egyptian crocodilian lore, Galliano infused the voracious predatory sexuality of the contemporary femme fatale with the menacing markings of the male crocodile god Sobek. The ominous aspects of the gown are mediated only by its lavishness, which asserts this deadly fatale's supremacy over the runway, her majestic domain.

Page 156: Egyptian (Ptolemaic Period). Relief of Crocodile-God Sobek wearing crown of Amun, Temple of Kom Ombo, 2nd century B.C. Photograph: Erich Lessing/Art Resource, NY

Page 157: Christian Dior Haute Couture, French (founded 1947) by John Galliano, British (born Gibraltar, 1960). Ensemble, autumn/winter 2002–2003. Photograph: copyright © Chris Moore

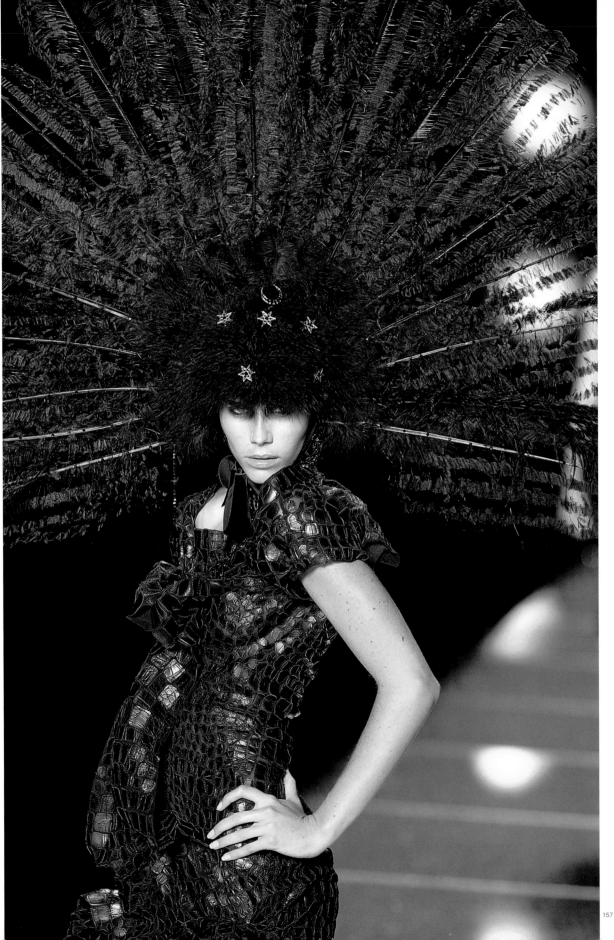

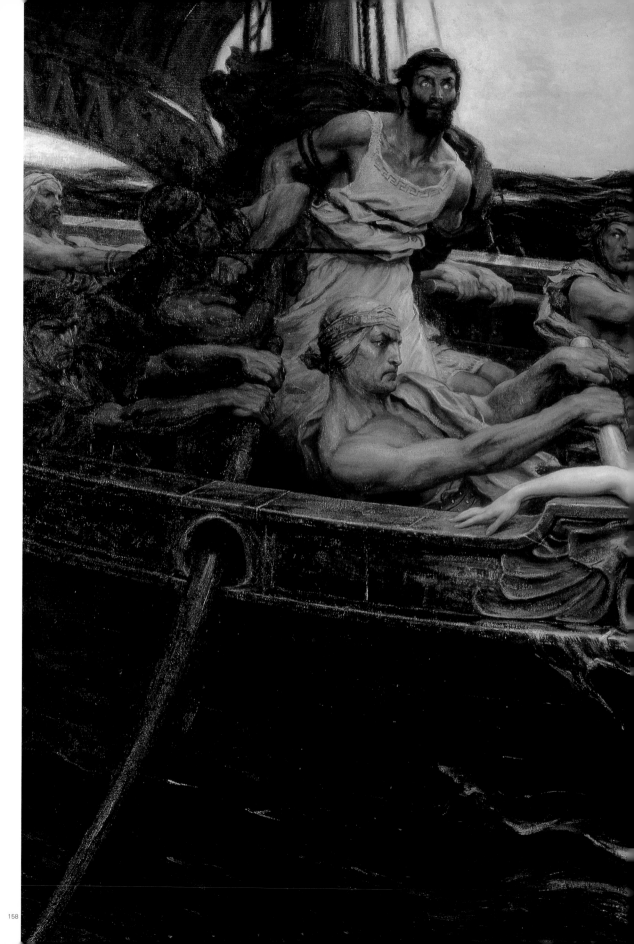

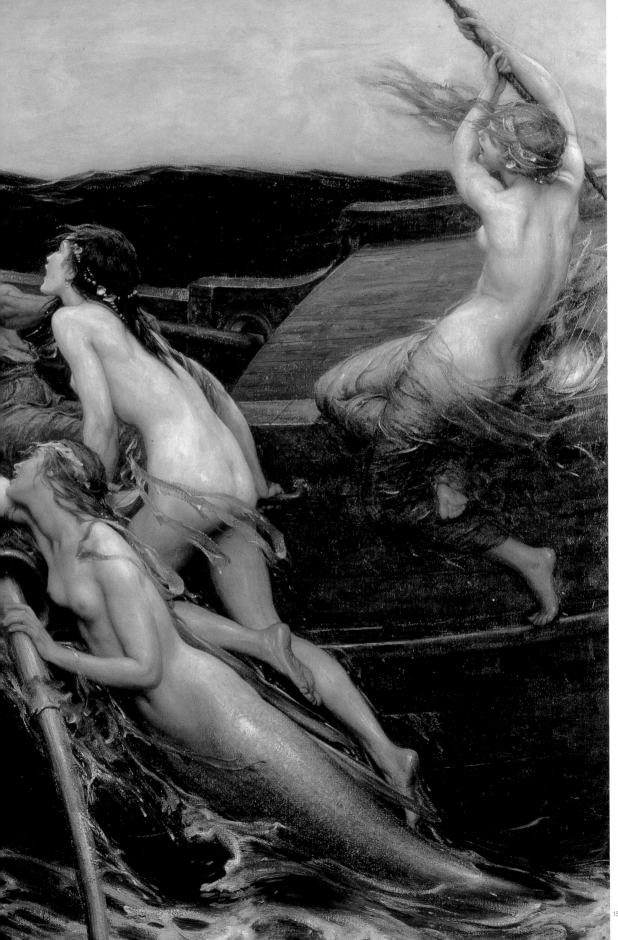

The shape-shifting serpent known as *lamiae* appears in Egyptian texts and was adopted in Greek myth as the insidious siren. Popularized by the Odysseian tale of Ulysses's encounter with the Sirens, this malignant female spirit lounges on sea walls, rocks, and ledges, enticing ships to their wreckage. Appearing demure, even angelic, the siren becomes ravenous in attack, vengefully tearing the flesh of her suitor after seducing him with her breathtaking song. While the mythologies of Medusa, Lilith, and the Minoan Snake Goddess generally perpetuated the duality of the femme fatale, as all possessed the ability to simultaneously kill and regenerate man, the siren emerged in Greek fable as a pure fatale, with a facility for psychosexual manipulation of man's own weakness to satisfy her depraved and destructive yearnings. This totemic sea-creature image of the sexually charged female assailant has surfaced in twentieth-century designs such as the early sequin-scaled vamp gowns of Paul Poiret and the slinky mid-century "Mermaid" sheaths of Norman Norell.

Herbert Draper, a devoted follower of Lord Frederic Leighton's school of classicist painting, often celebrated the traditional dynamic of the male hero and the helpless ingénue in his works. In *Ulysses and the Sirens*, reproduced on pages 158–59, his subject is more complex. In addition to expertly conveying the narrative details of the famed myth, Draper has cleverly insinuated the ambivalence of contemporary society to the persisting notion of the Victorian femme fatale. In *Exposed: The Victorian Nude* (2001) Alison Smith explained: "By representing two of the sirens as young women (devoid of the customary wings, claws, or tail), Draper would appear to suggest that the destructive allure of these sea-monsters is in fact a property of 'ordinary' women." The manifestation of the siren was a misogynist trope for the "uncontrollable" sexuality of the late nineteenth-century woman as perverse nymphomaniac, dominated by her sublimated hatred of men and her unbridled lust.

Through his sometimes-morbid manifestations of the huntress and the femme fatale, Alexander McQueen has continually advanced consciousness of the psychosexual power of women. In his 1998 collection for Givenchy Haute Couture, exemplified on page 161, the designer once again addressed the sexual identity of the contemporary woman, this time with a series of "Sirène" sheaths. In "Desire and Dread: Alexander McQueen and the Contemporary Femme Fatale," published in *Body Dressing* (2001), Caroline Evans examined the appeal of the Siren for the fashion créateur: "McQueen began to evidence a fascination with the dynamics of power, in particular with a dialectical relationship between predator and prey, between victim and aggressor." The "Sirène" dress masterfully arrests the eye with the reflective allure of its exquisite scale-like pavè of silver embroidery, its liquid, second-skin silhouette, and its torso-exposing décolleté neckline. McQueen also created the effect of a fish's tail in the form of an elaborate train. Photographer Steven Meisel exposed just a hint of the foot, capturing a moment of transformation from beautiful woman to seductive sea creature. Perhaps the most poetic detail of the ensemble is McQueen's headpiece, with its aureate-linked chains draped over the eyes like strands of wet seaweed. He constructed a webbed cage, a shimmering silver veil behind which lurks the true face of the sexual predator.

Pages 158–59: Herbert Draper, British (1864–1920). *Ulysses and the Sirens*, oil on canvas, 1909.

Courtesy of Ferens Art Gallery, Hull City Museums and Art Galleries, UK, and the Bridgeman Art Library

Page 161: Givenchy Haute Couture, French (founded 1952) by Alexander McQueen, British (born 1969).

Dress, spring/summer 1998. Photograph: Steven Meisel/Art + Commerce Anthology

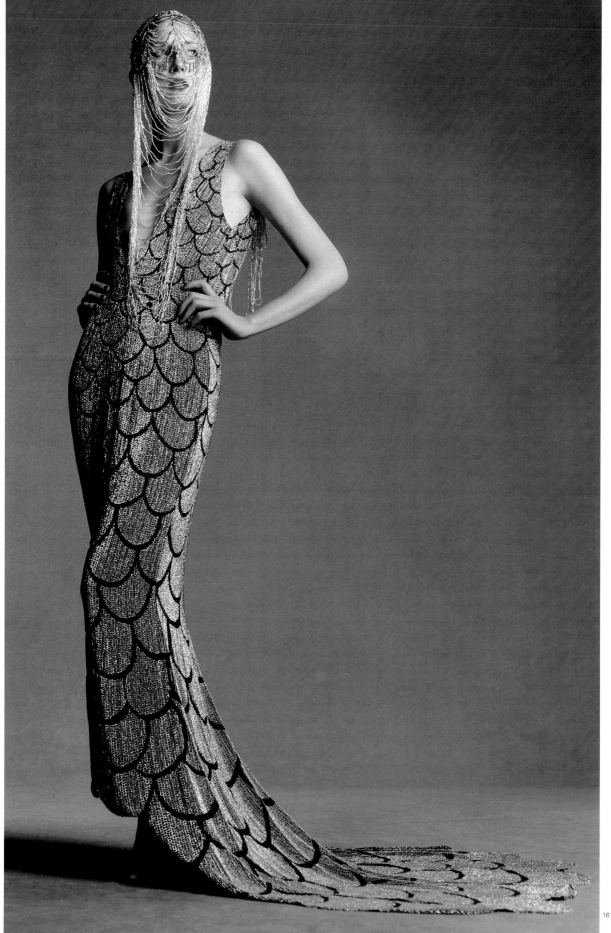

Inspired by the transient gypsy, John Galliano created willowy sheaths and lavish rags accompanied by intricate amulets for his spring/summer 1997 collection, "Russian Gypsy named O'Flanneghan" (see page 163). Perhaps the most telling design of the show, his webbed tulle "Spider" dress aptly conveys the gypsy's ability to enchant those around her capturing their hearts while snagging their wallets. The spider sheath first appeared in fashion in the early twentieth century, when the newly liberated flapper became associated with the carnal yearnings of the femme fatale. Designers produced layered webbed dresses that mimicked the deadly trap of one of nature's most feared female predators, the black widow. The poisonous black widow spider attacks those snared in her silken web. When she mates, she injects a powerful toxin into her partner and then devours him. In an article in the *Journal of the American Psychoanalytic Association* titled "Spider Phobias and Spider Fantasies" (1971), it is noted that "the spider is a powerful latent symbol embedded in the subconscious mind. . . . It reflects a form of defense produced by some personal, domestic problem more acute than any actual threat from, or fear of, spiders." When the early twentieth-century woman entered the workplace and eventually attained voting privileges, the spider and her web emerged as symbols that repudiated the conventional notions of female sexual passivity. The spider-woman was thought to overpower the male with her dangerous beauty, elaborate stratagems, and deadly traps. In the popular imagination, the black widow's accessory par excellence was her poison ring, a grandiose stone that concealed small doses of arsenic to be dropped into a suitor's drink. This stealthy assault was a nostalgic nod to the perceived sociopathology of the Victorian *empoisoneuse*. The poisonous femme fatale was also aided by the illusory fragility of her web. A 1919 issue of *Vogue* recalled an exquisite "diamond noir, delicate as fairy cobwebs." Barely visible in its open construction but structurally fortified, the web presents a mirage of delicate silver fibers that capture prey with their sticky surface. With translucent threads that both attract and confound the onlooker with their kaleidoscope construction, the web trap has precipitated periods of tarantism (fear of spiders, specifically tarantulas) throughout history. Women in spider-web gowns infested the dancehalls of 1920s Paris, perplexing and thereby dominating their male admirers. Just as the siren serenaded her hapless victims with her seductive song, these arachnophilic flappers sought to weave webs of inescapable enticement. Galliano's "Spider" dress, photographed on a model amid the ominous and looming cacti and endless desert expanse of the black widow's habitat, suggests an *empoisoneuse* who is at home in the solitary life she has created. Her black webbed sheath overlays a silk shift in lavender, the color of mourning. It recalls the spidery costumes of the 1920s to evoke the noxious lure of the black widow. The scene also suggests the film-noir conceit of the shallow desert grave, the bleak terminus of a fatal attraction.

Page 163: John Galliano, British (born Gibraltar, 1960). Dress, spring/summer 1997. Photograph: copyright © Ellen von Unwerth/Art + Commerce Anthology

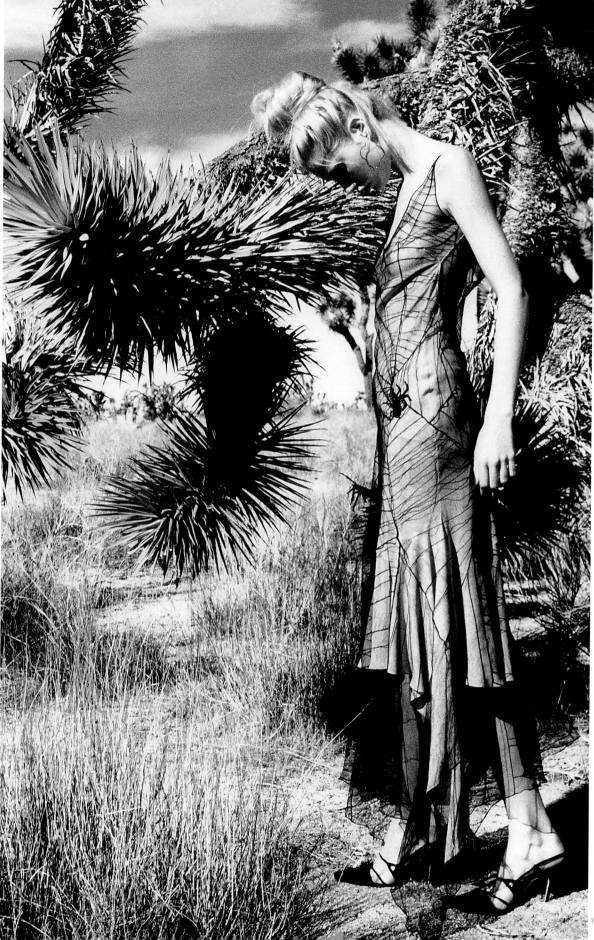

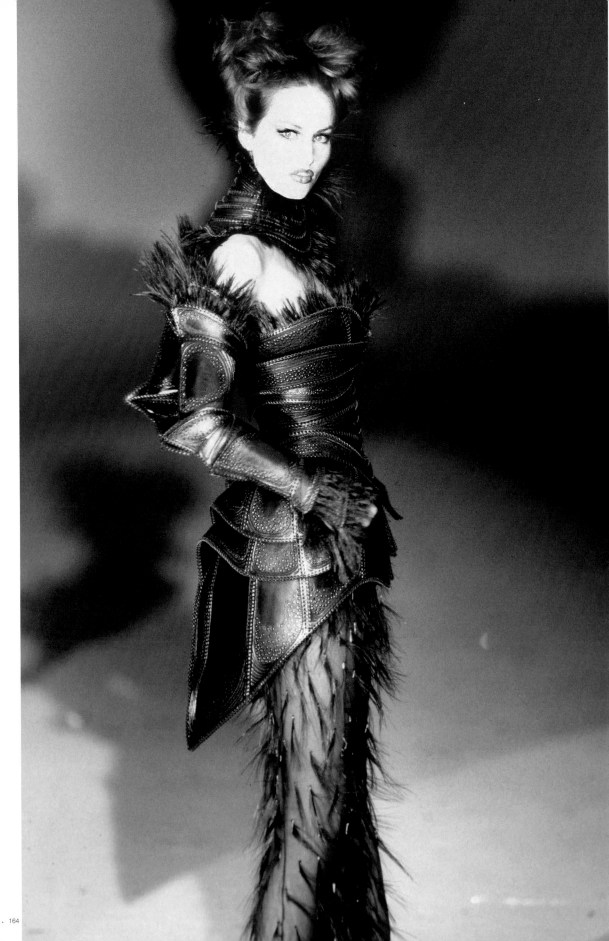

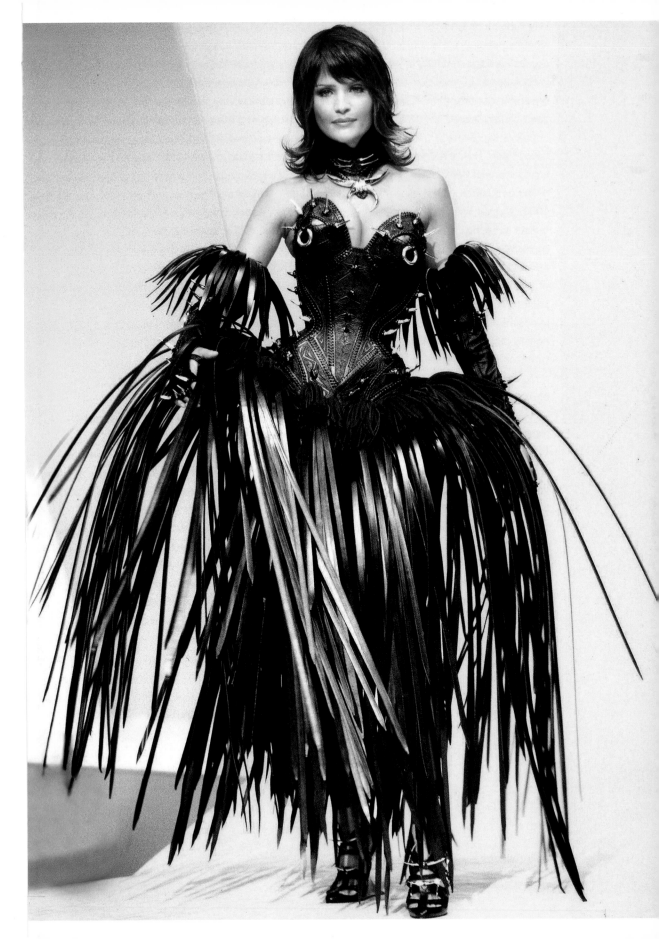

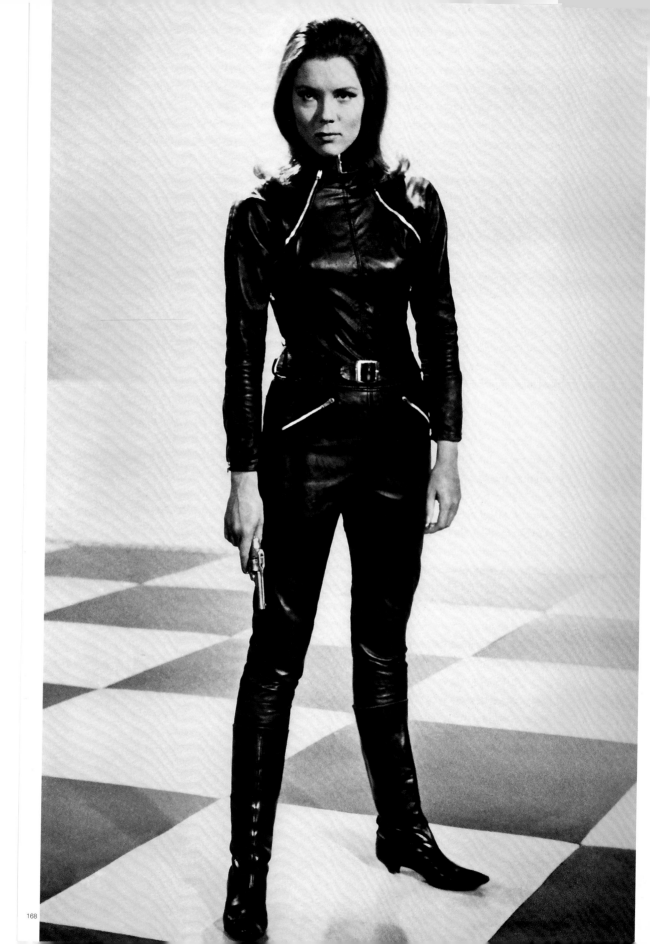

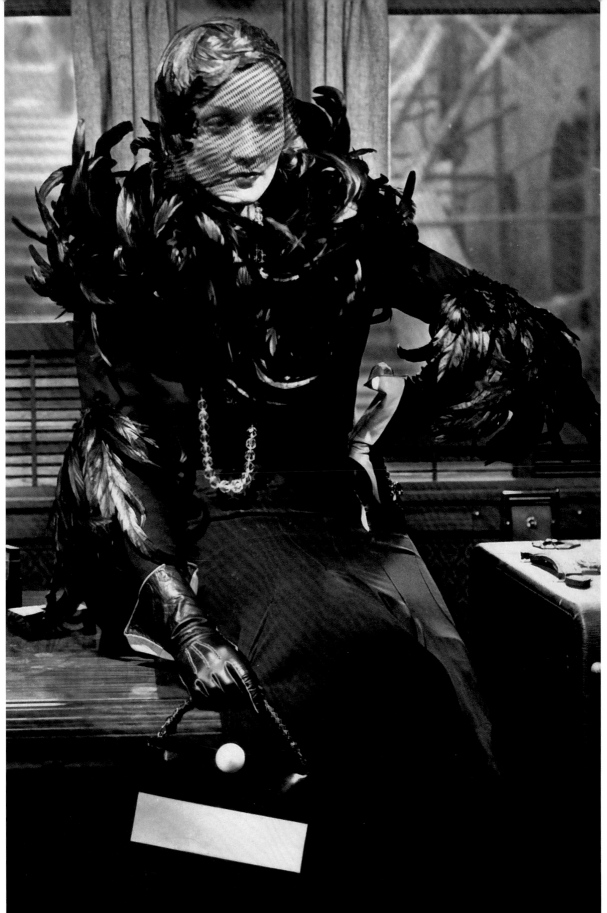

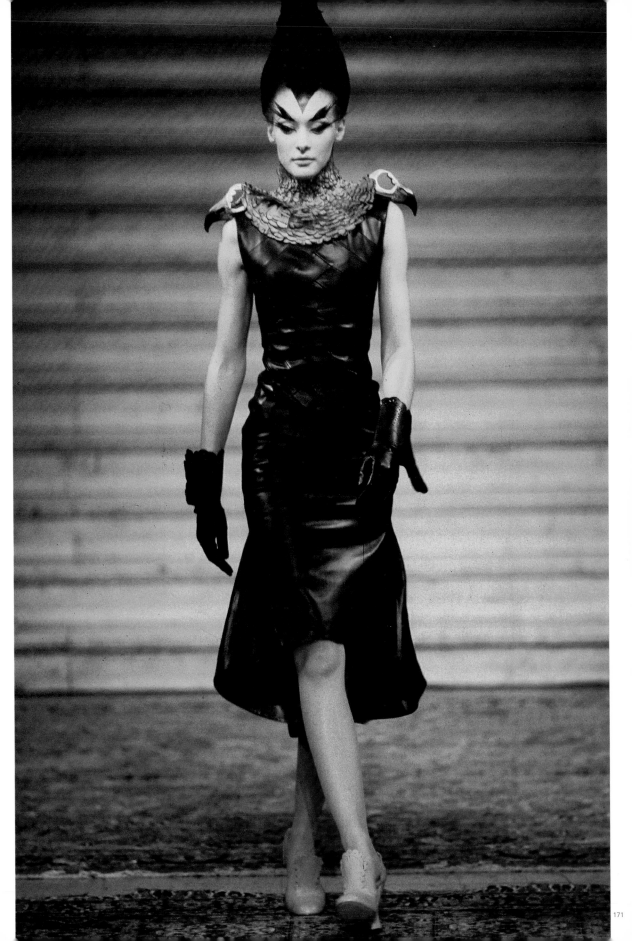

In *Femmes Fatales: Feminism, Film Theory, and Psychoanalysis* (1991), Mary Ann Doane documented the emergence of the femme fatale in films of the 1930s, as represented most dynamically by the seductresses played by Jean Harlow, Joan Crawford, and especially Marlene Dietrich, who was often adorned with the feathers or stuffed head of the black bird. Doane explained: "Her most striking characteristic, perhaps, is the fact that she never really is what she seems to be. She harbors a threat which is not entirely legible, predictable, or manageable." As Shanghai Lily in director Josef von Sternberg's film *Shanghai Express* (1932), Dietrich, veiled in black leather, feathers, and silk net from head to toe, embodied this cryptic fatale (see page 170). Her character was promiscuous yet emotionally unattached—manifestly sexual yet barely physically identifiable. Sternberg emphasized Lily's elusivity by erecting several layers of screening between Dietrich and the camera lens. He employed these translucent barriers to distance her from her audience, yet in nearly every other scene he exploited the close-up shot of Dietrich's face behind the markings of the screen. Dietrich and Sternberg helped perpetuate the femme fatale as a construct of femininity that could neither be fully appropriated and codified nor marginalized and dismissed by the audience. The actress's black feathered capes and collars, made to tremble and shiver under her breath, were ostensibly the simple, if luxurious, trappings of beauty. In fact, the weightless flutter of the fragile plumage suggests a state of erotic arousal even as it camouflages the predatory intentions of the sexual raptor.

Alexander McQueen's volatile autumn/winter 1997–1998 "Ecclect Dissect" collection for Givenchy alludes to the more dangerous perimeters of sexual expression and fantasy, evoking the designer's interest in the link between eroticism and death. As seen on page 171, his model is swathed tautly in a supple black leather sheath, crowned at each shoulder with the preserved heads of vultures and accessorized with clinical fetishist's gloves. The image is a synthesis of the visual markings of avian predator and dominatrix. The haunting gargoylesque vulture heads, with eye sockets empty, inspire a talismanic association to their carrion feeding practice. Longtime McQueen art director Simon Costin showed the designer the sixteenth-century engravings of famed anatomist Andreas Vesalius, who studied animals to understand the functions and structures of the human body. A revolutionary, Vesalius depicted the human form with figures flayed, trailing lines of disconnected muscle and placed in incongruous natural settings. The imagery of dissection correlates with the behavior of the necrophilic vulture, who tears apart its lifeless prey. McQueen's model squints with demonic red-rimmed eyes from beneath a hardened helmet of night-black hair. Her narrowed gaze is both sexually provocative and ominously sinister. McQueen's feathered femme fatale is a hybrid— part bird, part woman. Simultaneously attractive and repulsive, she resembles the avian archetypes described in oppositional terms by historian and archaeologist Edward Allworthy Armstrong in *The Folklore of Birds* (1970) as "soft feathers, sharp beak, songs and shrieks, amorousness and cruelty, devotion and fickleness."

Page 170: Marlene Dietrich in *Shanghai Express*, film still, 1932. Courtesy of Photofest

Page 171: Givenchy Haute Couture, French (founded 1952) by Alexander McQueen, British (born 1969).

Ensemble, autumn/winter 1997–1998. Photograph: copyright © MCV/Maria Valentino

Contemporary fashion has been inspired by a variety of historical femme fatales, but perhaps the most frequently cited is the late nineteenth-century model, a harbinger of subsequent advances in women's rights. In *The Victorian Nude: Sexuality, Morality, and Art* (1996), Alison Smith described the newfound role of women in British society as both "purchasers" and "objects of consumption." As images of the nude female body became more widely popularized, an increase in the objectification and commodification of the sexualized female form inevitably occurred. On the other hand, the Victorian period also saw the emergence of a number of utopian and suffrage movements. This provocative "feminism" was widely perceived as the beginning of a widespread "immorality" resulting from the destabilized roles of men and women. The socially and economically prominent woman soon became associated with the promiscuous deviant. In *Prostitution, Considered in its Moral, Social, and Sanitary Aspects* (revised 1870) William Acton insisted that during the early Victorian period, both the ethics and actions of the prostitute crept into the aristocratic classes, in effect resulting in a contamination of the prudish wife and matriarch. The catalyst for this assimilation was the femme fatale. While she was likely to be highly educated and enjoyed the accoutrements of wealth and social standing, she was also a libertine, bridling under the misogynist constraints of Victorian sexual practice. John Galliano, in his autumn/winter 1999–2000 collection for Christian Dior, merged the Victorian femme fatale with the empowered fashionista au courant (page 175). The tightly cinched waistline and deathly pallor of the early Edwardian vamp, as exemplified on page 174, underscored her reputation for barrenness; she was the social adverse of the married and child-bearing matron. Galliano's creation parodies the notoriety of this sterile character: the "internal corsetry" implicit in his model's waifish form exemplifies our contemporaneous acceptance and celebration of the childless woman.

The hyperbolic avian headdress was a prominent accessory of the Victorian and Edwardian beauty. The exploitative rage for exotic plumage, single feathers, and full carcasses, which began in the mid-nineteenth century, was responsible for the extinction of several bird species. Excessive, extravagant plumage is therefore an especially apt metaphor for the femme fatale as a threatening predator with ravenous material desire. In his designs for Dior, milliner Stephen Jones channeled the opulence and decadent consumption of that era. More constructions than confections, his hats incorporate boldly placed taxidermy birds and fur pelts. As seen on page 175, Jones added a veil to the historic design, thereby referencing the mystery and guile of the femme fatale. The deathly complexions of both Galliano's mannequin and the Edwardian beauty speak to the psychoanalytic description of the femme fatale as a societal poison or disease. The nineteenth- and early twentieth-century femme fatale, as both a social contaminant and a sexualized commodity, embodied the threat of the wild, rabid beast, unpredictable and uncontrollable. She symbolized the societal fear of the empowered woman and inspired in art and literature innumerable comparisons to the haunting predator, the mythical sexual aggressor. Juxtaposing the impeccably tailored double-belted coat and walking boots of the Edwardian English hunt with the astonishing bird-trimmed hat of the period's *demimondaine*, Galliano rendered a postmodern construct of empowered femininity, an athletic huntress and sexual adventuress, a sovereign *femme fatale moderne*.

Page 174: Rara Avis of the Edwardian Period, photograph, ca. 1908. The Metropolitan Museum of Art,

The Irene Lewisohn Costume Reference Library

Page 175: Christian Dior Haute Couture, French (founded 1947) by John Galliano, British (born Gibraltar, 1960).

Ensemble, autumn/winter 1999–2000. Hat by Stephen Jones, British (born 1957). Photograph: copyright ©

MCV Maria Valentino

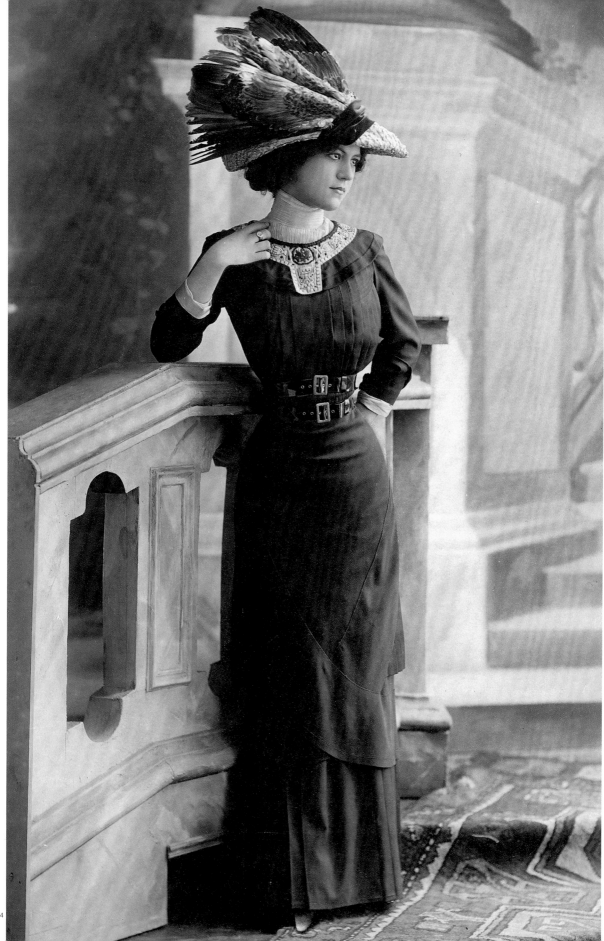

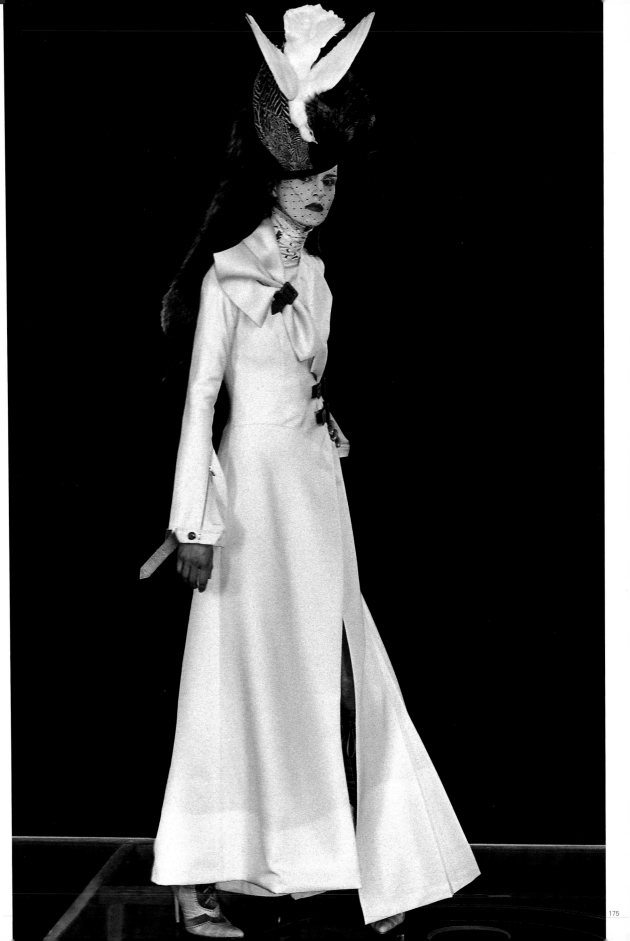

ACKNOWLEDGMENTS

There are many people who have been generous in their advice and support of this book and the exhibition it accompanies. In particular, we are indebted to Philippe de Montebello, Director of The Metropolitan Museum of Art; Emily K. Rafferty, Senior Vice President for External Affairs; Harold Koda, Curator in Charge of The Costume Institute at The Metropolitan Museum of Art; Anna Wintour, Editor in Chief of American *Vogue*; Roberto Cavalli; John and Laura Pomerantz.

We would also like to extend our special thanks to:

Our colleagues in The Costume Institute, The Metropolitan Museum of Art: Torrey Thomas Acri, Gail Anderson, Nick Barberio, Kitty Benton, Barbara Brickman, Elizabeth Bryan, Jane Butler, Beth Dincuff Charleston, Dina Cohen, Michael Downer, Jamilla Dunn, Eileen Ekstract, Lisa Faibish, Joyce Fung, Susan Furlaud, Jessica Glasscock, Charles Hansen, Stéphane Houy-Towner, Elizabeth Hyman, Betsy Kallop, Elizabeth Harpel Kehler, Susan Klein, Jessa Krick, Elizabeth Larson, Susan Lauren, Nina Libin, Joan Lufrano, Rena Lustberg, Melissa Marra, Bethany Matia, Veronica McNiff, Butzi Moffitt, Elizabeth Monks, Marci Morimoto, Doris Nathanson, Ellen Needham, Wendy Nolan, Julia Orron, Tatyana Pakhladzyhan, Christine Paulocik, Pat Peterson, Christine Petschek, Janina Poskrobko, Martin Price, Jan Reeder, Jessica Regan, Christina Ritschel, Eleanor Schloss, Lita Semerad, Rebecca Shea, Nancy Silbert, Katherine Smith, Judith Sommer, Heather Vaughn, Stacey N. Wacknov, Muriel Washer, Bernice Weinblatt, DJ White, the Visiting Committee, the Friends of The Costume Institute.

Our colleagues in the Editorial Department, The Metropolitan Museum of Art: John P. O'Neill, Barbara Cavaliere, Gwen Roginsky, Paula Torres.

The book designer and his assistants: Takaaki Matsumoto, Amy Wilkins, Keith Price.

Our colleagues in The Metropolitan Museum of Art: Sam Aaronian, Dorothea Arnold, Joan Aruz, Elizabeth Barker, Pamela T. Barr, Michael Batista, Kay Bearman, Sheila Bernstein, Eti Bonn-Muller, Susan Melick Bresnan, Barbara Bridgers, Eugenia Burnett Tinsley, Lisa Cain, Tom Campbell, Tim Caster, Jennie Choi, Teresa Christiansen, Aileen K. Chuck, Michael Cocherell, Clint Coller, Willa M. Cox, Deanna Cross, Jeffrey L. Daly, Nina Diefenbach, Stacey Elwood, Helen C. Evans, Priscilla F. Farah, Claudia Farias, Catherine Fukashima, Helen Garfield, Sophia Geronimus, Patricia A. Gilkison, George R. Goldner, Janis Good, Anne Goslin, Claire Gylphé, Megan Heuer, Marsha Hill, Jennifer D. Hinckley, Harold Holzer, Michael Jenkins, Marilyn Jensen, Julie Jones, Blanche Kahn, Andrea Kann, Eric Kjellgren, Alexandra Klein, Beth Kovalsky, Bernice Kwok-Gabel, Alisa LaGamma, Kerstin M. Larsen, Richard Lichte, Chris Lightfoot, Kent Lydecker, Tanya Maggos, Kristin M. MacDonald, Missy McHugh, David E. McKinney, Constance McPhee, Taylor Miller, Mark Morosse, Herbert M. Moskowitz, Matt Noiseux, Sally Pearson, Doralynn Pines, Diana Pitt, Hilda Rodriguez, Lucinda K. Ross, James Ross Day, Diana Salzburg, Christine Scornavacca, Linda M. Sylling, Mahrukh Tarapor, Gary Tinterow, Elyse Topalian, Valerie Troyansky, Daniel Walker, Virginia-Lee Webb, Karin Willis, Alison Williams, Steve Zane.

The institutional lenders to the exhibition: American Museum of Natural History (Enid Schildkrout, Naomi Goodman), Centraal Museum Ultrecht (Dr. José Teunissen), Fondation Pierre Bergé—Yves Saint Laurent, Hard Rock Café (Don Bernstine), Kedlestone Hall (Simon McCormack), Filmmuseum Berlin—Marlene Dietrich Collection (Werner Sudendorf), Los Angeles County Museum of Art (Sharon Takeda, Melinda Webber Kerstein), Museum of the City of New York (Phyllis Magidson), Philadelphia Museum of Art (Dilys Blum, Monica Brown, Sara Reiter), Warner Brothers Archives (Leith Adams).

The private lenders to the exhibition: Iris Apfel, Hamish Bowles, Pat Cleveland, Amy Fine Collins, Barbara R. Kaplan, Sylvia R. Karasu, Nancy S. Knox, Sandy Schreier, Mark Walsh, Leigh Wishner, Mark and Cleo Butterfield.

The photographic resources: Allan J. Hardy, LLC, Art and Commerce (Jennifer Palmer), Art Partner (Candice Marks), Art Resource (Jennifer Belt, Eileen Doyle, Robin Stolfi), AT LARGE (Laura Annaert-Hebey, Sylvie Flaure), Bill Blass Archive (Rachael Myers), Billy Rose Theatre Collection (Jeremy Megraw), Birmingham Museums and Art Gallery Picture Library (Pippa McNee), Bridgeman Art Library (Eliana Moreira), The British Museum (Kellie Leydon), British *Vogue* (Nicky Budden, Romney Thompson), Camera Eye Ltd (Ian Mills), Cardozo Fine Arts (Theresa Downing), Carole and Thomas Treuhaft, Chanel USA (Anne Fahey, Arlette Thebault), Chris Moore Studio (Johanna Morris), Christian Dior (Alixe Boyer, Vincent Meyer, Soizic Pfaff), Click Model Management (Nancy Menis for Alise

Shoemaker), CLM US (Peter Pugliese), Condé Nast Publications Inc. (Gretchen Fenston, Paul Hawryluk, Leigh Montville, Anthony Petrillose, Michael Stier), Contact Press Images, Inc. (Jeffrey D. Smith), Creative Photographers (Ania Gozdz), Demont Photo Management, LLC (Thierry Demont), Erwan Prigent (Michele Montagne), ESP Agency, LLC (Travis Kinsella), Flury & Company (Lois Flury), French *Vogue* (Stéphanie Ovide Guarneri), Fondation Pierre Bergé—Yves Saint Laurent (Hector Pascual, Pascale Sittler, Romain Verdure), F.R.I.C.S., Abercorn Estates (Robert W. L. Scott), Gardner, Carton & Douglas (Tina Kourasis), German *Vogue* (Birgitt Greim, Christina Schubeck, Andrea Vollmer-Hess), Hearst Publications (Jenna L. Gallagher, Wendy Israel, Alyssa Kolsky), IMG (Jen Ramey), Irving Penn Studio Inc. (Dee Vitale), KCD (Myriam Coudoux, Megan Wood), Little Bear Inc. (Nathaniel Kilcer), L'OFFICE (Franck Nasso), Maconochie Photography (Tiggy Maconochie, Becca McCubbin), Macfly Corp (Wes Olson for Andrew Macpherson), Management + Artists (Massimiliano Di Battista, Mark Mayer), MCV Photo (Maria Valentino, Jose E. Rodriguez), Michel Comte Studio (Eddie Adams), Michele Filomeno, Museum of the City of New York (Marguerite Lavin), The National Trust Photo Library (Chris Lacey, Liz Stacey), The New York Public Library for the Performing Arts (Kevin Winkler), Patrick Demarchelier Studio (Colby Hewitt), Photofest (Howard Mandelbaum), Prada USA Corp. (Christine Hanaway, Anita Joos, Katherine Ross), Rex Features Ltd. (Glen Marks), Richard Avedon (Norma Stevens), Roberto Cavalli North America, Sandro Hyams, SCOOP (Claudine Legros), Sefton Council (Yvonne Hardman), ShowStudio (Penny Martin), Solar Initiative (Monique van Hooff), Sothebys (Sue Daly), Staley-Wise Gallery (Etheleen Staley, Taki Wise), Stephen Burrows World (John Robert Miller), Streeters London (Rachel Clark), Steve Diet Goedde, Studio Peter Lindbergh (John Conley), Warren du Preez & Nick Thorton Jones, William Claxton Photography (Chris Claxton), Yevonde Portrait Archive (Lawrence Hole).

The designers: Gilbert Adrian, Adolfo, Miguel Adrover, Azzedine Aläia, As Four, Cristobal Balenciaga, Geoffrey Beene, Blackglama, Bill Blass, Donald Brooks, Stephen Burrows, Nicholas Ghesquière for Callaghan, Roberto Cavalli, House of Chanel, André Courrèges, James Coviello, Ann Demeulemeester, Giorgio di Sant'Angelo, Christian Dior Haute Couture, Dolce & Gabbana, Fendi, Tom Ford, James Galanos, John Galliano, Jean Paul Gaultier, Rudi Gernreich, Givenchy Haute Couture, Gucci Group, Norman Hartnell, Barbara Hulanicki, Sean John, Jacques Kaplan, Junko Koshino, Karl Lagerfeld, Adrienne Landau, Larrissa, Julien Macdonald, Bob Mackie, Maximilian, Alexander McQueen, Issey Miyake, Missoni, Frederic Molenac, Moschino Couture, Thierry Mugler, Nija Furs, Norman Norell, Todd Oldham, Rick Owens, Emeric Partos, Plein Sud, Alice Pollock, Prada, Paco Rabanne, Revillon Frères, Zandra Rhodes, Russell Sage, Arnold Scaasi, Anna Sui, Philip Treacy, Emanuel Ungaro, Valentino, Rose Valois, Gianni and Donatella Versace, Viktor and Rolf, Madeleine Vionnet, Vivienne Westwood, House of Worth, Yohji Yamamoto, Yves Saint Laurent, and Yves Saint Laurent Rive Gauche.

Special thanks are also due to: Charlotte Appleyard, Michael S. Bell, Gilles and Kelly Bensimon, Conrad Bodman, Elizabeth Bogner, Harry and Marion Bolton, Larissa Bonfante, Michael and Benita Bowdino, Inez Brooks-Myers, Vichai and Lee Chinalai, Cathryn Collins, Angelica Compagno, Maria Conelli, Rachel Cronin, Susan Cross, Oriole Cullen, Steve Da Cruz, Eyal Dimant, Edwina Ehrman, the Falk-Nelson-Buechler Family, Ann Fitzgerald, Tracy Funches, Susanna Greenwood, Lisa Hochtritt, Jane Holzer, John Hutchins, Lenny Inzirillo, Catherine Johnson-Roehr, Kevin Jones, Dr. Desiree Koslin, Lisa Lawrence, Bruce and Susan Luria, Heather Magidson, Michele Majer, Cristiano Mancini, Joanna Marchner, Angela Mariani, Bridgette R. McCullough, the Mirabelli Family, Patrick O'Connell, Karine Prot, Corentin Quideau, Laurie Riley, Jane Rosch, Jesse Sheidlower, Douglas and Lynette Schram, Denise Stone, Patsy Tarr, Marketa Uhlirova, Karole Vail, David Vincent, Ron and Betsy Weiss, Wilton Estate, Priscilla Wood, Thomas Zummer.

SELECTED BIBLIOGRAPHY

Allen, Virginia M. *The Femme Fatale: Erotic Icon*. Whitston. Troy, New York, 1983.

Behrens, Roy R. *Art & Camouflage: Concealment and Deception in Nature, Art, and War*. North American Review, University of Northern Iowa. Cedar Falls, Iowa, 1981.

Benard, Elisabeth, and Beverly Moon. *Goddesses who Rule*. Oxford University Press. New York, 2000.

Bothmer, Dietrich von. *Amazons in Greek Art*. Clarendon Press. Oxford, 1957.

Davis-Kimball, Jeannine, and Mona Behan. *Warrior Women: An Archaeologist's Search for History's Hidden Heroines*. Warner Books. New York, 2001.

Doughty, Robin W. *Feather Fashions and Bird Preservation: A Study in Nature Protection*. University of California Press. Berkeley, 1975.

Douthwaite, Julia V. *The Wild Girl, Natural Man, and the Monster: Dangerous Experiments in the Age of Enlightenment*. University of Chicago Press. Chicago, 2002.

Ellingson, Ter. *The Myth of the Noble Savage*. University of California Press. Berkeley, 2001.

Emberley, Julia V. *The Cultural Politics of Fur*. Cornell University Press. Ithaca, New York, 1997.

Engels, Donald. *Classical Cats: The Rise and Fall of the Sacred Cat*. Routledge. London, 1999.

Evans, Caroline. *Fashion At The Edge: Spectacle, Modernity and Deathliness*. Yale University Press. New Haven, 2003.

Ewing, Elizabeth. *Fur in Dress*. B. T. Batsford Ltd. London, 1981.

Fernbach, Amanda. *Fantasies of Fetishism: From Decadence to the Post-Human*. Rutgers University Press. New Brunswick, New Jersey, 2002.

Franz, Marie-Luise von. *The Cat: A Tale of Feminine Redemption*. Inner City Books. Toronto, 1999.

Glasscock, Jessica. *Striptease: From Gaslight to Spotlight*. Harry N. Abrams. New York, 2003.

Howey, Oldfield. *The Encircled Serpent: A Study of Serpent Symbolism in all Countries and Ages*. D. McKay. Philadelphia, 1928.

Krips, Henry. *Fetish: An Erotics of Culture*. Cornell University Press. Ithaca, New York, 1999.

Martin, Richard, and Harold Koda. *Haute Couture*. The Metropolitan Museum of Art. New York, 1995.

Municchi, Anna. *Ladies in Furs: 1940–1990*. Zanfi Editori. Modena, 1993.

Nadeau, Chantal. *Fur Nation: From the Beaver to Brigitte Bardot*. Routledge. London, 2001.

Pastoureau, Michel. *The Devil's Cloth: A History of Stripes and Striped Fabric*. Columbia University Press. New York, 2000.

Plumwood, Val. *Feminism and the Mastery of Nature*. Routledge. London, 1993.

Quilleriet, Anne-Laure. *The Leather Book*. Assouline. New York, 2004.

Ribeiro, Aileen. *Dress in Eighteenth-Century Europe, 1715–1789*. B. T. Batsford. London, 2002.

Sacher-Masoch, Leopold von. *Venus in Furs*. Penguin Books. New York, 2000.

Steele, Valerie. *Fetish: Fashion, Sex and Power*. Oxford University Press. New York, 1996.

Stuart, Andrea. *Showgirls*. Jonathan Cape. London, 1996.

Vale, V., and Andrea Juno, eds. *Modern Primitives: An Investigation of Contemporary Adornment and Ritual*. Re/Search Publications. San Francisco, 1989.

Wilde, Lyn Webster. *On the Trail of the Women Warriors*. Constable. London, 1999.